BOOKS BY CHRISTOPHER BENFEY

DEGAS
IN NEW ORLEANS

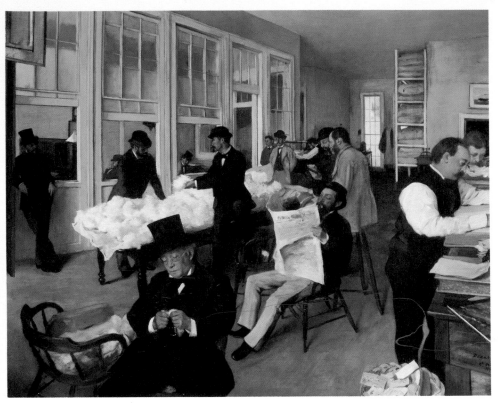

Degas, *A Cotton Office in New Orleans*, 1873

CHRISTOPHER BENFEY

DEGAS

IN NEW ORLEANS

Encounters in the Creole World
of Kate Chopin *and*
George Washington Cable

1997 Alfred A. Knopf *New York*

Library of Congress Cataloging-in-Publication Data

Benfey, Christopher E. G.
 Degas in New Orleans : encounters in the Creole world of Kate
 Chopin and George Washington Cable / by Christopher Benfey.—1st
 ed.
 p. cm.
 ISBN 0-679-43562-X
 1. Degas, Edgar, 1834–1917—Journeys—Louisiana—New Orleans.
2. New Orleans (La.)—Description and travel. 3. Creoles—
Louisiana—New Orleans—Social life and customs. 4. Degas, Edgar,
1834–1917—Psychology. 5. Cable, George Washington, 1844–1925—
Homes and haunts—Louisiana—New Orleans. 6. Chopin, Kate,
1851–1904—Homes and haunts—Louisiana—New Orleans. I. Title.
ND553.D3B46 1998
759.4—dc21 97-2817
 CIP

Manufactured in the United States of America
First Edition

For RACHEL THOMAS BENFEY
whose South and paintings were my first of both

and for NICHOLAS HENRY BENFEY
who grew with this book

They are there, yet something is missing; they are like a chemical formula exhumed along with the letters from that forgotten chest, carefully, the paper old and faded and falling to pieces, the writing faded, almost indecipherable, yet meaningful, familiar in shape and sense, the name and presence of volatile and sentient forces; you bring them together in the proportions called for, but nothing happens; you re-read, tedious and intent, poring, making sure that you have forgotten nothing, made no miscalculation; you bring them together again and again nothing happens: just the words, the symbols, the shapes themselves, shadowy inscrutable and serene, against that turgid background of a horrible and bloody mischancing of human affairs.

WILLIAM FAULKNER, *Absalom, Absalom!*

CONTENTS

ILLUSTRATIONS

DEGAS
IN NEW ORLEANS

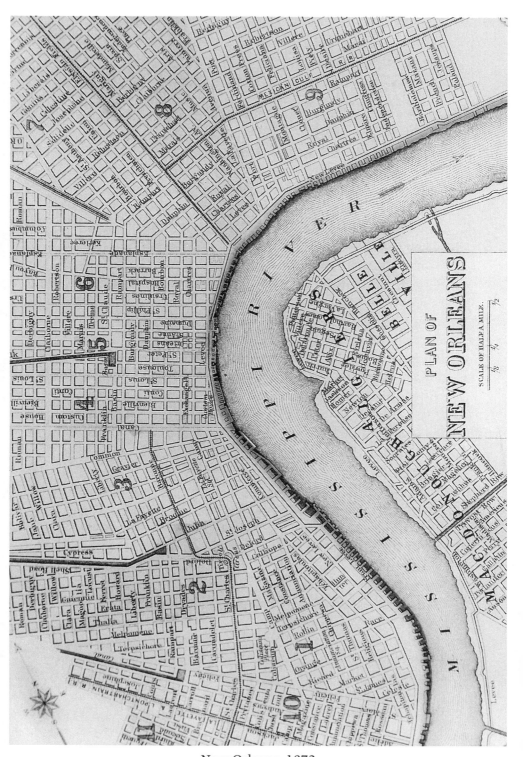

New Orleans, 1872

Esplanade: An Introduction

I F you should walk down Esplanade in New Orleans, with your back to the river and the dark green buildings of the old French Market, you will be skirting the border of the French Quarter, or Vieux Carré, on your left, while on your right jut out the oddly angled, herringboned streets of the Faubourg Marigny. The grand, high-ceilinged houses lining both sides of Esplanade, with their white columns and black ironwork along the balconies, date from the past century. The generous proportions of the shaded avenue, with its wide, tree-lined median or "neutral ground," as it is called in New Orleans (testifying to old enmities between neighborhoods), mark a sharp contrast with the tight fit of the streets in the Quarter. Here on Esplanade you can stretch your legs and breathe, though the air is the thick, stagnant stuff wafting from the Mississippi. With the arching branches of oaks and magnolias dimming the viscous greenish light, you can almost imagine you are traversing an aquarium.

Farther down, past Rampart Street, where an earthen wall once marked and protected another side of the Quarter, you begin to wonder how many more of these mansions there could be, one after the other like a formal receiving line. Who could afford to live in such luxury? Are they embassies? Funeral parlors? Did the U.S. Mint at the base of Esplanade spread its riches down the luxurious av-

enue? But as you leave the Quarter farther behind, you note that more and more of the houses are in evident disrepair, their Greek Revival features chipped and blurred, showing the wood under their marmoreal disguise. Chaotic clusters of mailboxes and doorbells indicate that they have been partitioned; careless piles of rubbish on verandas and unkempt lawns suggest apathetic renters.

Then, farther still, as the road turns almost imperceptibly upward (there are no hills in low-lying New Orleans), you have entered the neighborhood called Esplanade Ridge. Bayou Road crosses the broad avenue diagonally here, on its way to Lake Pontchartrain. On the left, metallic and scarred like a Civil War marker, is a sign that informs you that Hilaire Germain Edgar Degas, the French Impressionist painter, lived here in 1872. The house behind the sign looks no different from its neighbors. Its black cast-iron balconies, backed by green shutters, stretch like spider webs between white columns.

Edgar Degas travelled to New Orleans during the fall of 1872 to spend a few months visiting the considerable American branch of his family. His visit is something of a legend in New Orleans, told and retold with the casual disregard for historical accuracy that affects many New Orleans memories, but it is barely known elsewhere. The journey to New Orleans marked a key moment in Degas's career, however. Distracted and stalled in his profession on his arrival, he left the city with a new sense of direction and resolve. He also took with him, in his portfolio and his mind, several unforgettable images of New Orleans life.

As chance would have it, Degas's five-month sojourn in New Orleans coincided with an extraordinarily contentious period in the stormy political history of the city. One could argue that it was *the* decisive moment in Reconstruction New Orleans, as the city, under Federal control and under the constant threat of military occupation, tried to recover

from the ravages of the Civil War. Degas's American relatives were among the leaders in this political upheaval.

It was also a key moment in the cultural history of this most exotic of American cities. During precisely this uneasy period, several major American writers were beginning to mine the resources of New Orleans culture and history, often choosing the same subjects, experiencing the same events, and moving in the same social circles, as did Edgar Degas. What was it about this war-torn, diverse, and conflicted city that elicited from Degas some of his finest works? What can his paintings and letters tell us about New Orleans during a pivotal period in Reconstruction Louisiana? And what do we need to know about the intricate weave of New Orleans society—French and "American," black and white, native and newly arrived—to make sense of Degas's sojourn there?

In an attempt to answer these questions, this book follows the interwoven lives of several men and women of New Orleans during the years surrounding the Civil War. The central figures are three: Edgar Degas and the writers George Washington Cable and Kate Chopin. All three spent varying lengths of time in New Orleans during the 1870s. Ties of friendship and family linked these people, in turn, to others, connecting the stubbornly French (and still French-speaking) Creole colony in nineteenth-century New Orleans to its little-known mirror image: the "Louisiana colony" in France—*"notre petite colonie Louisianaise,"* as Degas's Parisian uncle Eugène Musson affectionately called it. This book places Degas within this transatlantic network of prominent individuals and families—both white and black—who maintained close connections with New Orleans, and moved freely between France and America, as though the two "colonies" constituted a single cultural realm.

Degas was the only major French painter of the Impressionist generation to travel to the United States and paint

what he saw there. Other French painters had ties to the New World, to be sure. As a young man, Édouard Manet had visited Brazil while working as a sailor, and painted some of the exotic sights, especially the women. Odilon Redon claimed to have been conceived in Louisiana, before travelling back to France in his mother's womb—he ascribed his taste for bright colors to the American South. Camille Pissarro's childhood in the Jewish community of the Virgin Islands gave him subjects for a few early sketches, though once settled in France he never looked back. To the extent that she turned herself into a French painter (under her close friend Degas's tutelage), Mary Cassatt is perhaps an exception. Nonetheless, it is surprising that Degas—one of the greatest painters to try his hand at American subjects—has received so little attention as an astute interpreter of the American scene.[1]

For Degas, who liked to call himself a *fils de Louisiane,* the American journey was a homecoming of sorts. His mother, Célestine Musson Degas, had been born in New Orleans into a prominent Creole family. Over the centuries, "Creole" has meant many different things. For the Degas-Musson family it meant that Célestine was descended from some of the original French and Spanish settlers of New Orleans. Her mother's name, Rillieux, was also familiar in the free black community of New Orleans; this book is the first to reveal the intimate and hitherto unsuspected connections between the black and white branches of the family.

Célestine's father, Germain Musson, had fled his native Haiti (the French colony of Saint-Domingue) after the triumph of Toussaint L'Ouverture's revolutionary forces in 1804, and made a fortune in Louisiana cotton and Mexican silver. At the corner of Canal Street and Royal, where the French Quarter joins the newer commercial or "American" sector, Musson erected, in 1825, an imposing commercial building of New England granite. In its shadow occurred some of the most explosive mass meetings of the Reconstruction period.

6

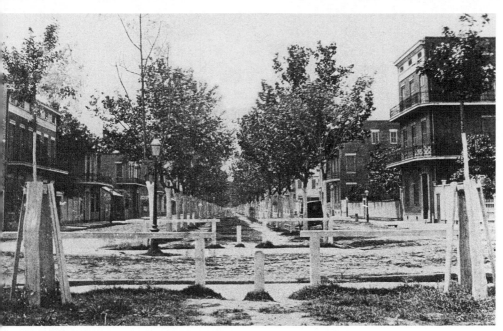

Esplanade, c. 1860

The Musson house on Esplanade

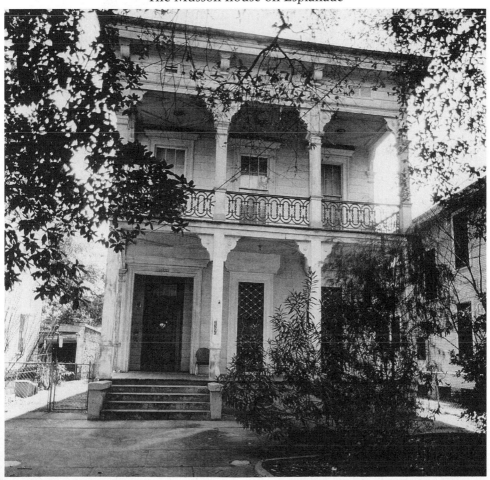

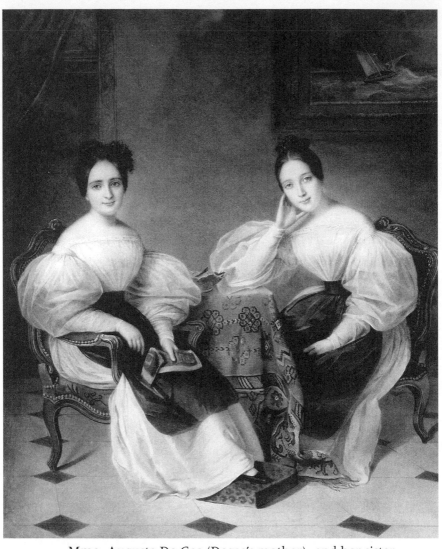

Mme. Auguste De Gas (Degas's mother), and her sister,
Duchesse de Rochefort, 1835

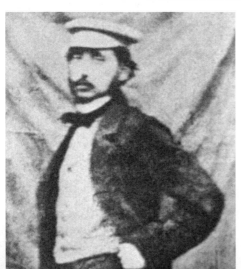

Edgar Degas in New Orleans, 1872

Maria Désirée Musson, Degas's maternal grandmother, died suddenly in 1819, at the age of twenty-five. The architect Benjamin Latrobe, who was then working in New Orleans, wandered by chance into her funeral Mass at the St. Louis Cathedral. "The Church was filled with her friends," he noted, "each of whom carried a lighted taper, and the service was long & loud." Grief-stricken, Germain took his children, including Célestine and her older brother Michel, back to France to be educated. There Célestine fell in love with her neighbor, a young banker called Auguste Degas; it was said that their romance bloomed in the garden between their houses.[2]

Célestine was eighteen when they married, during the summer of 1832. Her father's sale of a young slave girl in New Orleans boosted her already respectable dowry. At the birth of her eldest child, Hilaire Germain Edgar Degas, in 1834, she had not yet reached her twentieth birthday. To celebrate the birth, and to link his eldest son to the "mother country," Edgar Degas's father arranged that a house in New Orleans, a Creole cottage on North Rampart Street, be purchased in the newborn's name.[3]

Meanwhile, Célestine's brother Michel Musson acquired a European education—he was a classmate of Longfellow's at Göttingen—and returned to New Orleans. Musson was a successful businessman in cotton and insurance until Reconstruction policies, and the worldwide depression of 1873, threw a wrench into his finances. Something of a social chameleon, Musson called himself "Michael" when convenient, and moved freely between the two major parts of New Orleans white society: the old-line French-speaking Creoles, who lived mainly below (or downriver from) Canal Street, in and around the French Quarter; and the more recent "American" settlers in the city, who inhabited the commercial and residential neighborhoods, especially the Garden District, on the "uptown" side of Canal.

For Célestine, however, there was to be no return to her native city. Her marriage was a moody one, built of silences

and resentment. Accustomed to the social whirl of New Or-
leans, Célestine complained that in Paris she "passed my
life, my youth, next to the hearth, never going even once to
a ball, or even to the smallest party. Auguste, who's getting
more and more fed up with society, turns a deaf ear to my
prayers."[4] There were occasional visitors from Louisiana,
like the dashing young sugar-planter and horse-breeder
Duncan Kenner.[5] But Célestine would quickly sink back
into depression. Years later Degas confided to the poet Paul
Valéry a painful childhood memory of his parents at lunch:

> His [Degas's] mother, vexed by something his father
> had said, would drum her fingers irritably on the edge
> of the table, with an "Auguste! Auguste!" His father
> would sit tight and then, the meal over, sidle through
> the door, fling a cloak round his shoulders and glide
> noiselessly downstairs.[6]

Célestine had five children in eleven years, with the
youngest, René, born in 1845. Two years later, when Edgar
was thirteen, Célestine Degas was dead. The early loss of his
mother scarred Degas for life. Motherhood, from that time
forward, was always associated in his mind—and in some
of his greatest paintings—with mourning.

While Edgar Degas was growing up in Paris, Louisiana
must have seemed impossibly remote, and yet there were
constant reminders of it. He often heard his mother speak
of New Orleans with longing and nostalgia.[7] And visitors,
including his grandfather and namesake Germain Musson,
brought news of American friends and relatives. With his
other grandfather, Hilaire Degas (whose name he also
bore), in Naples, Degas seemed destined to look to not one
but two exotic realms—Italy and Louisiana—for his sense
of self and national identity.

Italy was crucial to Degas's early education as a painter,
which offers the paradox of a traditionally trained autodi-
dact. In 1845, Degas entered the secondary school of Louis-

le-Grand, and remained there for eight years. He seems to have made little favorable impression on his teachers, even in drawing class.[8] Within a couple of weeks of receiving his baccalaureate in 1853, Degas obtained permission to copy at the Louvre, part of the standard apprenticeship of aspiring French painters. He briefly attended law school (a concession to his father, who expected his eldest son to take over the family banking firm) and, for one semester, the École des Beaux-Arts, before his formal education stumbled to an end.

As with so many innovative minds, Degas's real education was elsewhere, accompanying his father, a connoisseur of early Italian art, as he made the rounds of dealers and collectors, or meeting his idol Ingres, who admonished Degas to "Draw lines, lots of lines, either from memory or from nature." He was already painting accomplished portraits of family members, such as the masterly 1855 rendition of his youngest brother, René (Smith College Art Museum), when he decided to pursue the Italian sojourn expected of French painters. With his father's backing, he could do so on his own, rather than under the auspices of the École des Beaux-Arts and its academy in Rome, the Villa Medici.

For three years, beginning in the summer of 1856, Degas divided his time between the cities of Naples, Florence, and Rome. Italy was the world of his father, who had grown up in Naples, and his grandfather, who had established the banking firm of Degas Padre e Figli after fleeing France during the French Revolution. (Both Degas's grandfathers left their native realms, Haiti and France, after betting on the losing side during revolutionary upheavals.) Degas sketched in the Uffizi and the Vatican collections, read Dante, and made friends among the painters gathered in Rome, one of whom, Joseph-Gabriel Tourny, wrote to Degas in 1858: "We are always thinking of the Degas who grumbles and the Edgar who growls."[9]

Even in the Italian world of Degas's father, his mother's

Louisiana sometimes intruded. In August of 1858, Auguste De Gas praised his son for a drawing of Angèle and Gabrielle Beauregard, ten-year-old twins of a famous New Orleans family (they were nieces of the "Creole General" Beauregard) who were visiting Rome. Auguste was less impressed with three other portraits Edgar painted of these Louisiana visitors, including Mme. and M. Millaudon, the mother and stepfather of the twins. Fifteen years later, Degas was reunited with the Millaudon family on their home turf.[10]

In 1858, Degas also began work on the masterpiece of his youth, *The Bellelli Family* (Musée d'Orsay), with its frontal treatment of a family divided: one daughter solidly in her doleful mother's camp, the other tugging towards her seated and estranged father. The parents are Degas's beloved aunt Laura Bellelli—pregnant and in mourning for her recently deceased father, Hilaire Degas, whose portrait hangs in the background—and her husband, Gennaro, banished from his native Naples for his participation in the revolution of 1848. Degas called the painting *Family Portrait*, underscoring both its generic treatment of family unhappiness and its record of three generations of his own family.

During the following decade, the dislocations caused by the American Civil War brought the French and Louisiana wings of Degas's family closer together. By 1870, Degas's restless younger brothers, René and Achille, had moved to New Orleans, refusing (with Edgar's support) to take their places in the family banking business in Paris or Naples. Like their father, they insisted on calling themselves "De Gas," flourishing a bogus coat-of-arms in their adopted country.[11] René promptly married his first cousin Estelle, a Civil War widow and one of Michel Musson's three daughters. The ill-fated alliance knit the precarious fortunes of the two families even more closely together.

A visit with René's family, who were expecting a child in

December, was a major motivation for Degas's journey to New Orleans. But there were other reasons as well. Degas had not yet settled on the subjects and styles that would occupy him throughout his career. He had painted his first pictures of ballet rehearsals and racehorses, but was uncertain about their quality.[12] His commitment to painting contemporary life was recent and wavering, and he had not yet established a consistent market for his work. His service in the National Guard during the Prussian siege of Paris, and the slaughter that followed the establishment of the Commune in 1871, had left him exhausted and depressed. When René visited Paris during the summer of 1872, and the brothers visited the sites where Edgar had served, René extended an invitation to accompany him back to New Orleans.

Degas was thirty-eight when he began his five-month stay in the Crescent City, a visit that extended between the great New Orleans holidays of All Saints' Day and Mardi Gras. This is a Degas we do not know well. Almost all the vivid, eyewitness accounts we have—from the writers Paul Valéry and Daniel Halévy, from the painters George Moore and Walter Sickert—date from a quarter of a century later, when Degas, celebrated and successful, had developed a crusty, cantankerous carapace, from which he emerged occasionally to deliver his famously caustic and enigmatic *mots*.[13] The Degas we meet in the early seventies, by contrast, is engaging and eager to please. A photograph taken in New Orleans shows a bearded man with a sailor's cap perched jauntily on his head. He holds himself upright, with a hint of the soldier that he still considered himself to be, but there is a friendly, amused look in his dark eyes.

Degas was showing his first gray hairs, but he had barely begun the career that led to his lasting fame. Much of the work for which he is best known—the dancers, the bathers, the racehorses—was still in the future. So were the Impres-

sionist exhibitions, in which he played such an important role. Degas in New Orleans was in transition, carefully weighing his options as he reinvented himself as a painter.

And what did he paint there? His family and their friends and business associates, mainly. Despite the brevity of his stay, however, Degas wasn't simply painting family portraits, like an itinerant painter making his New Orleans stop. He was also painting a society, and specifically the decimated Creole world of post–Civil War New Orleans. This self-styled aristocracy, always scornful of modern business practices, had already, before the war, financially lost out to the "American invasion" that followed the Louisiana Purchase of 1803, and statehood nine years later. While Creoles lamented the infusion of English-speaking "foreigners," New Orleans was quickly transformed into the major city of the South, and a port city that rivaled New York in the sheer volume of its trade.

The Civil War put an end to what remained of the Creoles' social status as well. Old Creole families like the Mussons continued to speak French and to cling to the props of the Ancien Régime way of life: the box at the opera, the mansion on Esplanade, the black servants. But financial circumstances forced the closing of the opera during the winter season of 1872, and the mansion on Esplanade was rented, not owned, by Musson. "Not own your residence!" exclaims an old Creole matron in a Grace King story set during the 1870s in New Orleans. "As soon not own your own tomb as your residence!"[14]

"Fair France still has a quarter of a foot in Louisiana," Degas remarked resignedly to his friend the painter James Tissot. "The Creole cannot measure strength with the Yankee." One result of the crumbling world of the Creoles was a powerful nostalgia for the pre-war world. The precarious status of the Creoles—beaten by the uptown "Americans" before the Civil War, and by the Northern Yankees during

and after it—had another, more troubling result, in their increasingly desperate attempts to restore their lost prestige.

In New Orleans, Degas happened to be living in the midst of a group of men of such strong political convictions, and such an acute sense of their own slipping status, that they were willing to resort to violence to seize what they regarded as their birthright. For these men, many of them Creoles like Musson, the enemy was the Reconstruction government made up of opportunist Northern politicians (dubbed "carpetbaggers") and their supporters among the freed slaves. Degas arrived just in time to witness the corrupt state election of 1872, and stayed long enough for the first of several coup attempts that followed. The bitterness arising from the election—which placed an African-American governor briefly in office—lasted for several years, culminating in the bloody confrontation of 1874 known as the "Battle of Liberty Place." In this pitched street battle, members of an all-white militia called the Crescent City White League fought with the integrated Metropolitan police, and thirty people died before Federal troops restored order.

The Musson family was deeply enmeshed in the very highest reaches of New Orleans politics. Michel Musson had been a leader in the "Unification Movement," an attempt to bring about cooperation between white and black businessmen. When Unification failed to catch hold in the rest of Louisiana, many of its participants, including Musson, looked to more radical measures to overcome the Reconstruction regime. Musson himself presided over the white supremacist White League's rally, just before the Liberty Place battle, while his son-in-law William Bell (another inhabitant of the Esplanade house) served as treasurer for the White League. Bell's friend and business partner, General Fred N. Ogden, was the military commander of the White League militia.

The involvement of his family in these events gave a turbulent backdrop to Degas's sojourn in New Orleans. Even

the Mardi Gras festivities that winter devolved into violence. The political turmoil in New Orleans turned out to be a prelude to more personal upheaval for the Musson-Degas clan, which suffered an extraordinary series of deaths, desertions, and scandals.

Just as the world of "Old New Orleans," with its quaint Creole customs and incendiary resentments, was on the wane, it became a rich subject for such writers as George Cable and Kate Chopin, whose works often help us to decipher the underlying meanings in Degas's paintings and letters. Cable was a cotton clerk and newspaperman by profession. A native of the city, he had fought for the losing side in the Civil War. By late 1872, while Degas was getting his bearings in the city, Cable was writing his first stories about New Orleans. In their seductive accounts of voodoo, quadroon mistresses, pirates, haunted houses, friction between Creoles and Americans, and so on, Cable's stories, collected in *Old Creole Days*, set the pattern for all later evocations of "Old New Orleans." His complex first novel, *The Grandissimes*, deploys a vivid cast of black and white members of the same family as they weave their interlocking destinies in the shadow of the "great mother-mansion of the Grandissimes," located on Esplanade.

When her own Creole stories were favorably compared to Cable's, Kate Chopin was delighted. Such praise indicated that she had learned her lessons well. Though descended from Louisiana Creoles on her mother's side, Chopin was a native of St. Louis. A passionate supporter of the Confederacy in her youth, she lost a beloved half-brother in the war, and the ghosts of the conflict haunt many of her finest stories. Chopin fell in love with New Orleans on her first visit there, in 1869, when she stayed in a house just off Esplanade; within a year she had fallen for a New Orleanian as well, when a young cotton factor called Oscar Chopin visited St. Louis. They settled in New Orleans in 1870, and Oscar set up his cotton business next door to

the Musson firm on Carondelet Street. Kate Chopin's novel *The Awakening* is a portrait of New Orleans during the 1870s. Even as it registers the lingering effects of the Civil War on New Orleans society, *The Awakening* portrays a domestic "civil war" between mismatched New Orleanians. Like Cable, Chopin placed the major address of her novel, and the breakdown of the Creole-American marriage at its center, on Esplanade—the main artery of the old Creole world.

Both Cable and Chopin had close ties to the White League. Cable was a firm believer in civil rights for blacks, but the man who served as Cable's literary mentor, and encouraged him to write his first novel, was a prominent propagandist for the League. Oscar Chopin had cooled his heels in France during the Civil War; the White League disturbances of 1874 gave him a second chance to fight, and he seized it.

George Cable called New Orleans a "hybrid city," and part of the myth and the truth of New Orleans is that it has long been a crossroads of different cultures, often in conflict, sometimes in harmony. Founded by the French in the early eighteenth century, under Spanish rule for thirty-five years after the French and Indian War, the colony was returned to the French under Napoleon, then hastily sold to the young United States, like a mature person turned over to the whims of a child. And all this before the Civil War.

Not only did New Orleans receive the confluences of any great port city—recently arrived sailors looking for a good time and recent immigrants looking for a good life—it also experienced as deeply as any city in the United States the interracial intimacy of slavery and its aftermath. "I doubt if there is a city in the world," wrote Frederick Law Olmsted after a visit to New Orleans during the 1850s, "where the resident population has been so divided in its origin, or where there is such a variety in the tastes, habits, manners, and moral codes of the citizens." Such diversity, while

17

sometimes impeding commerce, gave "greater scope to the working of individual enterprise, taste, genius, and conscience; so that nowhere are the higher qualities of man . . . better developed, or," Olmsted added slyly, "the lower qualities . . . less interfered with."[15] It is precisely this hybrid character of New Orleans that has made for many of her most distinctive creations: the jazz of Jelly Roll Morton and Louis Armstrong; the complex rituals of Mardi Gras; the stories of George Washington Cable and Kate Chopin; the New Orleans paintings of Edgar Degas.

I discovered early on that the materials that make up this book had a logic of their own. My successive attempts to find the "underlying meaning" or the "overarching argument" have proved themselves, one by one, an imposition. New discoveries pushed certain figures to the fore, while others—whom I had once chosen for starring roles—were banished to the wings. The design of the book came to reflect the intricacies of New Orleans society and the continual surprises—at least to me—of echoes and shared destinies.

Many years after his American journey, Edgar Degas heard that his friend the painter Paul Gauguin was looking for an exotic place in the world free of the strictures of modern life. Gauguin was considering the South Sea Islands. Degas advised him to go to New Orleans instead. "But he decided," Degas drily remarked, "that it was too civilized." Gauguin was probably right, as far as his own needs were concerned. But the advice suggests that New Orleans was just the right place for Edgar Degas, when he himself needed a change of scene and direction.[16]

PART ONE

Duncan Kenner in 1846. Portrait by Jules Lion,
free man of color

1

Soulié

The plain white muslin veil, (the usual head dress) thrown across the head & covering the shoulders & back, contrasts well with their beautiful black hair, which is generally of a very luxuriant growth. This want of a covering for the head easily accounts for the dark complexion of the Italian woman, for many of them might easily be taken for mullatoes.

DUNCAN KENNER, *Travel Diary, June 28, 1833*

DURING the 1830s, two travellers, having crossed the Atlantic Ocean in opposite directions, arrived at their respective destinations. Duncan Kenner, a young horse-breeder and sugar-planter from Louisiana, began his Grand Tour of Europe. And Harriet Martineau, an English social critic and novelist, set out on her equally grand circuit of the United States, including a stop in Louisiana. Each traveller—in accord with nineteenth-century practice—kept a diary. That of Martineau, the professional writer, is the more copious, and served as the basis for her book *Retrospect of Western Travel*. Kenner's diary is sketchier, except when his attention is prolonged by a beautiful painting, a beautiful woman, or an ingenious piece of machinery. By chance (and what is travel if not an opening of oneself to the workings of accident?), each traveller encountered in the street part of a New Orleans story, with a mystery attached.

21

Kenner is German for *connoisseur,* a "knower" of fine things, and Duncan Kenner, just out of college in 1832, was carefully schooling himself to appreciate the finer things of life. At nineteen, he already knew that he was destined for greatness. Money and status were his by birth; the life of a country gentleman, with a hand in politics and finance, was open to him as well. A portrait of Kenner, made in New Orleans in 1846 by the free black lithographer Jules Lion, shows an alert and sensitive young man whose pursed lips counter a lack of forcefulness in the face.

Duncan Kenner had a country squire's tastes. He was passionate about horses, breeding them and racing them, and came to be known, for his achievements at the New Orleans tracks, as the "Napoleon of the Louisiana turf." Kenner's standards were high. Visiting Tattersall's, a fashionable horse auction firm, in London in 1833, he found it "quite common." Kenner hired the great equine painter Edward Troye to paint his own stable of fine racehorses. As a patron, he took an interest in architecture and engineering as well, often trying out—during the years leading up to the Civil War—the very latest inventions on his vast sugar plantation of Ashland outside New Orleans.[1]

Kenner's zigzag tour of Europe, up to Great Britain and down through Italy, took him often to Paris, where he visited a few families with Louisiana connections, including the Mussons. Célestine Musson, formerly of New Orleans, had recently married Auguste De Gas, a French banker with Neapolitan connections; they were expecting their first child during the summer of 1834. When Kenner made his way to Naples, presumably carrying an introduction from Célestine, he was hosted by other members of the De-gas family. Kenner was particularly close with Auguste De Gas's brother Henri, also a banker in the family firm. (Henri's wistful, ironic face—as it looked many years later—peers from a fine portrait by his nephew Edgar Degas, now in the Art Institute of Chicago.) "In the evening," Kenner noted on January 18, 1834, "I went to a very pleasant Ball with

Mr. Degas, at the house of one of his friends." The next morning, waking late from the previous night's revels, he "took a ride upon a very nice horse Mr. Henry Degas was kind enough to lend me."[2]

Kenner disapproved of the "despotic" government of Naples, where "Justice is sold but not dispensed" (one can already hear the future politician in his words), and he would have found some sympathy among the Degas family. Henri's sister Laura had married a man of leftist sympathies called Bellelli, whose subversive activities led to his banishment from Naples. Kenner admired Naples's cultural riches, however. On January 17, he spent "a long morning at the Studii or Museo Barbonico," inspecting the paintings and antiquities from Pompeii and Herculaneum (objects that Edgar Degas would avidly sketch twenty years later), including "a comb, which is very coarse, & such as would be used in the present day to dress a horse, but the Roman ladies must certainly have had finer." While he admired a Venus attributed to Praxiteles, he found the statue's position "most unfortunate, wanting both grace & decency. She is looking over her shoulder, trying to catch a glimpse of her *backside* which she has uncovered for that purpose."[3]

By the summer of 1834, Duncan Kenner, who was fluent in French and eager to learn German, had made his way to Vienna, "one of the most agreeable places I have yet seen." On July 1, as he wandered through the city, he ran into an old acquaintance from New Orleans. "I was agreeably surprised at meeting Norbert Soulié today in the street," he noted. "He has just arrived from Italy & is travelling with a Portuguese. They are going to Dresden in 10 or 12 days. I think I shall accompany them." Kenner, who had connections in high places wherever he went, invited Soulié and his companion to join him in celebrating the Fourth of July, Kenner's "third fourth in Europe," at the American consul's house.

Ten days later, on Bastille Day, the three men left Vienna together in a hired carriage. They rolled through the pic-

turesque fields and valleys of Bohemia to Prague, where they visited churches and palaces together and attended a ball—"I never saw an uglier set of women in my life," Kenner remarked. Then on to Dresden, where two days in the picture galleries were the high point of Kenner's visit. He was dutifully impressed by Dresden's most famous painting, the Sistine Madonna: "The heads of the two cherubs near the bottom of the picture are the sweetest faces I ever saw." On the evening of July 24, Norbert Soulié and his friend left for Berlin, whence they planned to travel on to Stockholm and Moscow. "Soulié is an amiable and excellent fellow," Kenner noted that night, "but Penelta the Portuguese is one of the most selfish, ignorant, uninteresting men I have ever met."[4]

Duncan Kenner does not inform us (he's writing in his private diary, after all) how he knew Norbert Soulié, a gifted young architect from New Orleans, but we can reconstruct some of the prehistory of their friendship. A decade earlier, Benjamin Latrobe, the neo-classical architect whom Jefferson hired to complete the Washington Capitol and other public buildings, had won the competition to design the New Orleans waterworks. Latrobe, who had completed a similar commission in Philadelphia, was too busy to undertake the lucrative project himself, and passed it on to his son Henry, a young architect of great promise. Among the other commissions Henry accepted in New Orleans were the Orleans Ballroom (where, according to legend, white men selected their dark-skinned mistresses at "quadroon balls") and a new house, built in 1816, for William Kenner, father of Duncan Kenner.

Henry Latrobe's foreman and apprentice was Norbert Soulié. When Henry Latrobe died suddenly in 1817 of yellow fever, the recurrent plague of New Orleans, Benjamin Latrobe reported to a friend that he had received a letter from a "Mr. Norbert Soulié, who appears to have been a principal agent or foreman of my lamented son. . . ." Soulié

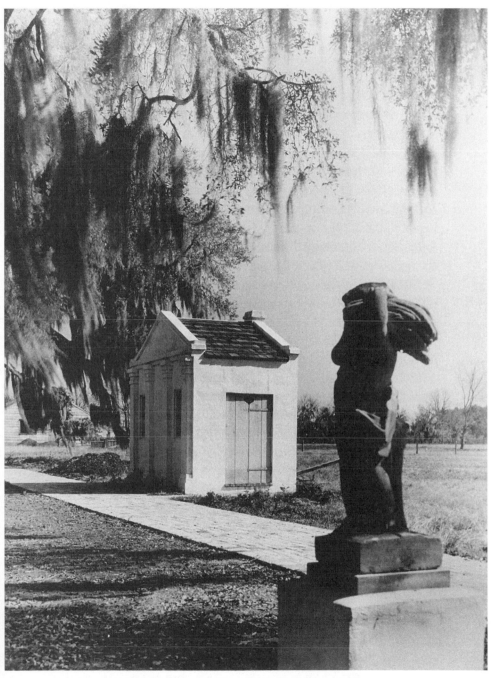

Classic privy at the Evergreen Plantation.
Photograph by Clarence John Laughlin, 1947

informed Latrobe that he had worked with Henry Latrobe since the latter's arrival in New Orleans in 1811, and that he owed his knowledge of the arts to Latrobe.[5]

Norbert Soulié continued to work in New Orleans after Henry Latrobe's death. He built several houses in the French Quarter, and his name appears on the financial statements for the Evergreen Plantation, one of the most beautiful and haunting groups of plantation buildings in Louisiana. Soulié, to judge from his surviving work, was drawn to a hybrid art, combining classical motifs with elements of native Louisiana architecture. A low-slung Creole cottage in the French Quarter, built for his aunt Constance Vivant, has a Greek Revival facade. The outbuildings of the Evergreen Plantation, including a neo-classical, double-chair privy, wittily engage both traditions. Norbert Soulié's ties to Latrobe apparently gave him a reputation in the design of public works as well. With his cousin (and Vivant's son) the builder Edmond Rillieux, he was hired in 1831 to build the Louisiana Sugar Refinery, two miles below Esplanade in New Orleans.

The Soulié family was one of the wealthiest in New Orleans, having made a fortune speculating in real estate. The men of the family—especially Norbert and his brothers Bernard and Albin—were so well established that they often neglected to add to their names the designation required by law: "free man of color," or "f.m.c." The Soulié brothers were of mixed racial background, with a white father and a quadroon mother. Technically free, such men as the Souliés and their families constituted a separate caste in pre–Civil War New Orleans. The free people of color, generally French-speaking and often of light complexion, had some, though not all, of the rights of white people. They could bring suits and testify in court, for example, but they could neither vote nor serve on juries, and they were banned from marrying whites. The talented and clever Norbert Soulié entered the building trade, as the architectural historian Edith Long notes, "because that was where, as a

free man of color, he could be prosperous, creative, and independent."[6]

One public document concerning Soulié's work does carry beside his name the letters "h.c.l." (*"homme de couleur libre"*). Dated 1831, it records the transfer of a piece of property on Burgundy Street from Soulié to his aunt Constance Vivant. On the same piece of land, Soulié built the delicate Creole cottage mentioned above, which still stands at 509 Burgundy near St. Louis Street. Constance Vivant and her sister Eulalie were free women of color of the wealthy Cheval family, which had real estate holdings in the city along Esplanade.[7] The two sisters had longstanding liaisons with white men—Vincent Rillieux and Juan Soulié, respectively. The two men had served, perhaps in each other's company, in the New Orleans militia, which, under General Andrew Jackson's command, successfully defended the city from British attack in the Battle of New Orleans in 1815. Presumably it was through the influence of Vincent Rillieux, a wealthy cotton factor and the owner of an extensive cotton press and warehouse, that Norbert Soulié and Rillieux's son Edmond, another free man of color, secured the contract to build the Louisiana Sugar Refinery below the city.

But something went deeply wrong with the Refinery arrangements, details of which can be gleaned from surviving notarial and court records. Contracts for the project between Norbert Soulié and Edmond Rillieux, and the head of the Refinery, Edmund Forstall, were signed early in 1831, and construction was soon underway. Then in early 1832, as work on the Refinery progressed, Edmond Rillieux suddenly and mysteriously disappeared, "without having appointed anybody to take care of his estate." Rillieux's present residence," according to a court document, "is wholly unknown to the friends and relations of said Rillieux, who have no reason to believe that he will quickly return to the state."[8]

Meanwhile, Norbert Soulié was ceding land to one of his

aunts, Constance Vivant, and selling a slave to another in preparation for his own departure from New Orleans, sometime in 1833, never to return to the city. The precise nature of the crisis over the Refinery remains uncertain. Did Edmond Rillieux abscond with funds? Did he find himself in over his head, lacking the necessary expertise to finish the project? It is hardly surprising, in any case, that a quarrel developed between Edmund Forstall, the head of the enterprise, and Vincent Rillieux, the underwriter of the ambitious young free men of color who had signed on to bring it to fruition. Vincent Rillieux died suddenly on July 16, 1833, at the offices of his cotton press. The New Orleans *Bee* says he died of a stroke. Family records indicate that he died in a duel. The death certificate gives no cause of death.[9]

When Duncan Kenner met him in 1834, Norbert Soulié was fleeing the fallout from the Refinery project. The designation "free man of color," which Soulié had dropped from his name in city directories, had probably become a burden to him as well. When Kenner met him, Soulié—like many other light-skinned free blacks from Louisiana—was "passing" for white in Europe. We can safely assume, however, that Kenner knew Soulié's racial identity; the Souliés were a prominent family in New Orleans, where their race was no secret. But Kenner surely saw no reason to blow his cover. And besides, what livelier guide to European architecture—the churches and palaces of Prague and Vienna—could Kenner dream of than this clever and well-informed student of the Latrobes?

If we could listen in on the conversations between Kenner and Soulié, as they rattled in their hired carriage through the well-tended Bohemian countryside, it would be interesting to know if the name Rillieux ever came up, either in relation to the Refinery or with regard to other applications of steam power. Kenner was profoundly inter-

ested in the wonders of steam. While visiting the Whitbread Brewery in London in May of 1833, he had noted that the grinding of the malt as well as the boiling and fermenting of the beer were done by steam. "Boiling by steam," he mused, "would I think be a good idea to the sugar planter—as it boils faster & is less costly." In an odd coincidence, Norbert Soulié's cousin, the brilliant engineer Norbert Rillieux (the similar names are confusing, but unavoidable), had just drawn up plans for precisely this kind of machinery: an efficient steam-driven apparatus for refining sugar.

Norbert Rillieux was the older brother of Soulié's former partner, Edmond Rillieux. A native of New Orleans, he had been studying and teaching in Paris. In 1833 he returned to New Orleans, on Edmund Forstall's invitation, to serve as the head engineer at the Louisiana Sugar Refinery. His father's quarrel with Forstall quashed his plans to run the Refinery, however. Instead, Norbert Rillieux was hired by several forward-looking planters, including, eventually, Duncan Kenner, to improve their sugar-refining equipment, with spectacular results. We will have much more to say about the multi-talented Norbert Rillieux, free man of color.

After bidding farewell to Norbert Soulié and his loutish Portuguese friend, Duncan Kenner travelled on alone to Paris, and a final visit with the Musson-Degas family, before returning to his horses and his sugar cane in Louisiana. Célestine and Auguste De Gas were celebrating the birth of a baby son, named Edgar, born on July 19, 1834. On that very day, Kenner and Soulié had been "strolling about the beautiful walks & town of Toplitz."[10]

Edmond Rillieux, who had disappeared without a trace during the Refinery crisis, returned to New Orleans after his father's death and placed an ad in the New Orleans *Bee*, on May 19, 1834, announcing that he and his brother Norbert would execute "with neatness, despatch, and at mod-

erate prices, all kinds of maps and plots, of cities, burghs, lots, houses, factories and of machinery of every description."

At the time of Edmond's unexplained disappearance the previous year, an inventory had been made of his possessions. According to his father's terse testimony, Edmond owned only the papers in his desk, including contracts for the Refinery, and "a negro [slave] named Robert . . . aged 21, acquired from Lucien Soulié."

Edmond Rillieux had no assets worth mentioning except one. A New Orleans client, Delphine Lalaurie, owed him a considerable amount of money. Vincent Rillieux testified, according to the notary's report, "that Madame Lalaurie told him that she owed fifteen hundred piastres [approximately the same amount in dollars] to Edmond Rillieux." The money owed was presumably for Edmond Rillieux's help in building her formidable mansion, completed in 1831, on Royal Street.

2

The Haunted House

(1834)

New Orleans was a kind of haunted place anyhow.

JELLY ROLL MORTON

TODAY you would hardly notice the house—there is so much else to see. Hundreds of visitors pass it every day on Royal Street, the busiest shopping thoroughfare in the French Quarter. On either side are the second-hand jewelry stores that have always lined Royal Street, testifying to the rapid rise and fall of fortunes, and perhaps of love. Second-hand books, Mardi Gras trappings, antiques, smut and erotica to please all tastes are on plain view in shop windows and courtyards. And then this tall and stately house, gunmetal gray, impervious to prying, so unlike its filigreed and ostentatious neighbors. It marks the corner of Royal and Governor Nicholls Streets, on the "uptown river corner," and just beyond is one edge of the Quarter, the tree-lined avenue of Esplanade. There is no marker on the house, no sign to alert the tourist that ghosts live here. Instead, just a

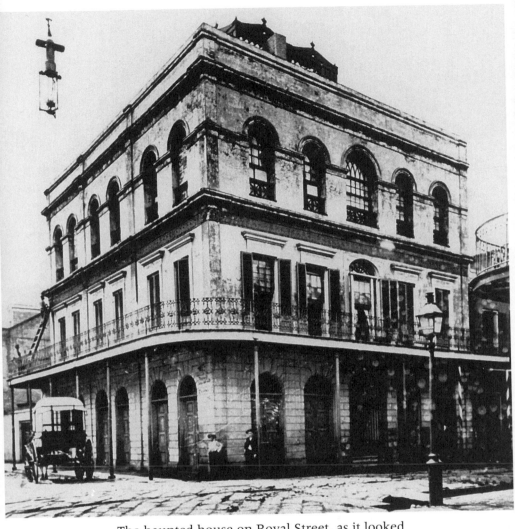

The haunted house on Royal Street, as it looked
at the turn of the century

thicket of mailboxes indicating that the house is divided into apartments, and closed to the curious.

More than a century and a half ago—the spring of 1836, to be exact—this statuesque house stood in ruins. Gutted and gaunt, its only ornament was the indignant graffiti that decorated the scarred outer walls. Surrounded by signs of prosperity, in a bustling city just entering its economic boom, this violated house (like a damaged church left unrestored in a bombed city) was evidently some sort of monument, but a monument to what, or to whom?

Harriet Martineau stood looking at the house a long time. The snub-nosed, blunt-spoken political thinker and novelist had arrived in New Orleans in early May of 1836, for a ten-day sojourn in the city, as she toured the South making notes on the peculiarities of American society. After her arrival in the United States from England, Martineau had gone directly from New York to Washington and farther south, determined to keep as open a mind as possible with regard to the slave society she deplored. Armed with her ear-trumpet and her prejudices, this extraordinary Englishwoman, partially deaf since childhood, had wandered the filthy streets of New Orleans—with their open sewers strewn with garbage—taking in the sights and watching her step. "The ladies of New-Orleans walk more than their country-women of other cities," she noted, "from the streets being in such bad order as to make walking the safest means of locomotion."[1]

She could tell that this battered house must have a story, and she was determined, despite her hosts' embarrassed hesitations, to hear it. "The house stands, and is meant to stand, in its ruined state," she wrote. "It was the strange sight of its gaping windows and empty walls, in the midst of a busy street, which excited my wonder, and was the cause of my being told the story."

In her book *Retrospect of Western Travel*, Martineau intro-

duces her tale with calculated casualness. Playing the role of tour guide, she describes an afternoon ride along the old Shell Road—so named for its surface of crushed, sun-bleached seashells—north towards Lake Pontchartrain. She notices details that she considers picturesque: the snakes that "coil about the negroes who are seen pushing their canoes through the rank vegetation, or towing their rafts laden with wood along the sluggish bayou." And she observes the other sightseers: "The winding white road is thronged with carriages, driven at a very rapid rate. . . . Many go merely as we did, for the sake of the drive, and of breathing the cool air of the lake, while enjoying a glass of iced lemonade or sangaree.

"It was along this road," Martineau adds, as though passing along another detail of local color, "that Madame Lalaurie escaped from the hands of her exasperated countrymen."

The ruined house, Martineau was told, had belonged to Delphine Macarty Lalaurie, a prominent hostess in the very highest Creole circles, and a direct descendant of the great Macarty family. Her grandfather General Barthelmy Macarty had distinguished himself in the Indian battles of the eighteenth century, when the frontier outpost of New Orleans was often threatened with massacre. Macartys had served in every important capacity in the city since.

So distinguished were the Macartys that when the New Orleans writer Grace King assembled materials for her snobbish but authoritative book on the old Creole families of New Orleans, she gave extensive attention to the Macarty family and their relatives the Forstalls. Though King was a brilliant writer of short stories, with a sharp eye for family secrets—her "Little Convent Girl" remains one of the masterpieces of New Orleans fiction—she steered clear of any whiff of scandal in her account of the Macarty family, ignoring both the family's ties to the free black family of the same name, and the whispered stories about Delphine.[2]

"The beautiful Delphine Macarty," according to Grace King's pedigree of the Macarty family, "became the mother of the no less beautiful Marie Françoise de Borja de Lopez y Anguillo ('Borquite'), who married Placide Forstall and became the mother of twelve children from whom descend the great New Orleans families of Forstall and Rathbone." Senators, bankers, wealthy plantation owners (including Edmund Forstall of the Louisiana Sugar Refinery) traced their ancestry directly to the beautiful Delphine. She had outlived two husbands and was now married to a third, the inconspicuous Dr. Lalaurie, who barely figures in accounts of his radiant wife.

In her house on Royal Street, Mme. Lalaurie entertained the Creole elite of the city. Guests arriving for the first time at the heavy iron door could have little sense of what awaited them inside. Amid richly ornamented ceilings and furnishings, Mme. Lalaurie served only the finest food and wine. A frieze of angels ran along the four walls of her dining room—"bristling angels," wrote someone who had seen them, "erect, severe-looking, holding palm branches in their lifted hands."[3] Guests commented on Mme. Lalaurie's extraordinary personal beauty, her sense of style, and her kindness—it was her kindness they especially insisted upon. "When she had a dinner-party at home," Harriet Martineau was told, Mme. Lalaurie "would hand the remains of her glass of wine to the emaciated negro behind her chair, with a smooth audible whisper, 'Here, my friend, take this; it will do you good.'"

The Lalaurie house was completed in late 1831, under the auspices of E. Soniat Dufossat.[4] Who the actual builders were, apart from Edmond Rillieux, remains unclear. Three stories high, with an attic and a belvedere, it was the tallest building in the neighborhood during the 1830s and for decades thereafter. From the belvedere, one could see in one direction the great Mississippi curving along the levee at Jackson Square, with its line of steamboats—like "great weary swans," thought Lafcadio Hearn—along the piers.

Along the levee (as Martineau observed), the turbanned women of the quadroon caste, many of whom were the mistresses of prominent white men, could be seen taking their evening promenade. At that time, the quadroon caste was "in its dying splendor," as George Cable noted, "still threatening the moral destruction of private society, and hated—as only woman can hate enemies of the hearth-stone—by the proud, fair ladies of the Creole pure-blood, among whom Mme. Lalaurie shone brilliantly."[5]

In the other direction one could see, beyond Rampart Street, the packed-dirt expanse of the "Place des Nègres," later known as Congo Square, where the slaves of the city were allowed to congregate and sell their wares on Sundays, and dance the Bamboula and the Calinda to the music of Africa and the West Indies. If the serene and elegant quadroon women represented one extreme of the black world of New Orleans, this Dionysian corner on the "back side" of town, the seedbed of jazz and voodoo, represented another.[6]

The rhythm of the baroque windows in the Lalaurie house is particularly satisfying. They are arched on the ground level and third floor, rectangular and faced by a wrought-iron balcony on the second, where the dining room was. Invisible from the street is the small paved court-yard—a favorite subject for generations of New Orleans photographers. Along one side of the court, partially hidden from the street, is a long narrow wing of four stories jutting from the main house, with latticed open hallways, or "galleries" in New Orleans parlance, extending the length of each floor. Each story is composed of a succession of small square rooms, with a door to the gallery and, at the opposite end, a small high window. Such wings are common in the fine houses of New Orleans. They were the slave quarters. Unusual in the Lalaurie house, and much remarked at the time, were the size of the locks (seven inches across, according to one report) on the doors, and the solid iron shutters on the windows.

Despite the austerity of its exterior, and its conspicuous height, the Lalaurie residence resembled in other ways many of the older houses in the French Quarter. Fortresses on the outside, they were oases of opulence and comfort within. Such houses struck even some nineteenth-century residents as somehow sinister and uninviting. Describing a similar house on neighboring Chartres Street, Kate Chopin remarked that "from the outside [it] looked like a prison, with iron bars across the door and lower windows."[7] The imposing walls protected the lively social life within, and preserved the privacy—or, if need be, the secrecy—of the revelers.

White New Orleans in 1834 was split between "Creoles" like Mme. Lalaurie, claiming descent from the Spanish and French families who had founded the city, and "Americans"—the later arrivals (or *"arrivistes"*) who settled in the city after the Louisiana Purchase of 1803, and, in even greater numbers, after the entry of the state of Louisiana into the Union in 1812. By the 1830s the balance of political and economic power was already shifting towards the Americans, though in private society the Creoles still held on to the prestige accorded the elite. "The division between the American and French factions is visible even in the drawing-room," Martineau observed. "The French complain that the Americans will not speak French; will not meet their neighbours even half way in accommodation of speech. The Americans ridicule the toilet practices of the French ladies; their liberal use of rouge and pearl powder." It was a time when the "slippery seepage" of American immigration was swelling into a flood, making the Creole, as George Cable later remarked, "tremble for his footing."[8]

New Orleans Creoles prided themselves on the good treatment of their slaves, so when rumors began to circulate about the haggard and bruised appearance of Mme. Lalaurie's "servants," it was assumed in Creole circles that this was just another example of American prejudice and

social envy. Uninvited inside, the resentful "Americans," so the argument went, invented stories about what went on behind closed, or locked, doors. When an "American" lawyer (a friend of Martineau's) heard reports about Mme. Lalaurie's mistreatment of her slaves, he sent a young Creole assistant to the house to alert the mistress to certain laws of the state of Louisiana, including Article XX of the Code Noir or "Black Code," drawn up many years earlier but still in effect: "Slaves who shall not be properly fed, clad, and provided for by their masters, may give information thereof to the attorney-general or the Superior Council . . . upon which information . . . the attorney-general shall prosecute said masters."

But Mme. Lalaurie's charm proved too much for the young law clerk, who returned, according to Martineau, "full of indignation against all who could suspect this amiable woman of doing anything wrong. He was confident that she could not harm a fly, or give pain to any human being." Later a neighbor testified that she had watched Mme. Lalaurie chase a little black girl, eight years old perhaps, up one story of the slave quarters to the next, "cowhide in hand," only to hear—she had covered her eyes in horror—the girl fall to the ground. A legal inquiry determined that Mme. Lalaurie had indeed abused her slaves, and the slaves were duly put on the market. But a relative was induced to purchase the human property, and they were promptly returned to Mme. Lalaurie.

Then came the fire, on April 10, 1834. It was set deliberately, as the only way to bring to light the horrors in the house, by the cook in Mme. Lalaurie's kitchen, who was fastened by an eight-foot chain to the area around the fireplace. "It is a pity," Martineau remarks, "that some of the admiring guests whom [Mme. Lalaurie] assembled round her hospitable table could not see through the floor, and be made aware at what a cost they were entertained." The flames—as though bent on cooking the guests as well as

their food—went up through the ceiling, into the elegant dining room with its vigilant angels, and up to the third story, with its great locks on the doors. When friends and neighbors arrived to help, someone asked where the servants were. Mme. Lalaurie indulged in a little joke. "Never mind them now—" she shouted, "save the valuables!"

But too many rumors had run unchecked to be stifled in the panic of the fire. Several men broke down the padlocked doors and entered what proved to be Mme. Lalaurie's private torture chamber. They found several black women, chained and bound with leg irons. One had a hideous, untreated wound in her head. The search progressed from room to room, and more victims were found and led from the house. The editor of the New Orleans *Advertiser* reported the next day:

> We saw one of these miserable beings. The sight was so horrible that we could scarce look upon it. The most savage heart could not have witnessed the spectacle unmoved. He had a large hole in his head; his body from head to foot was covered with scars and filled with worms! The sight inspired us with so much horror that even at the moment of writing this article we shudder from its effects. Those who have seen the others represent them to be in a similar condition.

And Mme. Lalaurie? The house that had been a prison for her slaves turned out to be surprisingly porous for her. At the time of day when the fashionable beau monde of the French Quarter were accustomed to taking their afternoon drive along the Bayou Road, northwest towards Lake Pontchartrain, a carriage appeared as usual at Madame's door. She walked calmly through the throng, gathered in chaotic indignation around the house, and boarded her carriage. Her mulatto driver seized the reins and the whip and she was off—for good, as it turned out, since arrangements had been made to get Mme. Lalaurie onto a schooner in the Lake.

The "sleek" coachman—Martineau's adjective adhered to him in every later version of the story—drove the empty carriage back to the city. The crowd took out their fury on the horses, whom they slaughtered, and on the carriage, which they smashed to bits. "What they did with the driver is not told," George Cable remarks drily, "but one can guess."

Then the crowd turned to the house. It took an hour to gut it. "The piano, tables, and chairs were burned before the house," Martineau noted. "The feather-beds were ripped up, and the feathers emptied into the street, where they afforded a delicate footing for some days." George Cable, in his later account of the destruction, is even more explicit:

> In a single hour everything movable disappeared or perished. The place was rifled of jewelry and plate; china was smashed; the very stair balusters were pulled piece from piece; hangings, bedding and table linen were tossed into the streets. . . . The very basements were emptied, and the floors, wainscots, and iron balconies damaged as far as at the moment they could be. The sudden southern nightfall descended, and torches danced in the streets through the ruined house.

The crowd destroyed the roof, "defaced the inner walls," and were in the act of tearing down the outer ones when the sheriff arrived, in the early morning, to put an end to the destruction.

It is difficult, over a century and a half after the event, to make out the constituent parts of the angry mob. Like the victim in an English detective story, Mme. Lalaurie had given many people many reasons to hate her. She was rich, she was white, she was a Creole, she was cruel; she was also a woman and a powerful one. "The rage of the crowd, especially of the French creoles, was excessive," Martineau was told. But why especially the Creoles? For giving the

Americans another reason to despise them? Accounts of the plundering of the house emphasize the richness of the artifacts expelled from the windows, and it may be that the crowd was as interested in scavenging from the house as in destroying it. Their zeal—so familiar in revolutionary times—suggests the transgressive thrill of inviting oneself into an interior hitherto off limits. "Those who rush in are all classes and colors," the reporter for the *Courier* announced the next day. But a participant assured Cable in the 1880s that "we couldn't have allowed that!" Fearing a slave uprising from the large black populace of New Orleans, the white gentlemen, according to Martineau, organized themselves into a patrol "to watch the city night and day till the commotion should have subsided."

Like a runaway slave herself, Mme. Lalaurie fled the city, escaping to France, where she holed up in Paris, only to be recognized and forced to flee again. When last heard from she was living in the resort city of Pau, in the French Pyrenees—"skulking about," according to Martineau, "in some French province under a false name." One day, out hunting, she herself became the quarry, when a wild boar dashed out of the underbrush and gored her to death.

For Harriet Martineau, Mme. Lalaurie's house was an emblem of the Southern mind, all elegance and gracious manners on the outside and violence and horror within. This was the art of Southern living: the generous table laid under the benevolent eyes of the plaster angels; the carefully selected guests assembled; the slaves tortured and in chains in the back rooms. Typical, or at least unsurprising behavior for a "flesh-peddling chivalry," to borrow a phrase from the historian Eugene Genovese.[9]

But there are other aspects of the story that give one pause. Assuming that Mme. Lalaurie was not simply insane, her motivations beyond our grasp, what could have accounted for her actions? The long and painful slide from social eminence that the Creole faction was experiencing

41

might provide a clue. Mme. Lalaurie here stands for a last-ditch attempt to hold on to her social position. In a sort of rehearsal for the Civil War, the slaveholding aristocrat holds out, all doors barred, against the "American" liberators of her slaves. The violence she feels from above—the Americans as they take over "her" city—she exacts on those below, her slaves. The cat, lest it lose its footing, sinks its claws in farther.

Harriet Martineau was an abolitionist, to be sure, but she was also an ardent feminist; one chapter in her *Society in America* is titled "The Political Non-Existence of Women." And yet, Martineau had no interest at all in Delphine Lalaurie *as a woman*. This is surprising, for the formidable Mme. Lalaurie—with her martial pedigree, her nonentity of a husband, her taste for cruelty and weapons—resembles certain heroines of nineteenth-century literature, Ibsen's Hedda Gabler above all. The brilliant woman, deprived of any scope for her talents beyond hosting social occasions, and further undermined by the "American" usurpers, took her revenge where she could find it.

When Martineau does momentarily align herself with Creole women like Mme. Lalaurie, it is in her outrage at the "all but universal" extramarital connections between quadroon women and prominent white men in New Orleans. "What security for domestic purity and peace can there be," she asks rhetorically, "where every man has had two connections, one of which must be concealed?" We know nothing about the inconspicuous Dr. Lalaurie's extramarital tastes. Macarty, on the other hand, was a common name among wealthy free people of color in New Orleans, and Martineau may be hinting that Delphine resented her relatives of mixed race, some of whom carried her own father's name.[10]

But perhaps it was Mme. Lalaurie who (like Hedda Gabler) looked beyond her marriage for companionship. Her contemporaries apparently sensed something "unnatural" about the Lalaurie arrangements. The strong, thrice-

42

married beauty who ran the house, her negligible husband, the black coachman who seemed her true partner—the whole situation was ripe for misogyny and racism. Instead of a quadroon mistress, Mme. Lalaurie had a mulatto companion, the "sleek mulatto" of every account. This would be reason enough for the special "rage" of the Creoles, and for the lynch mob's murder of the coachman.

For Harriet Martineau, however, Delphine Lalaurie was first and foremost a slaveowner, not a slaveowning woman, and the moral of the story was clear: "I was requested on the spot not to publish it as exhibiting a fair specimen of slaveholding in New-Orleans, and no one could suppose it to be so: but it is a revelation of what may happen in a slaveholding country, and can happen nowhere else."

There is an intriguing footnote. During her sojourn in New Orleans, Harriet Martineau took a special interest in a little slave-girl called Ailsie. She describes Ailsie in her travel book, immediately following her indictment of Mme. Lalaurie:

> I would fain know what has become of a mulatto child in whom I became much interested at New-Orleans. Ailsie was eight years old, perfectly beautiful, and one of the most promising children I ever saw. . . . As she stood at the corner of the dinner-table to fan away the flies, she was a picture from which it was difficult to turn away. Her little yellow headdress suited well with her clear brown complexion and large soft black eyes; nothing that she could at all understand of the conversation escaped her, while she never intermitted her waving of the huge brush of peacock's feathers. . . . When I think of her sensibility, her beauty, and the dreadful circumstances of her [mixed] parentage . . . I am almost in despair about her future lot.

What Martineau neglects to tell us, after this vivid evocation of Ailsie's beauty, is that she herself had hoped to adopt

Ailsie, and take her back with her to England, as a sort of human souvenir of her New Orleans sojourn. Ailsie's mistress was no Mme. Lalaurie, to be sure; according to Martineau, she was "one of the wisest and best of American women." That Martineau hoped to make of Ailsie not a daughter but a servant should perhaps not be held too much against her. Her passionate feelings about the child—hers is a lover's discourse—are evident in everything she says. But the rescue came to naught when Ailsie's mistress, a friend of Martineau's, died suddenly, and Ailsie passed into other ownership.[11]

About this entire adoption plan Martineau is silent in her book. Ailsie is the back room of Martineau's own New Orleans experience, the hidden story laced with guilt ("I am almost in despair about her future lot") that she cannot bring herself to tell. It is not unreasonable to suppose that some of her fury at Mme. Lalaurie is directed at herself. She too is complicit; she too has something—though hardly of the same magnitude—to answer for.

Through Harriet Martineau, the story of Mme. Lalaurie entered the lore of New Orleans history and legend. Whether recounted by George Washington Cable (in a story that Edmund Wilson judged worthy of Turgenev), or by such popular historians of the city as Henry Castellanos, Lyle Saxon, Herbert Asbury, or Robert Tallant, certain elements stayed the same: the elegant woman in her sumptuous house, the sleek coachman, the horror in the back rooms, the indignant crowd. The story of Mme. Lalaurie became, for a couple of generations of New Orleans writers, a way to think about the fate of their city, its outward elegance and its underself of hatred and violence.

For these writers, the story was mainly about Mme. Lalaurie herself: the debate turned on whether she stood somehow for the Southern mind, as Cable and Martineau implied, or whether she was merely an insane woman, a

curiosity, as Castellanos argued. As more time passed, there were even denials that Mme. Lalaurie had done anything wrong. The inconspicuous doctor, it was said, had unorthodox treatments, which he sometimes practiced on the slaves. Mme. Lalaurie's son suffered from an obscure illness, and screamed in the night. But the faded newspapers testified to the stubborn facts of the case.[12]

And yet, this is not a story of one woman but of two. When last seen, Delphine Lalaurie was amusing herself in the elegant resort town of Pau. And Harriet Martineau was glad to leave New Orleans forever, with a parting curse on her lips: "My strongest impression of New-Orleans is, that while it affords an instructive study, and yields some enjoyment to a stranger, it is the last place in which men are gathered together where one who prizes his humanity would wish to live."

The counterparts of these two formidable women, the self-righteous tourist and the haughty terrorist, would soon enough face each other across the divide of the Mason-Dixon Line. By the end of the story, the two women had almost changed places. Martineau, in Boston, made common cause with Garrison and other radical abolitionists; through her books and her incendiary speeches, she pleaded for the destruction of the "southern way of life," as exemplified by Lalaurie. Mme. Lalaurie, meanwhile, became a traveller abroad, wandering from city to city in search of safe haven. When she died, her body was secretly smuggled back to New Orleans for burial in the St. Louis Cemetery.

New Orleans has always been a divided city; only the names of the divisions have changed over time. Four flags have flown, in succession, from its flagpoles—the French, the Spanish, the United States, and the Confederate—and a constant flow of new immigrants has pitted neighborhood against neighborhood. Where two societies overlap, there you are likely to find a haunted house. The old inhabitants

move out—or are forced out—and the new occupants move in. The papers are signed; the title is filed at City Hall. But lingering spirits are not so easily eradicated.

The Lalaurie mansion became known as "The Haunted House," a sight for tourists to gawk at. But haunted by what, or by whom? On this score, the documents are vague. There were rumors of blue lights at the window, screams in the night. But this very lack of specificity is part of the story, for two kinds of ghosts linger. The slaves who were tortured and died there—surely they have stayed. Silenced in the story, they are given voice, posthumously, in the hereafter.

But there is also the ghost of Mme. Lalaurie herself—"the real ghost," according to Edmund Wilson, "whose presence is felt in the accursed house in Royal Street."[13] She stands here for a vanished Creole civilization, whose most formidable representatives—for good and evil—were often women, and whose greatest test was yet to come.

3

Tell

*And so I suddenly settled on another plan of action; I deter-
mined to leave Europe and go to America. At that very time,
in the port of B——, they were fitting out a fleet of ships
bound for Louisiana.*

CHATEAUBRIAND, *René (1802)*

A PENCIL and watercolor drawing, probably a farewell
gift. Three women are grouped around a mantelpiece,
the rococo curves of which echo their rounded, defeated
shoulders. There is another visual rhyme in their parted
hair, for the mantelpiece too is "parted." The women do not
smile, nor—and this is one aim of this portrait—do their
bodies. The crumpled figure seated in the foreground, fac-
ing us, is dressed in mourning attire, and carries a particu-
lar weight of sorrow. The hands of the other two women
gesture towards her, seem almost to touch her, as though
offering her their support.

Each figure occupies a different level and a different
space, marked off by molding and mantel. These women
are divided from one another by circumstance, but joined
by gesture, that intricate melody of hands woven around
the middle of the composition. The tall standing figure who

47

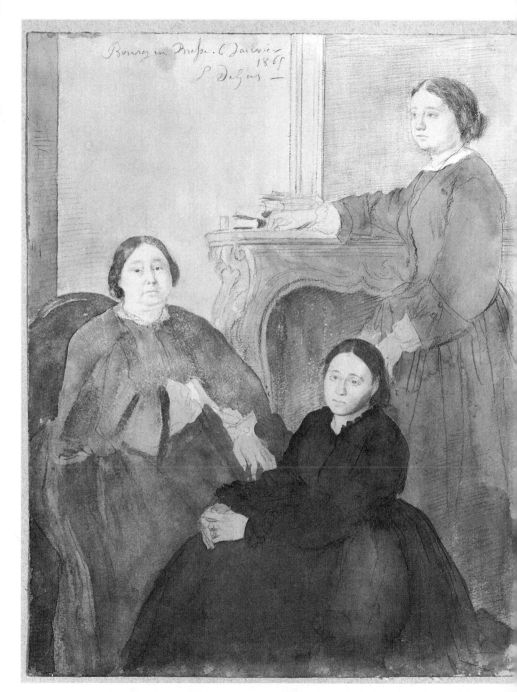

Degas, *Mme. Michel Musson and Her Two Daughters*, 1865

looms above the mantel, a stack of books behind one of her hands, is upright, her dress carefully drawn. The contrast is striking with the collapsed figure beneath her, whose chair, if she is seated on one, is invisible, as though she had sunk to the floor. This is the figure we are meant to attend to. Her broad black dress extends almost all the way across the lower edge of the picture, another black border to join the left-hand margin. The empty, dark fireplace that frames her head strengthens the sense of absence, and elegy; it is the echoing space of her misery.

The artist has carefully anchored these women in a particular room, and a rather desolate one. If one aim of this portrait is to make the bodies as expressive as the faces, another is to make the room as expressive as the figures. Only a few details and furnishings declare the contours of the room: the mantelpiece, the molding, the chair. There are no decorations on the bare walls; only the clutter of well-thumbed books suggests that the room, clearly a temporary habitation, is occupied. Nonetheless, the picture feels crowded; the women, who fill three-quarters of the depicted space, are huddled together in this small, alienating room by their shared sorrow. The picture is dated January 6, 1865, but there is no Twelfth Night celebration here.

The precise dating of the picture—"Bourg en Bresse / 6 Janvier 1865 / E. Degas"—asserts its documentary veracity, as though the artist were testifying that "these women were *here,* on this date, and I, Edgar Degas, saw them thus." It is one of the very few works that Degas both signed and dated. The seated figure in the black dress is Degas's first cousin Estelle Musson Balfour, affectionately called "Tell" among her New Orleans family. She is twenty-two, a young mother, and already—because of the rush to marry at the outset of the war—a Civil War widow. Degas deliberately draws our attention to the wedding ring on Estelle's interlaced left hand. She is attended by her sister Désirée ("Didi") and their mother, Odile (Mme. Michel Musson)—the latter a fine specimen of "the majestic Creole matrons,

all black lace and alabaster," as George Cable described them.[1] Mme. Musson hides her afflicted right hand, which she was treating with opium. The three women are posing—despite an attempt at casual grouping and expression, the painting is clearly posed—for their thirty-year-old cousin and nephew, who has travelled to the vacation resort of Bourg-en-Bresse, in the southeast of France, to spend the New Year's holidays with them, and bid them farewell.

War had brought the Louisiana city where his mother was born, and where this American branch of his family lived, back into Edgar Degas's awareness. Meanwhile, the Paris newspapers carried news of the occupation of New Orleans by Union forces; the largest and richest Southern city was the first to fall. On May 1, 1862, Commodore Farragut, in a daring act of bravado, ignored the Confederate forts and weaponry ("Damn the torpedoes," he is famously supposed to have said. "Full speed ahead!") and led his wooden fleet up the Mississippi, capturing the city. New Orleans was occupied by Federal troops for the remainder of the war.

General Benjamin Butler—"Ben" to his friends, "Beast" to his enemies—was in charge of keeping order in New Orleans; it was Butler's reign that brought the Degas brothers and the Musson sisters together. Butler's notoriety after the war was equalled only by William Tecumseh Sherman's. Together they had pioneered the techniques of making war not just on an army but on a whole populace. Walleyed and overweight (and a gift to caricaturists), Butler was a career politician from Massachusetts with no military training, but he was determined to exact obedience from his unruly wards. From his headquarters in the refurbished Lalaurie mansion on Royal Street (a peculiar choice of address, to say the least), Butler took it upon himself to subdue the white people, and in particular the white *women*, of New Orleans. One of his first official acts was to hang a man, a

reputed gambler named Mumford, from a flagpole for des-
ecrating the Union flag. "This outrage," Butler proclaimed,
"will be punished in such manner . . . that they shall fear
the *stripes* if they do not reverence the stars of our banner."[2]
The cruel wit of the punishment—hanging a man from the
same flagpole on which he had committed his offense—
was not lost on Butler's audience. While this action infuri-
ated the populace, another of Butler's decrees made him
infamous around the world, and also accounted for the
Musson women's flight to France.

Butler had provocations, to be sure. Still smarting from
the nasty reception his troops had experienced in the occu-
pation of Baltimore the previous year, when some women
had draped the Confederate flag across their bosoms, But-
ler was in no mood to be tolerant of similar behavior in
Louisiana, vowing "that in a very short period I shall be
able to ride through the entire city, free from insult and
danger, or else this metropolis of the South shall be a
desert."[3]

The women of New Orleans, especially those of the lower
classes, were openly contemptuous of the Federal soldiers.
One woman supposedly emptied a chamber pot from a
French Quarter balcony on Farragut's head, while another
spat in the faces of two Union officers.[4] When a group of
women turned their backs as Butler rode by, he remarked
that "those women evidently know which end of them
looks best."[5] Such conduct was the excuse for Butler's Gen-
eral Order Number 28, known as the "Woman Order," is-
sued on May 15. Its wording was blunt: "When any female
shall, by word, gesture, or movement, insult or show con-
tempt for any officer or soldier of the United States, she
shall be . . . held liable to be treated as a woman of the
town plying her vocation"—as a prostitute, that is.

Butler ignored the firestorm of protest that greeted this
document, in New Orleans and abroad. There were vehe-
ment objections in the British Parliament, where Prime
Minister Palmerston remarked that "an Englishman must

blush to think that such an act has been committed by one belonging to the Anglo-Saxon race."[6] The French were outraged. And the actual prostitutes in New Orleans, it was said, made a practice of placing Butler's portrait in their chamber pots. On the basis of the Woman Order and the hanging of Mumford, President Jefferson Davis declared Butler an outlaw and a felon. But the results of the order, in Butler's view, spoke for themselves: "On the 24th day of February last," he reported, with dubious grammar, "my officers were insulted by she-rebels in Baltimore. On the 24th of May last, they were not insulted in New Orleans by he or she."[7]

Butler's rule in New Orleans remains "one of the great atrocity stories of the Civil War," as the historian Gerald Capers has written, and it paradoxically gave a boost to Confederate morale.[8] "The damage done the American cause in France and England, where the antipathy aroused by [Butler's] highhanded acts was almost as intense as in the South—at a time when the Confederacy's best chance was foreign recognition—could well have resulted," according to Capers, "in the defeat of the Union."[9] It was at this time that Duncan Kenner conceived of a bold plan by which the South would seize the moral high ground by freeing its slaves in exchange for foreign recognition.[10]

One result of Butler's Woman Order was that it allowed the occupation of New Orleans to be reinterpreted, by politicians and artists alike, as a war on women. Another direct result was that women who could afford to do so left New Orleans in droves. Many of them, like the Musson trio, headed for France, the "mother country" with which many New Orleans Creoles had retained close ties. Mme. Musson took along as travel reading a copy of Marie Antoinette's memoirs—another aristocratic French victim! It may be among those volumes stacked on the mantelpiece. The Mussons had another reason for leaving New Or-

leans. In January, Estelle had married Lazare David Balfour, a captain in the Confederate Army, and a nephew of the president of the Confederacy, Jefferson Davis. On October 4, 1862, on the second day of the battle at Corinth, Mississippi—a hideous piece of mayhem fought amid tropical heat—Balfour was killed. Estelle, in shock, gave birth to their daughter Josephine three weeks later.

The three women arrived in Paris on June 18, 1863. A week later, Edgar Degas brought his uncle Michel Musson up to date:

> Your family arrived last Thursday . . . and is now entirely our family. One could not be on better or more simple terms. . . . Aunt Odile is walking extremely well. . . . Didi [Désirée] is completely her assistant.

Edgar was clearly as charmed by them as they were by him. His fascination with the widowed Estelle was already palpable. "One cannot look at her," he wrote, "without thinking that in front of that head there are the eyes of a dying man." Didi informed her father on the same day that Edgar, "who we had been told was very brusque," was actually "full of attention and kindness."[11] He obviously felt comfortable with his American cousins ("Your family . . . is now entirely our family"), and they brought out a cheerful, festive side of him.

The three women spent most of their eighteen-month exile in the resort town of Bourg-en-Bresse, where Odile, on the advice of doctors, hoped to recuperate from the illness that affected her legs. Edgar visited them frequently. On New Year's Eve, 1863, Edgar's sister Marguerite wrote to the Mussons in New Orleans:

> Edgar left here [Paris] the day before yesterday to share the festivities of the new year with them, and he is so gay that he will amuse and distract them a little.

Degas, *Portrait of Estelle Musson Balfour*, 1865

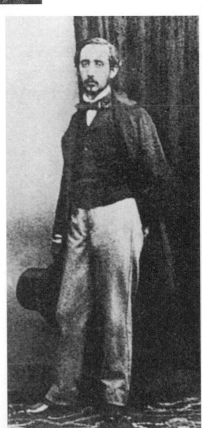

Degas, c. 1865

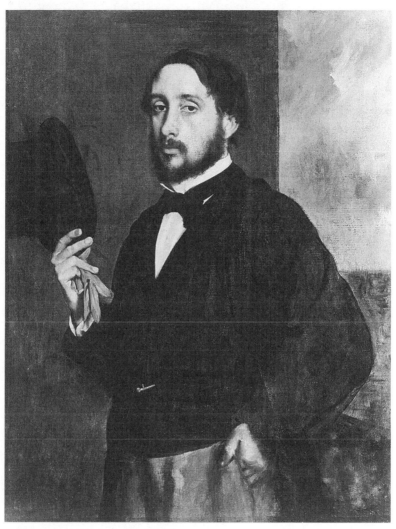

Degas, *Self-Portrait*, c. 1863–65

He took with him a lot of crayons and paper in order to draw Didi's hands in all their aspects, for such pretty models are rare.[12]

Didi herself, whose beautiful right hand we see resting on the mantelpiece in the group portrait of 1865, reported more news five days later:

We had been expecting Edgar, who did not arrive, and we had lost all hope of seeing him when, around nine o'clock this morning, he arrived, loaded with packages up to his neck. Mother and I were still at Mass. He got out of his carriage and when the Mass was over came in and tapped Mother on the shoulder. I was in the front row and saw nothing, and so was very surprised on returning to our house to find Master Edgar busily emptying a little trunk full of gifts, toys, candy, marrons glacés, etc. . . . He has done several sketches of baby Jo but isn't happy with them, since it is impossible to make her hold still for more than five minutes.[13]

Ten years later, Degas would return to the problem of keeping American children, including Jo, sufficiently still to paint them.

Degas left a permanent record in pencil and paint of how these women appeared to him, but what did he look like to them as he sketched their hands and faces, or greeted them in church? A self-portrait and a photograph, both from 1863, give us some idea. The self-portrait is one of the last of the many Degas had undertaken since the mid-1850s. Degas portrays himself here as a confident man of the world, alert and a bit ironical in the polite but slightly tentative doffing of his top hat. The gloves below and the hat above make a witty extension of the agile, sensitive hand. Betraying no other sign of the painter's vocation, this young man is a gentleman, comfortable in the costume and

appurtenances of his station. The vague, cloud-washed sky over the shoulder and the hint of landscape next to the elbow enforce the impression of a man at home in the wide world.

That this painting is, like most self-portraits, a somewhat idealized view finds confirmation in a photograph from the same period. The clothing is the same, and the dark background, while allowing no access to the outdoors, still provides a strong support for the upright figure. But the whole stature of the man has suffered a slight deflation. The confident chest has caved in; the hand in the pocket has lost its jaunty forcefulness; the legs are not as long as we had been led to imagine by the painting. Most important, the blank look of the face seems to lack the inner world we were invited to sense in the portrait.

Which image, then, portrait or photograph, is more accurate? It is difficult to say. And we should not be too quick to choose the photograph. In the presence of these women, Degas clearly came alive; brimming with "attention and kindness," he lost his habitual "brusqueness." Such uncharacteristic deportment has fueled speculation that Degas, drawn by those beautiful hands, was especially attracted to Désirée Musson.[14] There is little evidence to support such a view. His fixation on Didi's hands might even suggest that the rest of her body held little appeal for him.

From the start it was Estelle who fascinated Degas: the Civil War widow and young mother who was haunted by "the eyes of a dying man." She was his figure for the suffering American South; his representations of her face and body are his indictment of the violence inflicted on his own motherland. Estelle's tales of "atrocities" committed by Beast Butler and his men may well have had a bearing on his later paintings of women of New Orleans.[15] In a striking portrait of the same period, probably another gift for the departing guests, Degas painted Estelle's head against a background of barren trees. The painting looks like a turn-of-the-century mood piece. Estelle is all loneliness and sor-

row, her eyes darkened and downcast, her chin tucked under in bitterness. Looking at this portrait, we realize with a shock how young Estelle was at this time, as she tried to gather herself as a mother and widow in exile. Degas paints her as though she is almost blinded by grief—an intimation, perhaps, of the fate that was soon to befall her.

The subject of women suffering in a time of civil war haunted Degas's imagination throughout the decade from 1863 to 1873. One of his strangest and least understood early masterpieces is the *Scene of War in the Middle Ages,* which he began painting around 1863, at the time of the Musson women's visit, and exhibited in the official Salon of 1865. Into this composition he distilled many of his impressions from his years of study in Italy; scholars have found traces of Renaissance and medieval imagery, as well as contemporary landscape studies from Degas's notebooks. Goya's grisly *Disasters of War* etchings, of which Degas owned an 1863 edition, may also have contributed. But this diverse material has been fused into a picture that makes no attempt to hide its anachronistic details (armor from circa 1470, stirrupless horses, bows far too short for medieval usage, Gothic church, etc.). Degas has aimed, instead, for unity of impression, of mood. The thinned paint, or "essence," Degas used contributes to the primitive, fresco-like (and dreamlike) feel of the work.[16]

A schematic vision of the disasters of war, *Scene of War in the Middle Ages* is remarkable for its eerie combination of extreme violence and oneiric stasis. Fires rage in the background while storm clouds mass along the horizon. The rock-strewn roadbed in the foreground is the stage for a polarized struggle between men and women. The contorted naked women grouped to the left have suffered terrible atrocities. One of them is manacled to a barren tree. The mounted (and fully clothed) men to the right pause to inflict more pain before riding off, one of them carrying a still-living woman, whose buttocks and thighs he wrenches

Degas, *Scene of War in the Middle Ages*, 1865

towards us, as though gleefully displaying her body, his booty.

The painting cries out for psychosexual interpretation. Critics—Quentin Bell was the first—have helpfully pointed out that Degas tends to depict gender conflict in precisely this women-to-the-left, men-to-the-right way. Degas's portrait of the Bellelli family, for example, groups the mother and her two daughters to the left against the alienated husband to the right, a simmering civil war in domestic setting.[17] The specific poses of the women in the *Scene of War* prefigure to a remarkable degree the series of nudes bathing and drying themselves that preoccupied Degas during the 1890s.[18] Clearly, Degas was erotically engaged by these twisted, vulnerable bodies. The beautiful preparatory drawings for the painting raise further questions. A study for the mounted archer depicts a nude *woman* holding the bow, and the rouge-cheeked figure in the finished painting remains androgynous.

But what if the painting is meant, as the subject matter suggests, to be about war, and even perhaps a specific war? Since it is impossible to place the painting in any exact locale or period, Degas may well have meant this to be an allegory of some kind. His related history painting, *The Daughter of Jephthah* (Smith College Art Museum), has been convincingly interpreted as an allegory for the nineteenth-century sufferings of Italy.[19] But if the *Scene of War* is allegorical, what is it an allegory of?

Twenty years ago, the art historian Hélène Adhémar arrived at a brilliant explanation. She was brooding on the alternative title by which the painting was known after Degas's death: *The Misfortunes of the City of Orleans*. No one knows how it got this title, though Degas's own records were apparently the source. Adhémar found in the history of medieval Orléans no incident of violence directed so specifically at women. Then she noticed that in his letters Degas often abbreviated the French spelling of New Orleans



("la Nouvelle-Orléans") to *la Nlle Orléans.* Might this name, Adhémar suggested, have been misread as *la Ville d'Orléans?*[20] It is an ingenious explanation, and recent scholars tend to accept the connection between the *Scene of War* and Degas's response to the American Civil War.[21] Even if Adhémar's hypothesis should prove inaccurate in its particulars, there is ample reason to assume that Degas's imagination was preoccupied with the sufferings of New Orleans when he completed this picture in 1865.

Though it was accepted by the Salon jury, and exhibited in 1865, *Scene of War* was the last "history painting" Degas painted. It was as though the suffering of these flesh-and-blood women of New Orleans, Mme. Musson and her daughters, outweighed the hypothetical maimed women of the dreamlike *Scene of War.* In Degas's paintings of 1865, we are confronted with two opposing versions of history: a costume drama of "the historical," dreamed up in the studio; and three women embedded against their will in historical events. These women embody the historian C. Vann Woodward's famous observation that "the South has had its full share of illusions . . . but the illusion that 'history is something unpleasant that happens to other people' is certainly not one of them."[22] Henceforth, Degas left the costume drama behind, choosing instead to portray the kind of history—the sufferings and vanities of his own historical period—that directly impinged on his life and that of his family.

Degas's paintings of the Musson women huddled in their rented room at Bourg, and of Estelle's stricken face against a backdrop of desolate trees, are themselves "scenes of war," as devastating in their more oblique impact as the histrionic *Scene of War in the Middle Ages.* Through such paintings Degas explored one of his great subjects, the woman pushed by circumstance to the margins of her life. The theme finds its classic treatment in another portrait of

that fruitful year of 1865, the *Woman Leaning near a Vase of Flowers.* (The painting, now in the Metropolitan, is popularly known as the *Woman with Chrysanthemums,* though there are no mums in her bouquet.) The off-center woman, represented dramatically and unforgettably on the edge of the composition, may remind us of Estelle, pressed to the bottom edge of the farewell painting in Bourg.

Early in 1865, René De Gas, always a man of impulse and appetite, surprised his family by announcing his intention to accompany the Musson women back to the once again United States. The pretext was René's plan to liquidate some New Orleans property deeded to him and to Edgar by their late mother, but it was clear to the Degas family that René was going to New Orleans to seek his fortune, relying on the help of his uncle Michel Musson. Alone among the Degas family, Edgar—who also left the family lodgings in 1865, establishing his studio and living quarters elsewhere—supported his younger brother's decision.

René, twenty years old at the time, was at heart an adventurer. From an early age and throughout his life, his favorite response to difficulties was flight. Like his brother Edgar, he resisted the idea of taking his place in the family bank, but he had no obvious talent to pursue instead. New Orleans was by reputation a place for vague aspirations. "It is the country of young men who have nerve," René wrote his uncle Michel.[23]

Adventurism lay in René's bloodlines, reaching back two generations to the colorful career of his maternal grandfather. For René, Germain Musson was surely the most conspicuous "young man with nerve" in the family, who had shown what the right combination of boldness and careful calculation could win in New Orleans. Born in 1787 at Port-au-Prince, the capital of the French colony of Saint-Domingue, Germain was raised in the comfortable planter class of that fabulously wealthy island empire founded on

the exportation of sugar and the steady availability of African slaves. Distance and time have allowed a romantic image of colonial gentility to flourish, but the reality was far different. Among the planter class, as the historian C. L. R. James has noted in his classic *Black Jacobins,* there was "at all times a disinclination for sustained labour, fostered by the gluttony and lasciviousness bred by abundance and scores of slaves waiting to perform any duty, from pulling off shoes to spending the night."[24] Germain Musson had the bad luck to be born on the eve of the French Revolution, when the mulatto leader Toussaint L'Ouverture put his own dangerous spin on the Declaration of the Rights of Man. The independent black republic of Haiti was founded, and the refugee ships, loaded with whites and free blacks, made their way first to Cuba and then, with renewed hostilities between France and Spain, to Louisiana, the American territory recently acquired from the French.

The "flight of 1809" was a boatlift of extraordinary and overwhelming proportions. As George Cable notes in his history of the Creoles, "Within sixty days, between May and July, 1809, thirty-four vessels from Cuba set ashore in the streets of New Orleans nearly fifty-eight hundred persons."[25] The American Governor of Louisiana, William Claiborne, begged the American consuls in Cuba to stop the flood. When the last ship had dumped its human cargo, the city population of perhaps 14,000 had increased by almost 10,000, more or less evenly divided among the three castes of New Orleans society: whites, free people of color, and slaves. Through the slave immigrants developed several traditions of New Orleans black culture, including voodoo and the various dances and songs of Congo Square.[26] The white French-speaking population of New Orleans had unexpectedly received reinforcements in their "long battle against American absorption," and the Louisiana Creoles warmly welcomed their "West Indian cousins," as Cable calls them, who came with "the ties of a common religion,

a common tongue, much common sentiment, misfortunes that may have had some resemblance, and with the poetry of exile."[27]

Whatever poetry of exile Germain Musson carried with him, he also brought a cold-eyed business sense, along with great energy and ambition. While his confreres were whiling away their time in institutions like the Café des Exilés, remembering the good life in Saint-Domingue (and conveniently forgetting the putrid streets of Port-au-Prince, where the open sewers overran after every rainfall and slaves were routinely and publicly beaten), Germain Musson, only twenty-two when he arrived, lost no time in putting his house in order. He married a daughter of the old and distinguished Rillieux family, an alliance that placed him firmly in the New Orleans Creole aristocracy.

But unlike the great mass of Creoles, who ruled the social life of New Orleans while keeping a safe distance from its mercantile life, Germain was a visionary businessman. He exported cotton in his own ships to the textile mills of Massachusetts and loaded them for the return with chunks of ice from New England ponds, a valuable commodity in semi-tropical Louisiana. He bought land at the corner of Canal Street and Royal, accurately predicting that business would move uptown from the narrow old streets of the Vieux Carré. Diversifying his business holdings, he invested in Mexican silver mines. By 1819, having spent barely a decade in New Orleans, he was a man to be reckoned with. He visited France in 1834, to be present for the birth of his grandson Edgar, and commissioned a pastel portrait of his daughters Célestine and Eugénie, taking it back to New Orleans. He returned to Paris in 1853, when he posed—looking rich and a bit sour—for one of Edgar's earliest portraits. That May he travelled to Mexico. He died when his coach overturned on a mountain road.[28]

The life of Germain Musson was the inspiring, if perhaps a bit intimidating, example for René as he set his eyes on

Louisiana. As the Civil War drew to a close, René let his uncle know his intention to join him, either in New Orleans or Mexico. (Like many other Creoles, Michel Musson, embittered by the Federal occupation of the city, briefly considered emigrating.) Musson advised René to learn what he could about the cotton business in England. But René's first effort to demonstrate that he was a young man with "nerve" met with immediate disaster. In an attempt to impress his uncle, René made an ill-advised investment in imported cotton while visiting London during the summer of 1866, using funds entrusted to him by his father and his siblings, including Edgar, for his future New Orleans business.

René explained the result, a substantial loss of approximately $8,000, in a long and detailed letter to Musson. "It is not very lucky for a first start," he concluded, "& a speculation that gave me a little too costly a lesson. I am not saying anything about it to the family, that would only ruin me & at this time I need all their good graces. I will make up that money sooner or later, but to begin life with debts & to engulf the fortune of my brothers & sisters from the outset, *ça n'est pas gai.*"[29] This fiasco, which was to have far-reaching effects on the De Gas banking concerns, only strengthened René's resolve to flee to New Orleans.

Twelve years after Germain Musson's death, René De Gas found himself in his grandfather's city, determined to achieve a similar success. Like Germain, René worked fast, securing a job in his uncle Michel's cotton-export firm, then—tying business and family knots tighter—falling in love with his widowed cousin Estelle. (Had not his grandfather improved his prospects by a shrewd marriage?) When the third Degas brother, Achille, arrived in New Orleans, he and René, bankrolled by a huge investment from the Degas bank in Paris, set up shop as De Gas Brothers. In 1869, René and Estelle were married, against Michel Musson's strong objections. It is unclear whether Musson was repelled by the close blood ties of the couple, necessitating a

special dispensation from the Episcopal bishop, or by his own experience of his nephew's shoddy business practices.

Meanwhile, around 1866, Estelle's eyes had begun to fail. Her ophthalmia added another possible threat to the longevity of the marriage, the second Degas-Musson marriage in two generations. By the time of the wedding Estelle was almost totally blind.

4

Siege

IT was the snug proximity of European cities that struck Kate Chopin on her honeymoon during the summer of 1870. "How short the distance seems to us here, from one city to another," she noted in her honeymoon diary, "in comparison with those interminable miles and miles of night and day travelling in America."[1] Just the year before, when she was eighteen, she had taken her first long journey, from her home in St. Louis down the Mississippi to New Orleans. She was immediately drawn to the Crescent City. "It is so clean," she remarked, "so white and green. Although in April, we had profusions of flowers, strawberries, and even blackberries." The cosmopolitan feel of the city attracted her, especially an evening, "so delightful and novel" she would "never forget" it, spent in a "dear little house near Esplanade Street," with a wealthy merchant and his German wife, the singer and actress Miss Ferringer.[2]

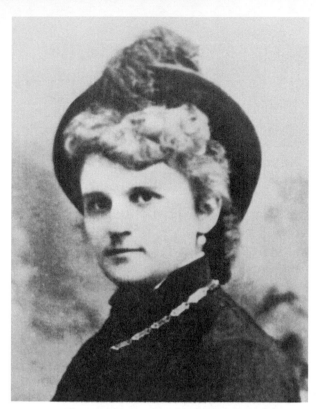

Kate Chopin during her New Orleans years

Oscar Chopin, c. 1870

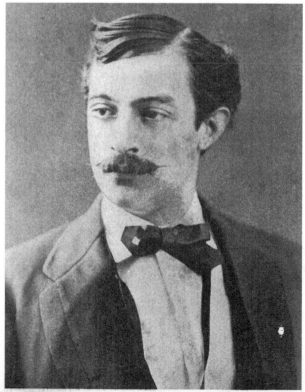

A few months later, Kate O'Flaherty fell in love with a New Orleans cotton factor called Oscar Chopin, who was visiting St. Louis on business. Oscar had taken refuge in France during the Civil War, and while his draft-dodging did not endear him to the veterans he met every day, his years abroad gave him a dashing, cosmopolitan air. He was, moreover, connected to a prestigious Creole family; episodes from *Uncle Tom's Cabin* were rumored to have been based on occurrences on the family plantation.[3]

Kate and Oscar were married on June 9, 1870, and departed the following day on their honeymoon to Europe. First they had to cover the "interminable miles" over rail, to Cincinnati (where "the sole life sustaining article of the inhabitants is *Beer,* simply Beer; without it they would cease to live—'vanish in thin air'"), and "gloomy puritanical" Philadelphia with its "everlasting white shutters": "Oh! those white shutters; what rows and rows and miles of them! Will not *someone,* out of spite, out of anything, put up a black blind, or a blue blind, or a yellow blind—anything but a white blind." Two weeks in New York, waiting for good sailing weather, were "dull, dull," though she enjoyed a visit with Oscar to the Stock Exchange on Wall Street— "proceedings which interested me very much." They finally sailed on June 25th, on the German vessel *Rhein.*

The ship was appropriately named for the purposes of the Chopins. They had planned the classic river-and-mountain tour of nineteenth-century lovers: the charming cities of the Rhine and the sublimity of the Alps. They spent three days in their debarkation point of Bremen, where Kate admired the "exquisite" private houses, "so white, so neat and so ornamented with flowers"—not unlike her description of New Orleans. During their time in Bremen and throughout their German sojourn, the Chopins were accompanied by a Mr. and Mrs. Griesinger from New Orleans.

Then they ascended the Rhine by boat: Cologne, Bonn, Wiesbaden, Heidelberg, and finally the famous Falls at Schaffhausen. Along the way, they visited the obligatory

shrines: Beethoven's house and Goethe's birthplace, and the house where Rothschild was born. Kate allowed herself to be overwhelmed by the beauties of the Rhine, with its "gray and stately ruins—the churches peeping out of the dense foliage and those vineyards sloping to the water's edge." As they toured these pilgrimage sites, Kate Chopin let other themes creep into her descriptions. She discovered that marriage entailed, paradoxically, unfenced expanses of independence. "Dear me!" she noted after a night of drinking "quantities of that maddening Rhine wine." "I feel like smoking a cigarette—think I will satisfy my desire and open that sweet little box which I bought in Bremen."

In Zurich, having left the Rhine behind, Kate found she could navigate the lake with ease, and all alone. While Oscar took a nap in the afternoon, she ventured bravely out:

> How very far I *did* go. Visited a panorama which showed the Rigi Kulen in all its grandeur—the only audience being myself and *two* soldiers. I wonder what people thought of me—a young woman strolling about alone. I even took a glass of beer at a friendly little beer garden quite on the edge of the lake: and amused myself for some time feeding the importunate little fish who came up to the surface as tame as chickens to receive their crumbs.

The whole trip had been an education in the myths of the Rhine—culled from Longfellow and Heine—and of independent Switzerland. Having heard Rossini's *William Tell* in Wiesbaden, the Chopins visited Tell's Chapel a month later near Lucerne.

But those soldiers by the lake turned out to be a portent. On July 17 the Chopins had first heard news of the declaration of war between France and Prussia. "What an uproar! What an excitement!" Kate noted. "I do not see how we got out of Wiesbaden alive. . . . This morning all the hotels emptied their human contents into the various depots.

French women with their maids, their few children, their laces and velvets hastening to get started on their homeward journey—every other nationality equally anxious to get back to their respective domiciles." And on the 23rd, as they made their way towards Chamonix, they heard the appeal calling on all men capable of bearing arms to try to save France. "Vain appeal, I fear," Kate noted drily.

Along with the declaration of war, however, came a more private development in the Chopins' lives. After a night at the opera, Kate sighed that she "would have enjoyed it, had I felt better, but have been feeling bad all day." She was pregnant. The two events, the declaration of war and the realization of her pregnancy, occurred within twenty-four hours of each other. As they travelled into the mountains, the war cast a shadow over the Chopins' journey. "Nothing now claims the attention but war news," Kate noted on August 9th. "We learned today of the defeat, on every side, of the French. The Prussians have retaken Saarbruck—defeated the enemy at Wissenburg."

The picturesque Rhine was now a disputed border between enemy nations, and the daily perusal of the guidebook yielded to the desperate search for the latest newspapers. It was the height of the tourist season, but seemingly overnight the landscape was emptied of its tourists, leaving everything "stupidly quiet." From Schaffhausen, where the Chopins had a charming view of the Rhine Falls, Kate wrote: "The Bluebein Hotel where we have taken quarters seems to be entirely at our disposal: the war having frightened off all visitors." The hotel stage, returning from town, was "always empty." As the tourists scurried home, soldiers replaced them.

And then, in the hotel in Heidelberg, a startling apparition: the face of the commander of the Prussian forces.

There is such movement—especially about the hotel— such an influx of troops. I met the commander in chief

Von Moltke face to face on the stairway. What an iron countenance! The French I fancy will meet their equal when they encounter the rugged old general and his troops.

Abruptly the rains arrived, blanketing with gloom the celebrated countryside. "Rain! all the day rain," Kate noted on July 29, at the Bluebein, "so we could not venture out." The next day, "still cloudy and raining." They seemed not so much at the Falls as *in* them. "Have not yet left the Falls," she remarked on August 10. "The weather was so inclement yesterday that we could not leave, and today the rain is pouring in torrents."

The Chopins doggedly continued their pilgrimage—despite the rain, despite the war, despite Kate's morning sickness. And despite their fears that they might be prevented from reaching their eventual destination: "That would indeed be deplorable; for what is Europe outside of Paris?" Meanwhile, they reveled in this haunted landscape, so unlike the empty American distances. Rousseau's spirit was pervasive as they admired Geneva and its environs. "I did not believe that Switzerland had anything so enchanting in reserve for us, as the lake of Geneva," she wrote. "How indescribably lovely it was this morning—22nd [August]—as we glided over its blue waters! Saw in the distance the castle of Chillon—and gave a tender thought to Byron, en passant." On August 26, they took their "last view of the Alps at Lausanne. How grand they were in the deepening twilight. It is very hard to get to Paris: tomorrow let us hope we start."

They arrived in Paris just in time for the terrible news from Sedan, confirming Kate's worst fears. "Very sad and very important news had reached Paris during the previous night, from the seat of war. The Emperor was prisoner in the hands of the Prussians—MacMahon either wounded or dead, and forty thousand armed men had surrendered! What did it mean?"

It meant, of course, that the border had been breached.

The Prussians were coming, and Paris was vulnerable. A thousand emergency measures went into effect. The paintings in the Louvre were removed from their frames, rolled up, and sent to the provinces for safe-keeping. The French defenders manned the outposts of the city—"the familiar horizon of the yellow ramparts dotted with the little silhouettes of National Guards," as Edmond de Goncourt observed.[4]

On the momentous day of September 4, Kate found herself a witness to history:

> *Sunday, Sept. 4th, 1870.* What an eventful day for France, may I not say the world? And that I should be here in the midst of it. This morning my husband and myself rose at about eleven and after taking our coffee, started off in the direction of the Madeleine for Mass. . . . The people on the streets looked sad and preoccupied. It was now nearly one and we entered church where Mass had not yet commenced. It was also the hour when the Corps Législatif was going to meet to decide on an important affair of state, and already there were determined looking people marching towards the Chamber. The short Mass was soon over. We hastened out and stationed ourselves on the church steps, from which position we commanded a splendid view of the entire length of the street up to the chamber of the Corps Législatif. There were thousands of people forming one great human mass. In the chamber was an all important question being decided, and without was an impatient populace waiting to learn the result. Scarcely an hour passed, when down they came, the whole great body, and at once it seemed to pass like an electric flash from one end of Paris to the other—the cry "Vive la République!"

The Chopins had seen the fall of the Second Empire, the definitive end of the reign of Napoleon III, and the declaration of the Third Republic, with its renewed determination

to defend Paris from the advancing Prussian troops. "I have seen a French Revolution!" Kate exulted. "The Gendarmes have been dispersed, and the Garde Nationale has taken under its care the public buildings and places of the city. Oscar has gone tonight on the Boulevards, where men, women and children are shouting the Marseillaise with an abandon and recklessness purely *French*." But all the jubilation could not conceal the bitter facts of the Parisians' predicament. As Kate Chopin remarked shrewdly, "If now they will form their batallions against the Prussian and cease their cry of 'À bas l'Empereur.'"

On September 10 the Chopins sailed from Brest for New York, aboard the *Ville de Paris*, their honeymoon journey into war at an end. After a "very stormy and threatening passage," they made their way as quickly as possible back to New Orleans. There Kate unpacked the "black lace shawl— some Brussels and Valenciennes lace—table and bed linen, etc.," which she had bought in Heidelberg "in anticipation of that housekeeping" which awaited her on the "other side."

2

When Edgar Degas found that he couldn't make out the target with his right eye, he knew that his dream of being a sharpshooter, and picking off Prussian soldiers, was at an end. By mid-September of 1870, Degas, like most of the other able-bodied men in Paris, had joined the National Guard, the motley and ill-trained militia assigned to defend the city from the oncoming Prussian Army. Like his friend and fellow painter Édouard Manet, he enlisted in the infantry, only to find, when he was sent to Vincennes for rifle practice, that he couldn't draw a bead on the target. "It was confirmed that this eye was almost useless," Paul Valéry reported, "a fact which he blamed (I heard all this from his own lips) on a damp attic which for a long time had been his bedroom."[5]

Degas joined the artillery instead, where his captain turned out to be his old school friend Henri Rouart, an industrialist and amateur painter. Rouart specialized in railroad equipment and refrigeration techniques—a client was the Paris morgue. Rouart confided to Degas that after the war ended he planned to open a refrigeration plant in—of all places—New Orleans. Like Degas's grandfather Musson, who shipped New England ice to New Orleans, Rouart knew there was always a market in that semi-tropical city for someone who could keep things cold.[6]

In the meantime, von Moltke of the "iron countenance" had determined on a siege of the city of Paris. His strategy was simple. Instead of storming the city, and placing his troops in danger, he would starve it. By September 25 the encirclement of Paris was complete, with all supply lines blocked. Von Moltke counted on a siege of six weeks or so, but he underestimated the determination and resourcefulness of the Parisians.

As fall ebbed into a particularly hard winter, the Parisian citizenry, especially the poorer people, suffered horribly. The trees in the Champs-Élysées were cut down for fuel; the Seine started to ice over. The soldiers of the National Guard fought frostbite at their posts along the city walls. Vegetables were nearly non-existent; the finer restaurants served such things as kangaroo and elephant (after the Paris Zoo was plundered), and the occasional cat. The writer Edmond de Goncourt, walking home through the night, heard a young woman whisper, "*Monsieur, voulez-vous monter chez moi . . . pour un morceau de pain?*"[7]

By early October, Degas was showing up each morning for service along the fortifications, and as the weeks dragged on he longed for some kind of action, complaining to the society hostess Mme. Morisot (mother of the painter Berthe Morisot) at the end of the month that he hadn't yet heard a cannon go off, and was eager to know whether he could stand the noise.[8] Meanwhile his brother Achille, a former cadet, had returned from New Orleans to serve in

the French Navy on the Loire, where he apparently saw little action. But other acquaintances were not so lucky. Degas was particularly moved by the death of his friend Joseph Cuvelier, a sculptor of equestrian scenes, on October 21. Mme. Morisot told her daughter Berthe that Degas was so upset he was "impossible," almost getting into a fight with Manet over the defensive strategies of the National Guard.[9]

On January 5, with the besieged populace frozen and hungry, von Moltke ordered the bombardment of Paris, which lasted twenty-three nights; on January 28, the city surrendered. In the ensuing chaos, the patriotic battle against the Prussian invaders devolved, almost overnight, into civil war within France.[10] A left-wing uprising on January 22 had failed; on February 8 there were new elections for the Republic; on March 28, the fateful election of the radical municipal government known as the Commune. By that time Degas and Manet had fled the city: Manet to the south, while Degas accepted an invitation from his close friends the Valpinçons to join them on their Normandy estate.

For Degas, Ménil-Hubert was an idyllic escape from the worsening situation in Paris, a pastoral contrast to the rigors of civil war. His delightful composition, *Carriage at the Races,* which he may have painted that very spring, is a portrait of the Valpinçon family, pausing in their elegant carriage while the wet-nurse, one breast bared, attends to baby Paul. Father watches protectively from his seat, whip in hand, and a dog keeps vigil beside him.

A modern Adoration, *Carriage at the Races* is a picture of peace in the animal and human world, with the horse race in the distance. Degas has inserted, nonetheless, a tiny warning in that distant scene: in between the two horses that gallop across the grass is positioned a soldier on horseback, and next to him, farther back, a mysterious man dressed in black seen from behind. Disturbers of the peace?

Degas, *Carriage at the Races*, c. 1870

Figures of strife and death? They hardly seem weighty enough to carry such ponderous meanings. And yet, they are ineluctably there. Like the soldiers visible on the pregnant Kate Chopin's honeymoon, they add a bit of static to the pastoral harmony.[11]

Degas, for unknown reasons, hurried back to Paris on June 1, when the news was most ominous, and the French forces under Thiers had begun their ruthless suppression of the Communards. Degas and Manet sympathized with the victims during the "Bloody Week," as citizens were rounded up and shot by the thousands. Mme. Morisot, who didn't share their views, was appalled. She wrote to her daughter Berthe on June 5: "Manet and Degas! Even at this stage they are condemning the drastic measures used to re-

77

press [the Communards]. I think they are insane, don't you?"[12]

A year later the Siege of Paris was still on Degas's mind. René De Gas, visiting from New Orleans in June 1872, noted that his older brother "has aged, and there are a few white hairs sprinkled in his beard; he is also calmer and more serious." The two brothers often went to "dine in the country and visit the places made memorable by the siege," where Edgar could take a veteran's pride in his memories. He complained to René of his war-weakened eyes. "Unfortunately, his eyes are very weak and he is forced to use them with the greatest caution." A rest would do him good, and what better rest than a journey, out of war-torn Europe, to Louisiana?

Once plans were in place for departure, Degas, who knew little English, developed a passion for English words. He wandered through the streets of Paris repeating his favorite phrases. "Edgar . . . is crazy to learn to pronounce English words," René wrote to his wife Estelle in New Orleans on July 12, 1872. "He has been repeating *turkey buzzard* for a whole week."[13]

5

Three Sisters

Tell all the truth but tell it slant,
Success in circuit lies,
Too bright for our infirm delight
The truth's superb surprise

EMILY DICKINSON, *c. 1868*

THE first thing Edgar Degas saw when he stepped down
from the train in New Orleans, on the cloudless morn-
ing of October 28, 1872, was the dazzling sun glinting on
the twin surfaces of his uncle's spectacles. The Pontchar-
train railroad depot, where the Degas brothers alighted,
consisted of a long roof—just wide enough to keep waiting
friends and relatives out of the sun or rain—supported by
posts. The makeshift depot was "consecrated to emptiness,"
a New York visitor sniped, and "dreary enough in appear-
ance and feeling for the horse-shed of a New England
'meeting-house.'" Located at the busy river end of the ave-
nue called Elysian Fields, it was tucked away in a maze of
decrepit houses and narrow cross-streets. First-time visitors
to New Orleans were always quick to notice the contrast
between the cluttered avenue and its glorious Parisian
namesake, the Champs-Élysées. Along both sides of the road

stretched stagnant open gutters, foul and fragrant in the warm morning mist.[1]

Edgar and René Degas, their journey from Paris at an end, were greeted on arrival by a gaggle of American relatives of all ages.

> My uncle [Edgar reported] looked at me over his spectacles; my cousins, their six children were there. The surprise that René had planned for them by not saying that I was with him failed; as there had been some talk of yellow fever still persisting at New Orleans he had telegraphed to Achille asking if that meant there would be any danger for a stranger, and the cat was out of the bag.

The cousins were Michel Musson's three daughters: Désirée, Mathilde, and Estelle. Mathilde's husband, William Bell, a prosperous merchant and elegant man about town, was probably there as well. Surrounded by these close relatives, some of whom he had never met, the bachelor Degas found himself reflecting, not for the last time during his stay in New Orleans, "What a good thing a family is."

They made their way by coach along the waterfront, past acres of cotton bales and sugar barrels waiting on the levee, and lines of riverboats with tall smokestacks—"twin funnels as tall as factory smokestacks," Degas noted—to the river end of Esplanade, a far more elegant avenue than Elysian Fields. The oaks and sycamores along the neutral ground were whitewashed around the trunks, creating a charming harmony of green and white.[2]

The carriages stopped in front of a spacious house with a generous porch, white columns, and cast-iron balconies. More suburban estate than city house, the mansion rented by Michel Musson was set back from the street and bordered by an iron fence in front. In back stretched carefully tended gardens and ornamental grass, shaded by handsome trees. Edgar Degas joined the bustling extended family in the house. On the first floor lived his uncle Michel Musson,

recently widowed, and Musson's unmarried daughter, Désirée. The families of René De Gas and William Bell occupied the second floor. Edgar took a spare bedroom in his uncle's wing of the house, which also doubled as his studio.[3]

From the moment of his arrival in the New World, everything American had impressed Degas. New York, after the ten-day crossing by ship, struck him as a "great town and great port," with "charming spots" that Monet or Pissarro (those outdoor painters) could have made something of. He felt more at home in the "immense city" of New York than in London, observing—as though to claim his mother country as his own—that American faces had much more in common with French physiognomies than English. He reported to his father, in a letter from New York, that his ear was already becoming accustomed to the English language, and in a few days he was certain to "insinuate himself" into conversations.[4]

As the brothers continued their journey overland, Degas was entranced by the American railroad, rebuilt after the decimation of the Civil War and extended throughout the South. After four days aboard the train, from New York to New Orleans with a stopover in Louisville, he and René, he insisted, were "as fresh and fatter than when we left." Always an admirer of technical innovation, in science as well as in art, Degas was particularly in awe of the sleeping cars. "You must have heard of the Wagons Lits," he gushed to his musician friend Désiré Dihau;

> but you have never seen one, you have never travelled in one and so you cannot imagine what this marvellous invention is like. You lie down at night in a proper bed. The carriage which is as long as at least two carriages in France is transformed into a dormitory. You even put your shoes at the foot of the bed and a kind negro polishes them while you sleep. —What luxuri-

ousness you will say. No, it is a simple necessity. Otherwise it would be impossible to undertake such journeys at a stretch. And then the ability to walk all round your own coach and the whole train, to stand on platforms is immensely restful and diverting. Everything is practical and very simply done here.

Though Degas, unlike Monet or Manet, did not make the railroad a conspicuous subject in his painting, he had a technical interest exceeding theirs. He viewed railroads less with the eye of the tourist-artist than with the perspective of an engineer. He identified with the bankers, builders, and designers who had accomplished this remarkable feat. And rightly so, for Degas, the banker's son and grandson, owned stock in American railroads.[5]

From his first days in New Orleans, Degas was all eyes, the ambitious painter seeking out fresh material. "Everything attracts me here," he wrote. "I look at everything." He marvelled at the visual feast offered up by the markets and streets of the city, and filled his letters, including one to the painter James Tissot, with breathless lists of scenery:

> Villas with columns in different styles, painted white, in gardens of magnolias, orange trees, banana trees, negroes in old clothes like the junk from *La Belle Jardinière* or from Marseilles, rosy white children in black arms, charabancs or omnibuses drawn by mules, the tall funnels of the steamboats towering at the end of the main street . . .

Each day Degas made his way—by those mule-drawn streetcars or on foot—along Esplanade and across the French Quarter to the office of De Gas Brothers on Union Street, in the commercial sector above Canal Street. There he checked for mail from France, responded to letters—his brothers' firm, he found, was "not too bad for writing"— and read the local newspapers. "Politics!" he exclaimed, as

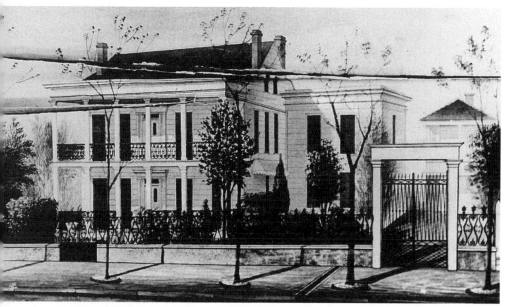

The Musson house on Esplanade, as depicted in a plan book, 1860

though it was all he read about. "I am trying to keep track of what is happening back in France in the Louisiana papers."

Michel Musson's cotton office was just around the corner from De Gas Brothers, in the suite of handsome red-brick buildings on Carondelet known as "Factors' Row," so called because of all the cotton factors who did business there. Musson's son-in-law William Bell worked in the same neighborhood, selling cotton-baling materials with his partner, Frederick Nash Ogden. (We will have much more to say, in the course of this narrative, about Mr. Ogden.) Degas could visit all these men on foot, and listen to them talk. The conversation seldom strayed from one all-important topic. "Here one speaks of nothing but cotton," he wrote Tissot.

From this realm of black-suited, English-speaking businessmen, Degas returned to his Creole refuge on Esplanade, where he chatted with his female relatives and worked on portraits of them. "All day long I am among these dear folk," he reported, "painting and drawing, making portraits of the family."

New Orleans during the 1870s, as Degas observed it, was a city with one foot in the eighteenth century and one foot firmly in the nineteenth. Always careful of his travel reading, he had brought Rousseau's *Confessions* along on his American journey. As he reread Rousseau in the evenings, he noticed a similarity between the "tenderness of the 18th century" in the comportment of Rousseau's contemporaries and that of the Creoles of New Orleans. "Of the families here several came over in knee breeches [the costume of eighteenth-century French noblemen] and that flavor has not yet disappeared."[6]

In many New Orleans arrangements one felt the overlap of outmoded customs and the pressures of modernity. If Rousseau might have felt at home on certain streets in the French Quarter, the latest Parisian fashions were nonetheless on show in the trendy shops along Canal Street, including the up-to-date offerings in the Musson building built by Degas's grandfather at the corner of Royal.[7]

The musical tastes of the Creoles were as conservative as their clothing; and yet, such advanced works as Wagner's *Tannhäuser* had had their American debuts in the famous New Orleans Opera House. There were musical soirees in the Esplanade mansion, a favorite pastime among Creole families. Degas painted one such occasion, with his brother René at the piano, and two women singing animatedly beside him. But a month into his visit, Degas was complaining to his friend Frölich that "I need music so badly. . . . Last night I attended a rather pathetic concert, the first of the year. A Mme. Urto played the violin capably, but with sorry accompaniment, and concerts have no intimacy, especially

here where people applaud even more stupidly than else-where." He regretted the absence of opera, a particular pri-vation, he noted, for his cousin Estelle, who was a devoted musician. The opera was cancelled for financial reasons during the winter season of his sojourn, and the family had to make do with a company of vaudevillians instead.[8]

Deprived as he was of opera and ballet, two of his fa-vorite diversions (and subjects), we might speculate in what other ways Degas amused himself. The fashionable world—and the Mussons were fashionable—made a point of attending the horse races in New Orleans. Though at-tempts to link some of his pictures to the New Orleans track remain inconclusive, we may safely assume that Degas, an avid connoisseur and painter of the sport, attended the races there. His cousin-in-law William Bell served on the board of the new track a few blocks farther down Es-planade. The spectacular Lüling mansion, formerly owned by good friends and relatives of the Mussons (Mme. Mus-son and Mme. Lüling were sisters), served as the club-house.[9]

During the years after the Civil War, New Orleans was al-ready known for its raucous and sometimes dangerous nightlife. As an important port, it catered to the easy mix-ing of permanent inhabitants, new arrivals (including thousands from Germany in the early 1870s, "fleeing the *Vaterland*," as Degas noted), and visitors in transit. It seems likely that Degas sampled the Crescent City nightlife, the café-concerts so like the Parisian ones he had shown off to René the previous summer, and would later paint with such élan. Did this connoisseur of Parisian brothels partake of the ample offerings in New Orleans? A quarter century later, the city tried to restrict prostitution to the back-of-town district known as "Storyville." But New Orleans, dur-ing Degas's sojourn there, was already famous for the whorehouses of every description that ornamented (or contaminated) almost every block in the French Quarter. Degas certainly had a taste for them in Paris (he began his

pornographic brothel monotypes just a few years later), and New Orleans society would have winked at the needs of a bachelor nearing forty. If he indulged, he left no record of it—though why would he?[10]

If Degas is reticent about nightlife in New Orleans, his letters are laced with admiring references to the daylight wonders of American technology. Here, too, past and present were in conflict in Louisiana. The sanitary arrangements in the city, as every scandalized tourist noticed, were among the most primitive and unhealthy in the country; the open sewers between sidewalk and street were a medieval stew of rubbish, raw sewage, and dead animals. The first underground sewers were not built until 1880, long after Degas's departure. For a city bounded by a lake above and a river below, New Orleans had little water for private use. Rainwater cisterns, of which the Musson mansion had two, were the traditional source of water for drinking and cooking. Much of the city was below sea level and there were swamps within the city limits. This was the reason for New Orleans's most famous architectural oddity, the burial of bodies above ground.

And yet, some of the most sophisticated modern machinery was on view in New Orleans. This was the golden age of steam power, and inventors, among them some of Degas's own friends and relatives, were using steam to change the face of the city. Steamboats lined the river bank. Steam was harnessed to refine sugar and to press cotton into bales. To his friend Henri Rouart, a man always interested in the latest machinery, Degas wrote about some local experiments with applying steam power to streetcars. "A person here called Lamm," Degas reported, "has invented an instrument said to be rather ingenious, which sets buses in motion at the top of the town ["*haute ville*" may mean simply "uptown"] by means of steam with which it supplies itself." He promised to bring Rouart a more detailed description.

Since New Orleans streetcars remained horse-powered

until the 1890s, Degas's mention of Lamm has given rise to some confusion among Degas scholars. In fact, Émile Lamm was hired by the financier Laurent Millaudon, the major developer of the new town of Carrollton (upriver from the residential Garden District) and the head of its suburban railroad into New Orleans. Lamm perfected the design for the tramway, which afforded "a method of using steam without carrying fire," and was "thus free from all danger of explosion," in 1872, just in time for Degas's visit. Presumably it was Millaudon, a close friend of the Mussons, who showed off the new invention to Degas.[11]

Rouart himself had business interests in New Orleans, having designed and financed a steam-powered ice factory in the city. Degas dined with Rouart's associate in the ice business, Mathieu-Joseph Bujac, reporting that he "looked very sad and worried, poor man!"—perhaps because of the uncertain results of the recently held state elections. "One day," Degas promised Rouart, "I shall go to the ice factory with him."

Ice had always been in demand in New Orleans, and for many years was hacked from New England ponds and shipped to the city. An English visitor in 1877 noted that the domestic manufacture of ice was a way to free New Orleans from dependence on the North. "The people are determined," wrote William Saunders, "as far as is possible to render themselves independent of the Northern States and to make all the articles they want. The chief ice factory is well worth a visit. The water flows down a series of perpendicular iron pipes cooled by ether, and ice forms on these pipes about a foot thick in two days. The factory is capable of producing seventy tons daily, employing only ten men."[12]

Henri Rouart's genius made this factory possible. Built in 1868, the Louisiana Ice Manufacturing Company was the largest ice factory in the world. Located by the river next to the railroad tracks on Tchoupitoulas Street, it employed, according to Marilyn Brown, "an advanced artificial-cooling

system based on an absorption process involving the compression of liquified ammonia gas in salt water." Rouart's invention, Brown concludes, "had far-reaching effects on the refrigeration industry in the United States and Europe."[13]

Degas had known Rouart since they attended school together in Paris. They were reunited when Degas found himself under Rouart's command in the National Guard, during the Siege of Paris of 1870. Degas's remarkable portrait of his friend, painted a couple of years after the New Orleans visit, shows Rouart in his captain-of-industry mode, posed outdoors in front of the Louisiana Ice Works, as Degas remembered it. The painting is composed in such a way that Rouart's top hat in the foreground—tall and black as a smokestack—divides the roof of the factory in two, while the Tchoupitoulas railroad tracks jut diagonally downwards from his piercing eyes. It is a portrait of the industrialist as visionary, capable of transforming his dreams into mechanical reality.[14]

The inventive Rouart portrait is just one example of how Degas's excitement about the technological innovation in New Orleans sparked his own ambitions as a painter. Surrounded by new subjects and settings, he struck out in several directions during his stay in the city. His New Orleans paintings cannot, as a consequence, be grouped around shared techniques or style—this was a time of great experimentation for Degas. Twice in his letters from New Orleans, he drew attention to a passage late in the *Confessions,* when Rousseau reported that he "used to go out at daybreak [and] whichever way he went, without noticing it, he examined everything; . . . he started on work that would take ten years to finish and left it without regret at the end of ten minutes." "Well," Degas added, "that is my case exactly." What extraordinary paintings he could make of all this New World splendor. "I am accumulating plans which would take ten lifetimes to carry out," he promised.

Degas, *Henri Rouart in front of His Factory*, c. 1875

But almost immediately, with the caustic irony that would deepen as Degas got older, he claimed to be unable to paint any of these things. The light was too bright; the models wouldn't stand still; his sojourn in New Orleans wasn't long enough to make sense of these materials: "Nothing but a really long stay can reveal the customs of a people. . . . Instantaneousness is photography, nothing more." And besides, a painter of exotic scenes like Delacroix or Manet was more right for these subjects than Degas, the urbane Parisian. "Manet would see lovely things here," he wrote. "Everything is beautiful in this world of the people," he confided to Tissot. "But one Paris laundry girl, with bare arms, is worth it all for such a pronounced Parisian as I am."

2

Nonetheless, Degas was strongly drawn to the dark-eyed Creole women of New Orleans. This connoisseur of imperfect marriages, who pictorially dissected the imbalances among his married siblings and cousins, found himself scrutinizing, half-seriously, the women of New Orleans for a possible mate. This was also the city of his own mother, and he noted with evident satisfaction that "the women here are all pretty," adding that "many have even amidst their charms that touch of ugliness without which, no salvation. But I fear," Degas concluded, "that their heads are as weak as mine, which *à deux* would prove a strange guarantee for a new home."

Degas did not, as a rule, accept commissions for portraits, preferring to paint his family and friends instead, where his hand was generally freer and his knowledge deeper. His most frequent and available models in New Orleans were his three beautiful cousins, Désirée Musson, Mathilde Bell, and Estelle De Gas. Désirée, the eldest of the sisters, was four years younger than Degas and still unmarried; the second, Mathilde, had given birth to a son, called William Bell

like his father, a month before Degas's arrival; and Estelle, the youngest, was pregnant, and due in late December.

Whatever stature Degas had achieved in Paris did not count for much among his cousins in New Orleans. "True, I am working little, but what I am doing is difficult," he wrote Frölich on November 27. "Family portraits must be done to suit the taste of the family, in impossible lighting, with many interruptions, and with models who are very affectionate but a little too bold—they take you much less seriously because you are their nephew or cousin." René had done little to elevate their respect. In his letter from Paris announcing Edgar's impending visit, René had joked that the family should be prepared to meet "the g-r-r-r-eat artist."[15] And here was this friendly, curious, odd-looking man in the funny hat, who rarely left the house and was wiling to look at their faces for hours at a time. What was it about their faces that so fascinated him? Perhaps he himself did not know.

The three sisters sat for Degas in turn, and the resulting portraits are, among other things, a remarkable record of how New Orleans looked back, so to speak, at her French visitor. Three of these subtle and ambitious portraits, with their differing shades and settings, could almost be thought of as portraits in gold, silver, and lead—after the three metals traditionally assigned in myth to the three sisters (whether the Fates, the three caskets of Shakespeare, or the king's daughters in folk tales).

A decade earlier, Degas had particularly admired the hands of Désirée, when she was in exile in France during the American Civil War. He had drawn her then, with her right hand on the mantel, fingers curved as though playing a piano, while the fingers of the other hand were hidden by her sister Estelle's hair. In his New Orleans portrait of Désirée, generally called *Woman with a Vase of Flowers*, Degas placed the hands in almost exactly the same position, the fingers of the right hand curved over the back of a green

chair, while the left hand is partially obscured by the large blue vase in the foreground. The outstretched fingers of one of the crumpled golden gloves on the table are placed wittily on the same line as her obscured hand, as though her fingers had gone behind the vase and into the glove.

Dressed in soft gold, Désirée is wedged, in a left-tilting parallelogram, between the vase on one side and the curved chairback on the other. Her extended arm echoes the curve of the vase, while the chairback and the same curve form another parallel. The sunlight on her dress and left cheek, which also illuminates the golden gloves and jewelry (resembling eye-glasses) on the table, casts the other side of her face in shadow, a shadow echoed by the dark space behind the chair. Her face in three-quarter view has two contrasting sides: one is bright, smiling, "sunny," while the other is shadowed and firmly unsmiling.

The vase, with its large red bloom and sprawling green leaves, takes up precisely as much space as Désirée, creating a visual pun between the two. Flower and woman are given contrasting backgrounds as well; a rich dark green and a lighter pastel shade mark where the walls join behind and between them; these shades are picked up again by the leaves. The painting invites us to ponder whether this is a woman accompanied by a vase, or vice versa. The wide green leaves with their pointed tips dangling across Désirée's breast and elbow, and jutting towards her demurely high neckline, have a hothouse sexual energy, spidery and flamboyant.

The second sister, Mathilde Bell, peers at us from the Musson balcony overlooking Esplanade (*Woman Seated near a Balcony*). She is dressed in a loose-fitting cotton *matinée*, its low-slung bodice and waist decorated with ribbons of orange. A black choker sets off her pale skin. Degas has worked the pastel of her dress and the illuminated area around her head into a silvery sheen, suggesting moonlight. A dazzling preparatory drawing, in the Metropolitan

Museum, doubles a sketch of Mathilde's face with a second, ghostly image in which chalk cross-hatchings highlight the surfaces around the hollow eyes—a disembodied moon goddess.

In this whiteness we can see one result of the sheltered lives these women lived. In a city in which skin color signified so much, women like Mathilde always wore veils outside. "Pale complexions were desirable for several reasons," notes Robert Tallant. "One was their horror that there exist any suspicion of café-au-lait." The fan that Mathilde holds in her lap was also characteristic of New Orleans Creoles. Creole ladies "were always flushing and blushing and swooning and the fan was useful as well as decorative."[16]

During the nineteenth century, when respectable women were barred from so many public places, balconies had a special meaning. There, as in some evocative paintings by Degas's friend Berthe Morisot, a solitary woman could see, without being too clearly seen. These intimate, half-private spaces, neither entirely inside nor out, were particularly prized in semi-tropical New Orleans. The journalist Edward King, visiting the city during the winter of 1873, admired the "daughters of Creoles on the balconies, gayly chatting while the veil of the twilight is torn away, and the glory of the Southern moonlight is showered over the quiet streets."[17] And Grace King, in her nostalgic collection *Balcony Stories,* wrote a prose-poem about the secret world of New Orleans balconies: "There is much of life passed on the balcony in a country where the summer unrolls in six moon-lengths, and where the nights have to come with a double endowment of vastness and splendor to compensate for the tedious, sun-parched days."[18]

The balconies were viewing stands for parades, shaded refuges from the heat inside and out, and places to talk, especially for the women of the city. Grace King's description of this women's realm makes a fitting caption for the portrait of Mathilde.

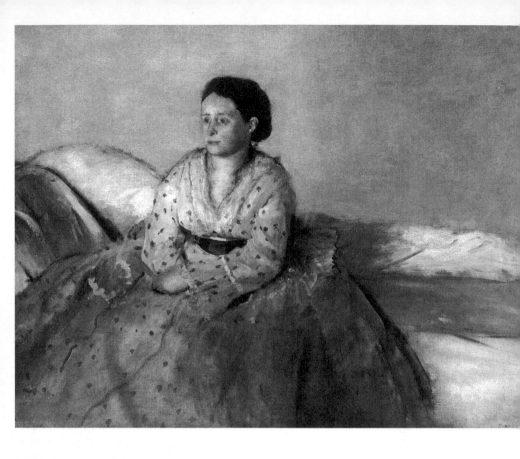

Degas, *Woman with a Vase of Flowers* (Désirée Musson), 1872

LEFT ABOVE: Degas, *Mme. René De Gas*, 1872
LEFT BELOW: Degas, *Woman Seated near a Balcony* (Mathilde Bell), 1872

And in that country the women love to sit and talk to-
gether of summer nights, on balconies, in their vague,
loose, white garments,—men are not balcony sitters,—
with their sleeping children within easy hearing, the
stars breaking the cool darkness, or the moon making
a show of light—oh, such a discreet show of light!—
through the vines. And the children inside, waking to
go from one sleep to another, hear the low, soft
mother-voices on the balcony, talking about this per-
son and that, old times, old friends, old experiences;
and it seems to them, hovering a moment in wakeful-
ness, that there is no end of the world or time, or of the
mother-knowledge.

Mathilde's ear near the open balcony could be listening for
the sleeping Willy, "a little brat of two months," as Degas
described him. He complained to Tissot that "to make a
cousin sit for you who is feeding an imp of two months is
quite hard work"—a reference, one may assume, to this
picture.

Another architectural feature of the balcony figures in
this portrait, the cast-iron railing sketched in with black be-
hind the sitter. A ghost of the upper portion of the railing
continues right across Mathilde's eyes, like a blindfold,
adding a melancholy shadow to the portrait.

The portrait of Estelle, the third and youngest sister, is at
once the most austere in composition, and the most com-
plex in meaning. Of the three sisters, Estelle, his first cousin
and his sister-in-law, had always engaged Degas's attention
most deeply. Indeed, he seemed half in love with her, in the
way he had often fallen for unavailable women: Mme.
Valpinçon, Laura Bellelli, and so on. He mentioned Estelle
in almost every letter from New Orleans, focusing espe-
cially on her blindness. "She bears [her blindness] in an in-
comparable manner," he noted; "she needs scarcely any
help about the house. She remembers the rooms and the

position of the furniture and hardly ever bumps into anything. And there is no hope!"

In his portraits of Estelle, Degas invested some of his own anxiety about his eyes, which were giving him trouble at the time. There is an uncanny mirroring quality, as well as an unmistakable yearning, in Degas's portraits of his beautiful and sorrowful cousin, especially the unnerving portrait of Estelle in the National Gallery in Washington. Estelle is placed to one side of the composition, awkwardly perched on a chaise longue, and surrounded by an eerie reddish background with no props or furniture—a blind person's disorientation and void. If Désirée, as Degas paints her, is bathed in golden sunlight, while Mathilde on the balcony seems illuminated by the moon, Estelle's surroundings, as befits her name, seem dimly lit by the stars.

In this portrait Degas plays on our expectations of a woman reclining on a sofa, the great tradition in French painting that includes such masterpieces as David's Mme. Récamier and Manet's scandalous portrait of Berthe Morisot, *Le Repos,* of c. 1870. Instead of the traditional rendition of a woman reclining seductively for the male beholder, her sprawled body coyly inviting, Degas takes the radical step of turning the woman's gaze inward. He tries to paint what it feels like to be Estelle, looking out and seeing nothing. The off-center composition reflects her own sense of being off center, not quite sure of her bearings. She sits, anxious, expectant, not knowing what to do with her hands. And resigned, too, as though she has just heard bad news. She is pitched forward, not quite comfortably. She doesn't even really seem to be *on* the sofa—she might be perched instead on a chair pushed up against it. Her hastily painted hands also contribute to her appearance of helplessness, and draw our attention back to the eyes.

Estelle's eyes drift to the side, aimed vaguely at the middle distance. The rest of the face is delicately, lovingly modeled, but not the eyes. The left eye especially is glassy, brushed over. Her auburn hair is pulled back and gathered

to reveal her left ear. Her ear is what faces us, as though she is seeing with it. And in a sense she is. In some curious, not quite describable way, those polka dots seem like so many eyes exploding everywhere. Like Rilke's statue of Apollo, missing its head "where the eyeballs [in German, "eye apples"] ripened," the rest of the body has taken on sight: "For there is no place / that does not see you."

But if there's no glow in the eyes, there is in the shiny black belt. Portraits of visibly pregnant women are rare in nineteenth-century art, and Degas has minimized Estelle's bulge. But he has found other ways to suggest her condition, in her crossed hands over the belt, and in the billowing pillows of the sofa, arched away from her waist.

The third sister, in mythology and literature, is in close touch with death. Shakespeare's Cordelia is such a figure, or Chekhov's Irina, whose first words are: "I am in mourning for my life." Baudelaire's sonnet "Les Aveugles" suggests that the blind are in close touch with death:

> *Ils traversent ainsi le noir illimité,*
> *Ce frère du silence éternel.*
> (Thus they cross the endless darkness,
> This brother of the eternal silence.)

Degas's painting of his widowed cousin is a portrait of a woman who knows that darkness, that sibling silence.

If, as the philosopher Jacques Derrida claims, all portraits of the blind are in some sense self-portraits, it is tempting to find in this haunting portrait of Estelle De Gas a self-portrait with a difference.[19] In painting the pregnant Estelle, Degas could have been painting his own mother, dead at roughly Estelle's age, a Creole like Estelle, and with something of her niece Estelle's features. For Degas, Estelle came to embody his experience of his mother's city. Like the Janus float in the annual Mardi Gras parade, it always presented two faces to Degas: stunning visual beauty, and occluding mournful darkness.

An unconscious link to Degas's mother would help explain the intensity of the portrait of Estelle, which seems to impinge on Degas's portraits of the other two sisters. They too, as Degas paints them, are Janus-faced: in the discordant, smiling-frowning division of Désirée's face, in the double-faced drawing of Mathilde. And some obstacle or darkness to the eyes is present in all three: in the jewelry deployed like gold spectacles on Désirée's table; in the black band across Mathilde's face; in Estelle's unseeing eyes.

3

It was precisely during his New Orleans trip that Degas's own eyes—those indispensable tools for a painter—were giving him serious trouble. That the very first thing he saw in New Orleans was his uncle's spectacles was somehow ominous, talismanic. For Degas, at this moment, was afraid he was going blind. The trip to New Orleans may well have been planned with this emergency in mind, to give his eyes a rest, especially from the intense, small pictures—like those of the ballet rehearsals—that he had been working on in Paris.

After one of his many lists of visual enticements—black women of various shades, white columns, and the rest—he added a rueful aside about the "brilliant light at which my eyes complain." On November 27 his eyes were feeling "much better," but a week later he was complaining again about the light that prevented him from working along the river, where the ship-lined levee and the French Market offered so many inviting subjects: "My eyes are so greatly in need of care that I scarcely take any risk with them at all."

The origin of his eye trouble was obscure even to Degas himself, and some have suspected psychosomatic causes, or at least irritants. But he consistently traced his problems to his days in the National Guard during the Franco-Prussian War, when he joined Manet and other artists in the defense of Paris. Perhaps an infection set in, caused by a combina-

tion of malnutrition and frigid air in the attic where he was quartered. Or perhaps, as he told his friend Paul Valéry, his eyes were ruined by the gunnery practice. In any case, Degas thought of his damaged eyes as a war wound, a badge of courage he could have done without. He had no way of knowing, in 1872, that his eyesight would trouble him for the rest of his life, but never darken completely. At this time he was filled with foreboding, almost panic. At the start of his late-blooming career as an artist, here he was, going blind.[20]

And yet, there is something disingenuous about all Degas's disclaimers and excuses in his New Orleans letters. He seems to be saying that of course he would paint all the expected exotic sights of New Orleans—if only his eyes could tolerate the light. If this were Monet or Pissarro, portable easel in hand, we might believe him. But this is Degas, after all, who never showed any fondness for plein air painting, and who was perfectly happy to fake seashores ("I spread my flannel coat on the floor in my studio and make the model sit on it," he explained to Henri Rouart's son Ernest), and deploy miniature horse races within the confines of his studio. The landscapes he painted during the 1880s were often purely imaginary, or loosely based on remembered glimpses from a train. "For you, natural life is necessary," he told a landscape painter; "for me, artificial life."[21]
It seems more likely that Degas knew what his friends would expect from a Louisiana sojourn—the sort of exotic images Manet or Delacroix brought back from Spain or Egypt—and with his habitual orneriness found a way to sidestep them. His eye problems, no doubt real enough, gave him a ready excuse to paint what he felt like painting, and to stay—where he always preferred to stay—indoors. Consequently he was able to paint a deeper portrait of the troubled society he found in New Orleans, and in the crowded house on Esplanade, than the slick surfaces of exoticism would have allowed.

4

What those troubles and tensions consisted of, we will have more to say in coming chapters. In the meantime, a metaphor drawn from another New Orleans artist might convey something of the feel of this deeper view of the city. In Grace King's "The Little Convent Girl," the finest of her *Balcony Stories*, an innocent young woman of sixteen, in mourning for her father, makes her way from Cincinnati towards New Orleans, her mother's city. There a revelation awaits her, having to do with the racial background of her mother. As the steamboat makes its slow journey down the river, she is invited up to the pilot-house, where the pilot, by way of describing the perils of the river, prepares her for her arrival in New Orleans:

> It was his opinion that there was as great a river as the Mississippi flowing directly under it—an underself of a river, as much a counterpart of the other as the second story of a house is of the first; in fact, he said they were navigating through the upper story. Whirlpools were holes in the floor of the upper river, so to speak; eddies were rifts and cracks. And deep under the earth, hurrying toward the subterranean stream, were other streams, small and great, but all deep, hurrying to and from that great mother-stream underneath, just as the small and great overground streams hurry to and from their mother Mississippi.

It is a mark of New Orleans stories that there is generally a "second story" lurking out of sight beneath the first, as the slaves are hidden in the second story of Delphine Lalaurie's mansion. Sooner or later this "underself" emerges, often with unsettling or appalling results.

While chatting dutifully in his letters about the picturesque sights around him, Degas was also struck by images of death and blindness in his own "mother city." Other visitors confirmed that the Crescent City, so pleasing to the

eye, so bursting with color, was also a city in mourning, dressed in black. The journalist Edward King, visiting at the same time Degas was there, described the extraordinary gardens glimpsed in French Quarter courtyards, with their rose bushes and orange trees set against the dark green of magnolias. But then the reality of the scene shifts:

> From the balconies hang, idly flapping in the breeze, little painted tin placards, announcing "Furnished apartments to rent!" Alas! in too many of the old mansions you are ushered by a gray-faced woman clad in deepest black . . . and you instinctively note by her manners and her speech that she did not rent rooms before the war.[22]

When we think of Degas's portraits of New Orleans women we can see how he used the juxtaposition of flowers and mourning in ways quite similar to Edward King's, in this city where there was a separate loge for widows at the French Opera. Degas had arrived just in time for the important New Orleans holiday of All Saints' Day, on November 1, when New Orleanians made a pilgrimage to their famous graveyards to place flowers on the graves of their loved ones.

These were the "rifts and cracks" in his own experience of the city. For Degas, New Orleans was a place of visual splendor duelling with visual impairment. The two were intertwined: the too-bright light that dazzles and blinds. This ambivalence is the dominant register of Degas's New Orleans paintings. Degas's vision of the city—for such is the match of subjectivity and actuality—accurately discerned something in the city itself. New Orleans in 1873, as its citizens prepared their costumes for Mardi Gras, was about to enter a crisis that would divide it in two. Conspicuous among the leaders of division would be some familiar names in the Musson-Degas household.

PART TWO

George Washington Cable, c. 1884

6

Old Creole Days

Not actual experience, not actual observation, but the haunted heart; that is what makes the true artist, of every sort.

GEORGE CABLE, *"After-Thoughts of a Story-Teller"*

GEORGE Washington Cable, a cotton clerk and part-time stringer for the *Picayune*, was assigned by the paper to cover the 1873 Mardi Gras celebration. It was rumored that the Krewe of Comus parade, the preparations for which were supposed to remain secret, would be something special that year, and Cable made his way to the *Picayune* offices to muster whatever shreds of advance information were available. There he met a team from *Scribner's Monthly*, a young reporter called Edward King and his European-trained illustrator, J. Wells Champney. King and Champney also planned to profile the 1873 carnival season, as well as other features of New Orleans life, for a series on the American South to be published in *Scribner's*. The three men, despite obvious differences in background and temperament, hit it off immediately. In their friend-

ship—it is not too much to say—lie the seeds of modern Southern literature.

Diminutive and devout, Cable was an unlikely choice to cover anything as potentially racy as a Mardi Gras parade. He refused to work on the Sabbath, and had a life-long aversion to theater. Mark Twain, who was fond of Cable in later years, once described him, with affectionate exasperation, as "a Christ-besprinkled, psalm-singing Presbyterian," who had taught Twain "to abhor and detest the Sabbath-day and hunt up new and troublesome ways to dishonor it."[1] Cable led an unobtrusive life as a bookkeeper in the offices of cotton firms before acquiring an interest in debating societies and local history. In his free hours he dabbled in old documents about New Orleans, some of which he worked up as newspaper sketches under the odd pseudonym of "Drop Shot," and others he turned into short stories of his own. It was with a debater's logic that Cable wrestled with the moral issues presented by racial conflict in the documents he perused, and he steadily acquired a sympathy for the blacks of New Orleans.

For a man of puritan tendencies, Cable had an unusual curiosity about the secrets and rituals of his native city; he turned out to be a perfect guide for the visiting Northern reporters. He entertained them in his house, introduced them to the leaders of the new Cotton Exchange, and regaled them with arcane lore about the French Quarter and its inhabitants. It was the beginning of a long and mutually beneficial friendship between Cable and Edward King. In the wake of their encounter, Cable achieved the dubious distinction of being regarded as "the most cordially hated little man in New Orleans."[2]

George Cable had come to the writing of stories by a roundabout way, but his eclectic education had given him an insider's view of New Orleans society. A native New Orleanian of New England and Indiana stock, Cable was born in 1844. He left school at fourteen, after his father's death

made it necessary for him to get a job. He joined the Confederate Army at nineteen and was twice wounded in the war. During the early 1870s, however, he began to have doubts about the justice of the Lost Cause. By late 1872, Cable was writing his first stories about New Orleans, stories which—in their rich weave of exotic "local color" and cold-eyed realism—would have an immense influence on later Southern writers.

Edward King too had travelled far from his beginnings, as the orphaned son of a Massachusetts minister. Born in 1848, he had worked in a factory as a youth, then left home at sixteen to become a reporter. He covered the Paris world exposition for the Springfield *Republican* in 1867—good training for the French-speaking corners of Louisiana—and gathered material for his first book, *My Paris* (1868), published when he was twenty. Two years later, having joined the staff of the Boston *Morning Journal,* he returned to France, covering the Franco-Prussian War and the fall of the Commune. Clearly an adventurous—and perhaps foolhardy—reporter, he was arrested twice by the Germans as a spy, served as an emergency nurse, and took it upon himself to claim and care for the bodies of Americans killed in the street fighting arising from the Commune. When Dr. Josiah G. Holland (best known as a close friend and correspondent of Emily Dickinson's) left the Springfield *Republican* to become editor of the New York–based *Scribner's Monthly,* he hired King and Champney to explore the South with an eye to the effects of the Civil War and the possible economic promise of the region to Northern investors. The resulting articles and illustrations were eventually gathered in *The Great South,* published in 1875. King's many other books include *Joseph Zalmonah* (1893), an exposé of New York slum life that may be his best known novel. He never married.[3]

In King's view, as he expressed it in *The Great South,* the post-war South was experiencing a time of profound and unsettling transition, rife with promise as well as danger.

"Louisiana today is Paradise Lost," he wrote in the winter of 1873. "In twenty years it may be Paradise Regained. It has unlimited, magnificent possibilities. Upon its bayou-penetrated soil, on its rich uplands and its vast prairies, a gigantic struggle is in progress. It is the battle of race with race, of the picturesque and unjust civilization of the past with the prosaic and leveling civilization of the present." In drawing that shrewd contrast, King refused to lament the passing of the antebellum culture, while at the same time expressing some anxiety at the current attempts to redress the injustices of the past. In this regard, he followed Cable's lead, and shared his views.

But Cable was not King's only guide to New Orleans. The bitter Creole historian and jurist Charles Gayarré was his other witness. Gayarré and Cable turned out to be the perfect contrapuntal guides for King and Champney, with the historian portraying the grim circumstances of the beaten city (paradise lost) and the cheerful cotton clerk pointing to encouraging signs for the future (paradise not yet regained, but regainable).

Under Gayarré's tutelage, King dutifully noted the sadder aspects of the new post-war regime: the vacant houses, the widows with rooms to let, the high taxes, the pervasive corruption and incompetence. He shared Gayarré's horror at the "negro government" imposed on the city by the Northern victors. The state legislature, a popular spectacle for visiting white tourists, included (according to Gayarré) fifty-five black members who could neither read nor write. "The Louisiana white people," Gayarré informed King, "were in such terror of the negro government that they would rather accept any other despotism." "With the downfall of slavery, and the advent of reconstruction," King reported, "came such radical changes in Louisiana politics and society that those belonging to the *ancien régime* who could flee, fled; and a prominent historian and gentleman of most honorable Creole descent [Gayarré again] told me that, among his immense acquaintance, he did not

know a single person who would not leave the State if means were at hand."[4]

Edward King was particularly appalled by the recently held state election. "The history of the infamy which, in the name of law, was perpetrated in New Orleans, in December of 1872, is well known to all who have taken any interest in general politics." King allowed that the election was probably no more irregular than most post-war elections in New Orleans; there was widespread agreement that fraud and coercion had been liberally practiced by both sides. Still, the Democrats were convinced, apparently with some justification, that the election had been "stolen" by the Republicans, with the backing of Federal officials, like-minded judges, and troops. Refusing to concede defeat, the Democrats helped to impeach the current governor, Warmoth (the distinguished black leader P. B. S. Pinchback was acting governor for a few weeks), and in January set up an alternative state house in New Orleans, with their own candidate, John McEnery, installed as governor. Two governors sat in New Orleans that winter, and two legislatures.[5]

Gayarré, King noted, was representative of a large class of men who "accepted the results of the war, so far as the abolition of slavery" was concerned, but found current conditions intolerable. Their pervasive discouragement was "written on the faces of the citizens." King appended an extraordinary passage on the physiognomy of the city of New Orleans in 1873:

Ah! these faces, these faces;—expressing deeper pain, profounder discontent than were caused by the iron fate of the few years of the war! One sees them everywhere; on the street, at the theatre, in the salon, in the [street]cars; and pauses for a moment, struck with the expression of entire despair—of complete helplessness, which has possessed their features. Sometimes the owners of the faces are one-armed and otherwise crippled; sometimes they bear no wounds or marks of

wounds, and are in the prime and fullness of life; but the look is there still. . . . The struggle is over, peace has been declared, but a generation has been doomed.[6]

Without George Cable's guidance, this dark note might have remained King's dominant interpretation of Louisiana. Cable did not deny the pervasive gloom of post-war New Orleans, but he took it upon himself to introduce Edward King to a more progressive and forward-looking faction of what was, roughly speaking, the Democratic Party in New Orleans. (With Republicans and supporters of the Reconstruction regime in New Orleans, King and Cable had nothing whatsoever to do.) These men hoped to "redeem" the state of Louisiana from Federal control by changing its business structure so that its lagging economy might flourish again, providing prosperity for all citizens of the state, and making the de facto Federal occupation obsolete. Many of these men were former Whigs, who had earlier put their trust in the Whig ideals of industrial and internal development; after the war they continued to argue for new railroads, especially as the importance of the Mississippi waned as a mode of transport for cotton and sugar, and Texas crops began to bypass New Orleans on their way east. King was merely echoing the widespread opinion of New Orleans businessmen when he claimed that "the good burghers of New Orleans must look to a speedy completing of their new railways if they wish to cope successfully with the wily and self-reliant Texan."[7]

Another antebellum arrangement eroded by new conditions was the old relationship of the rural cotton planter and his New Orleans agent, or "factor." As tenant farmers replaced slave labor, local shopkeepers and middlemen—"country traders," as King called them—had taken over many of the tasks of the factor: extending loans and providing necessities to the planters, buying and selling the crop, and so on. To restore New Orleans to its central place in the cotton economy, new standards for cotton produc-

tion were needed, as well as cooperation among the factors. And something had to be done to bring the cotton business into the modern world of international speculation and trade. To answer these needs, several prominent factors and entrepreneurs—including Cable's boss, William Black, Edgar Degas's uncle Michel Musson, and his brother René De Gas—banded together to establish the Cotton Exchange. "The Cotton Exchange of New Orleans sprang into existence in 1870," King noted, "and merchants and planters were alike surprised that they had not thought its advantages necessary before. It now has three hundred members, and expends thirty thousand dollars annually in procuring the latest commercial intelligence, and maintaining a suite of rooms where the buyer and seller may meet, and which shall be a central bureau of news."[8]

As Edward King and J. Wells Champney were preparing to leave New Orleans to continue their journey through the South, Cable invited them to his raised cottage in the Garden District, and read aloud to them some of his own stories, based on his researches into early New Orleans history. King found these stories perfectly distinctive, and promised to try to persuade *Scribner's* to publish them. And that was how, as Cable often expressed it later, Edward King "discovered" him. King gracefully countered that "Cable discovered himself, and would have dawned upon the world had there never been any 'Great South' scribes in New Orleans, to hear his mellifluous reading of his delightful sketches."[9]

For the next few years, King served as Cable's unofficial agent and publicist. He promptly sent a couple of Cable's tales to his employers in New York. King failed to interest Richard Watson Gilder, associate editor of *Scribner's*, in "Bibi," the fact-based story of an African prince who refuses to submit to the humiliations of American slavery. Gilder, not known for the breadth or daring of his tastes, probably shared the objections voiced subsequently by the *Atlantic*,

concerning "the unmitigatedly distressful effect of the story."[10] Since the "distressful effect" was precisely what Cable intended, he put the story aside, and later used it as the centerpiece of his novel *The Grandissimes*.

King had better luck with another of Cable's stories, "'Sieur George." On July 22, 1873, having in the meantime returned to New York, he wrote excitedly to Cable: "The battle is won. 'Monsieur George' is accepted, and will be published in *Scribner*. . . . I read the story myself to the editor, who liked it; it trembled in the balance a day, and then Oh ye gods! was accepted! I fancy I can see you waltzing around the office of the venerable cotton brokers, shouting the war-cry of future conquest!"[11]

Readers of "'Sieur George" in the October 1873 issue of *Scribner's* were introduced to an entirely new landscape in American literature. Cable, borrowing some of his methods and moods from Hawthorne's excavations of old New England, guided his readers into the narrow streets of the French Quarter, with their dilapidated buildings, wrought-iron balconies, and secluded courtyards harboring the secrets of the inhabitants. He invited his readers to peek "through a chink between some pair of heavy batten window-shutters, opened with an almost reptile wariness," or to look "through the unlatched wicket in some *porte-cochère*—red-painted brick pavement, foliage of dark palm or pale banana, marble or granite masonry and blooming parterres."[12]

The intricate plot of "'Sieur George" is difficult to summarize, and baffled readers then as now. A derelict veteran of the Mexican War, known to his neighbors only as George, has been entrusted by a late friend with his fortune, his widow, and his daughter. George carries around with him a battered hair-trunk, the mysterious contents of which are a constant challenge to the curiosity of George's landlord, Kookoo, "an ancient Creole of doubtful purity of blood." Kookoo functions as a sort of detective in the story,

whose efforts to decode the mysteries surrounding his tenant parallel the reader's puzzlement. As George's fortunes decay over time (the Civil War is a pregnant and palpable gap in the story), so do the streets of his neighborhood. He sinks into the "unmanly habit" of drink, carousing in the midnight streets with a soldier "on either arm, all singing different tunes and stopping at every twenty steps to tell secrets." When he proposes marriage to the daughter of his friend, his polite offer is met with horrified repulsion. The contents of the trunk turn out to be useless tickets for the Cuban lottery—George's last desperate attempt to support the women entrusted to his care.[13]

In the final scene, the orphaned daughter looks down on the outstretched city from the belvedere of the convent where she has taken refuge. The time is roughly 1870, and the city, invaded by non-Creole "Americans," has spread steadily upriver:

> Far away southward and westward the great river glistened in the sunset. Along its sweeping bends the chimneys of a smoking commerce, the magazines of surplus wealth, the gardens of the opulent, the steeples of a hundred sanctuaries and thousands and thousands of mansions and hovels covered the fertile birthright arpents which 'Sieur George, in his fifty years' stay, had seen tricked away from dull colonial Esaus by their blue-eyed brethren of the North. Nearer by she looked upon the forlornly silent region of lowly dwellings, neglected by legislation and shunned by all lovers of comfort, that once had been the smiling fields of her own grandsire's broad plantation; and but a little way off, trudging across the marshy commons, her eye caught sight of 'Sieur George following the sunset out upon the prairies to find a night's rest in the high grass.

"'Sieur George" has much in common with the other six stories Cable published during the 1870s, collected in his book *Old Creole Days* (1879). For Cable, New Orleans is a

haunted city, and its secret tales of the past are coaxed from particular buildings and streets. 'Sieur George's gray stucco rooming-house, identified by Lafcadio Hearn and still pointed out to tourists in New Orleans, "has a solemn look of gentility in rags, and stands, or, as it were, hangs, about the corner of two ancient streets, like a faded fop who pretends to be looking for employment." The massive half-ruined plantation house of the slave-trader Jean-ah Poquelin, in another story, is "a strong reminder of days . . . when every man had been his own peace officer and the insurrection of the blacks a daily contingency. Its dark, weather-beaten roof and sides were hoisted up above the jungly plain in a distracted way, like a gigantic ammunition-wagon stuck in the mud and abandoned by some retreating army."

Though the two stories have much in common, "Jean-ah Poquelin" is more successful than the loose-jointed "'Sieur George"—Mark Twain was especially fond of it. Its mundane present, as a cohort of "American" New Orleans financiers try to build a road through the old Creole Jean-ah Poquelin's jungle-like property to make way for the expanding city, is effectively contrasted with Jean's mysterious activities in darkest Africa. Jean and his half-brother Jacques had carried on the slave trade, outlawed in Louisiana after the Purchase. At the outset of the story, seven years have passed since the disappearance of Jean's younger (by thirty years) half-brother, and the possibility that Jean has done away with him provides an attractive pretext to separate the old man from his land and make way for "progress." The crass businessmen try various ways to terrorize Jean into abandoning his property. They also hope to prove he has murdered his brother—who eventually appears, a ghostly presence suffering from leprosy.

As with all successful ghost stories, "Jean-ah Poquelin" is not resolved by its "solution." Leprosy doesn't seem a big enough secret to explain the richness of innuendo in the story, even if we assume, in accord with nineteenth-

century folklore, that the disease was contracted by illicit sexual practices in Africa. Two webs of intrigue, in particular, need further exploration. First, there is the peculiar insistence on *whiteness* in the story. Leprosy turns Jean's brother Jacques "white as paint," and the brothers' only defender in the American community is the secretary of the business syndicate, "Little White." Here, following the logic that Toni Morrison explores in her book *Playing in the Dark,* whiteness implies its opposite, the blackness that actually accounts for the brothers' isolation in New Orleans. It makes sense, then, that leprosy was contracted in Africa, along with the "Guinea niggers" the brothers went in search of. The darkness has entered their bodies, and they allow a "jungle"—Cable insists on the word—to grow around their ruined house in New Orleans, their own little private Africa.

A second web of intrigue surrounds the brothers' intimacy. The implication that Jean is "not the marrying kind" is grounds for vigorous gossip in the city. We are told of Jean's earlier life, as "an opulent indigo planter, standing high in the esteem of his small, proud circle of exclusively male acquaintances in the old city," and his present isolation: " 'The last of his line,' said the gossips." Cable adds: "There was no trait in Jean Marie Poquelin . . . for which he was so well known among his few friends as his apparent fondness for his 'little brother.' "

> They had seemed to live so happily in each other's love. No father, mother, wife to either, no kindred upon earth. The elder a bold, frank, impetuous, chivalric adventurer; the younger a gentle, studious, book-loving recluse; they lived upon the ancestral estate like mated birds, one always on the wing, the other always in the nest.

We are invited to speculate that the "sin" of Poquelin is not only the crime of trading slaves with Africa, but also the sin of loving other men, and specifically his younger half-

brother Jacques. The New Orleans practice of *charivari*—a ritual of public humiliation comparable to tar and feathering—that the mob plans to inflict on Jean is traditionally reserved for inappropriate marriages, especially those between older men and young girls.

Why, then, does Cable make the Poquelins *half* brothers? To reduce the suggestion of incest by half? To suggest that the older (and much darker) brother may be half black? To make this marriage of youth and age ripe for *charivari?* In surrounding the brothers with a cloud of suspicion, Cable probably had all these things vaguely in mind.

Despite their unmasking of vice among New Orleanians, there was nothing much in "'Sieur George" or "Jean-ah Poquelin" to ruffle the feathers of local readers. In both stories, the vices and crimes of the central characters—gambling and drinking in the former, sexual transgression and slave-trading in the latter—are associated with a heart of darkness elsewhere, which the characters have carried back to New Orleans. Even the subtle innuendo (less subtle to our contemporary ears) that George and Jean-ah displayed homoerotic tendencies was directed at tastes acquired under extreme and distant circumstances: in the army in Mexico and in the amoral jungles of Africa.

Only when Cable turned to the truly explosive issue in post-war New Orleans—namely, race—did his stories inspire controversy. "'Tite Poulette" was published in *Scribner's* in the October 1874 issue, at a time when racial violence had erupted in the streets of New Orleans. The story explores the antebellum system of *"plaçage,"* by which white men selected quadroon and octoroon mistresses—the courtesans of their time—at "quadroon balls" specifically arranged for that purpose. The pathos of mothers introducing their daughters into these practices was not entirely new to literature, having been broached as early as 1845 in the interesting French-language collection *Les Cenelles,* written by a group of free black poets headed by

Armand Lanusse. Lanusse's "Épigramme" describes a priest asking such a mother if she intends to renounce Satan. The poem, in Langston Hughes's modern translation, concludes:

> "I wish to renounce him forever," she said,
> "But that I may lose every urge to be bad,
> Before pure grace takes me in hand,
> Shouldn't I show my daughter how to get a man?"

The last line in the original French, "*Que ne puis-je, pasteur— Quoi donc?—plaçer ma fille?*"—includes a slight hesitation, signified by the dashes, before the mother risks the technical verb for "placing" her daughter with a white protector.[14]

Mme. John in Cable's "'Tite Poulette" is treated with no such sarcasm; she is a maternal figure of virtue and pathos. "You would hardly have thought of her being 'colored,'" Cable writes. "Though fading, she was still of very attractive countenance, fine, rather severe features, nearly straight hair carefully kept, and that vivid black eye so peculiar to her kind." Having met her own kindly protector, M. John, at a quadroon ball, she has raised their daughter, 'Tite Poulette, in the house—a fine Creole cottage on Dumaine Street still known as "Madame John's Legacy"— bequeathed to her at his death.

As the story opens, Mme. John's daughter, who can pass for white ("White?—white like a water lily! White—like a magnolia!"), is seventeen, the age when she too is ripe for *plaçage*. But a neighbor, the kindly Dutch clerk Kristian Koppig, has fallen in love with her and asks for her hand. "It is against the law," 'Tite Poulette replies, for white men were not allowed to marry free women of color. Koppig, undaunted, fights the whole *plaçage* system, including the unsavory organizer of the quadroon balls. He is rewarded for his pains. At the conclusion of the story, Cable fixes the legal tangle with a bit of narrative sleight of hand, as the truth about 'Tite Poulette's parentage comes to light: she is as white as the driven snow. Even with its fairy-tale ending,

"'Tite Poulette" introduced a serious black character into American fiction, in the person of Mme. John, and gave her a nobility of character hitherto unknown in Southern writing. Along the way, Cable attacked the unjust arrangements by which white men preyed on black women, and raised some uneasy questions about the racial purity of New Orleanians.

In "Belles Demoiselles Plantation," Cable went even further, as he contrasted the fates of the cousins Colonel De Charleu and Old De Carlos (known as "Charlie"), one white and the other of mixed race. Both men are descended from a French count who came to Louisiana many years earlier and had two families, since, after all, "A man cannot remember everything." De Charleu has as his legacy a beautiful plantation by the Mississippi; De Carlos in turn has inherited a block of houses in New Orleans. (There were, in fact, many prosperous free black landlords in the city.) De Charleu covets the houses, De Carlos will only trade if the plantation is the bait. When De Charleu finds that his plantation is slowly being eaten away by the river, and will soon be completely submerged, he conceals his discovery and agrees to the trade, only to repent of this deceit on his deathbed. Cable, in the voice of the narrator, concludes: "One thing I never knew a Creole to do. He will not utterly go back on his ties of blood, no matter what sort of knots those ties may be. For one reason, he is never ashamed of his or his father's sins; and for another—he will tell you—he is 'all heart.'" Teary-eyed, De Carlos watches lovingly over his cousin's demise.

This was too much for many New Orleans Creoles, who felt that Cable was implying—in the widely read pages of *Scribner's* no less—that they were a population of halfbreeds and philanderers.[15] One of those who led the charge against Cable was none other than the historian Charles Gayarré, Edward King's other guide to New Orleans. Gayarré wanted to deny all past associations of black and white in the city, and to "purify" the term "Creole"—a word

that before the war meant anyone born in New Orleans—so that it only referred to whites. Cable, by contrast, felt that the way to achieve genuine racial harmony in New Orleans was a frank acknowledgment of past associations between the races—an accommodation that for Cable meant, in effect, the acknowledgment of miscegenation as a pervasive fact of antebellum life in the city. The deathbed reconciliation of De Carlos and De Charleu represents in narrative form just such an acknowledgment.

Gayarré, who had initially dismissed Cable as "no more than a malevolent, ignorant dwarf," eventually became so incensed with Cable's views and his popularity as a writer (a popularity that put Gayarré's own extensive writings on Louisiana history in the shade) that he rented a hall to denounce Cable in public, accusing him of proposing as a panacea to Louisiana's ills a bottle labeled "social and conjugal fusion of the blacks and the whites."[16] Placide Canonge, son of the judge who had first told Harriet Martineau the story of the Haunted House, joined the fray, publishing several "sizzling editorials" in the New Orleans *Bee,* attacking Cable. Meanwhile, a story went around New Orleans that Mme. Lalaurie had refused to receive Cable in her house because he had "colored blood," and that he had written "The Haunted House in Royal Street" to even the score.[17]

This venom merely confirmed Cable's influence, of course, not least upon writers who followed his lead. Such later New Orleans storytellers as Kate Chopin and the African-American writer Alice Dunbar-Nelson gratefully inherited the themes and characters Cable had first devised. And even writers hostile to Cable's example, such as Gayarré's devoted friend Grace King, learned from him and were inspired by him—if only by reaction. When Richard Watson Gilder, editor of *Century* magazine, asked King to explain the New Orleanian hostility towards Cable, she responded that "Cable proclaimed his preference for colored people over white and assumed the inevitable superiority—

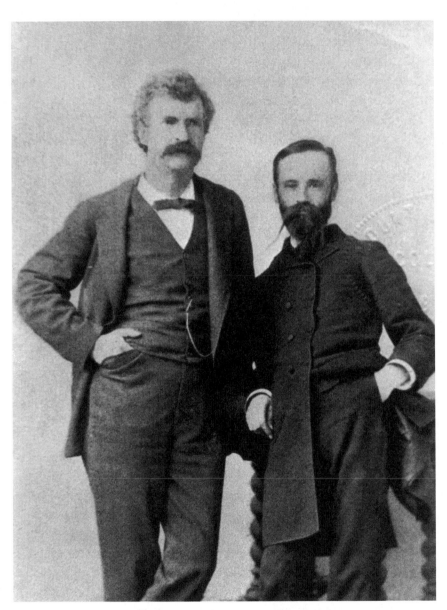

Mark Twain and George Cable, 1884

according to his theories—of the quadroons over the Creoles." Gilder challenged her to right the balance, and her acceptance was, she claimed, the beginning of her own career as a writer.[18]

If Cable became, in the illustrator Joseph Pennell's words, "the most cordially hated little man in New Orleans,"[19] he was also the guide most sought after by visitors to the city. Edward King was merely the first to appreciate his special insight into the city. Lafcadio Hearn and Mark Twain came to New Orleans in large part because Cable was there, and they looked among the narrow streets of the Vieux Carré for the city that Cable had in part invented. In *Life on the Mississippi,* Mark Twain wrote of "the privilege of idling through this ancient quarter of New Orleans with the South's finest literary genius. . . . In truth, I find by experience, that the untrained eye and vacant mind can inspect it and learn of it and judge of it more clearly and profitably in [Cable's] books than by personal contact with it."[20]

To the Southern writers who followed him—Kate Chopin, Mark Twain, William Faulkner, and the rest— George Washington Cable posed a challenge: How was the Southern writer to acknowledge the past of the region, and especially those racial "ironies" of Southern history and society that did not lend themselves to a smiling, nostalgic, "local color" treatment? How could those contentious Creole cousins De Carlos and De Charleu be brought to the same table, and make peace with one another? How could divided families, joined by the same name and the same ancestors, heal their divisions?

7

Rillieux

. . . the oft-encountered apparition of the dark sharer of his name . . .

GEORGE WASHINGTON CABLE,
The Grandissimes (1880)

DESPITE a reputation for flamboyant misbehavior, the city of New Orleans yields its secrets grudgingly. Edgar Degas was a notoriously secretive man, especially late in life. He declared his ambition to be *"illustre et inconnu,"* famous and unknown, and he was largely successful in this regard, much to the frustration of his biographers. But a major clue to Degas's hooded temperament, unknown and unsuspected by Degas scholars, emerges from a closer look at the illustrious Rillieux family, to which Degas's maternal grandmother belonged. It is a tale involving genius, miscegenation, and some Confederate luminaries.

Degas was impressed by many things in New Orleans, but he was particularly fascinated by the large black population of the city—about a quarter of the total population of some 250,000. Again and again in his letters from New Or-

leans, Degas returns to the omnipresence of black people and the fact of racial mixing:

> Nothing pleases me more than the black women of all shades, holding little white children, so very white, in their arms, against white houses with columns of fluted wood and in gardens of orange trees, and ladies in muslin against the fronts of their little houses . . . and fruit vendors with stores filled to overflowing, and the contrast between the bustle and efficiency of offices with this vast dark animal force, etc., etc. And the pretty pure-blooded women and the pretty quadroons and the strapping black women!

Degas's contrast between efficient white offices and the black work force—he witnessed the latter along the waterfront, where the muscular "roustabouts" ("ebony-breasted, tough-fisted, bullet-headed," as Edward King described them) unloaded cotton from the steamboats—has an obvious bearing on his painting *A Cotton Office in New Orleans*. With its intense blacks and whites, the painting is like a photographic negative: the black suits represent the power of these white men, while the gleaming white cotton spread out on the table implies, as Marilyn Brown notes, the labor of the invisible black work force.[1]

Despite his fascination with blacks, Degas only painted one image of a black person among the fifteen or so paintings he began in New Orleans, the almost effaced nurse in the sketch-like *Children on a Doorstep (New Orleans)*. In his final letter from New Orleans, just before his departure in early March 1873, Degas regretted not having done more with the subject of race: "The black world, I have not the time to explore it; there are some real treasures as regards drawing and color in these forests of ebony. I shall be very surprised to live among white people only in Paris. And then I love silhouettes so much and these silhouettes walk."

Of course there are many reasons why Degas might have

neglected the "black world." His eyes were bothering him, and he avoided the bright Louisiana light along the river and near the French Market, where black "subjects" might be found. He suggested that such painters of black subjects as Auguste Biard (known for his large-scale *The Slave Trade*) and Manet would have done a better job in New Orleans. Still, for a master of artifice such as Degas, staying inside wasn't necessarily a hindrance. And besides, there were many black servants in the Musson house, all of them presumably available to sit for portraits. Is it possible, then, that there was some inhibition at work in Degas's reluctance to paint these black people, a submerged awareness that the "walking silhouettes" were closer to him than he wished to admit?

Degas's great-grandfather Vincent Rillieux fought for the Spanish king against the British amid the complicated alliances of the Louisiana phase of the American Revolution. Don Vicenze's exploits as a clever naval captain are granted a paragraph or so in histories of Louisiana. With a crew of fourteen Creoles he once captured an English transport and—as his men shouted uproariously to suggest a much larger force—took prisoner the fifty-six soldiers it was carrying.[2]

Vincent Rillieux built a large house on Royal Street around 1795—Brennan's restaurant is the current occupant—where he raised his daughters and his two sons, one of whom, Michael, died young. His daughter Eugénie married the Englishman James Freret; their grandson, the Paris-trained architect James Freret, built some of the most distinguished New Orleans buildings. Vincent's other daughter, Maria Désirée, married Germain Musson, Degas's grandfather.[3]

A closely guarded secret of the Rillieux family—a secret kept until now—was that Vincent Rillieux's other son, also called Vincent, had a liaison with a woman of color called Constance Vivant. Vivant belonged to the Cheval family,

free blacks who had extensive holdings in land and rental properties. She had several children with Vincent Rillieux, Jr. One of their sons, Norbert Rillieux, became a leading chemical engineer of his time, whose inventions revolutionized the sugar industry throughout the world. Another son, Edmond, was a prominent builder and businessman who served for a time as superintendent of the city water works. Norbert and Edmond Rillieux were first cousins of Degas's mother, and of his uncle Michel Musson. While it was not unusual for Creole men of wealth to have mistresses of mixed race, it is perhaps more surprising that Degas's close relation with someone as significant as Norbert Rillieux should have been overlooked for so long.

The birth record in the municipal archives reads: "Norbert Rillieux, quadroon libre, natural son of Vincent Rillieux and Constance Vivant. Born March 17, 1806. Baptized in St. Louis Cathedral by Père Antoine." Norbert and his mother belonged to the large caste of "free people of color"—intermediate in rights and for the most part skin color between slaves and whites—that made New Orleans unlike any other city in the South. The free quadroon and octoroon women—so fascinating to New Orleans writers from George Washington Cable to William Faulkner—were reputed to be of extraordinary beauty, and sometimes relied on white protectors for support.

Many of these relationships were between white militia members and free women of color. Vincent Rillieux had served in the militia in the Battle of New Orleans of 1815, when Andrew Jackson turned back the British invaders in the last battle of the War of 1812. He and another militia member, Juan Soulié, set up houses with two sisters: Constance and Eulalie Vivant. The couples served as godparents for each other's children, and the children in turn became close friends and business associates of one another.[4]

Harriet Martineau, as we noted earlier, was shocked by how widespread such *plaçage* practices were: "The quad-

roon connections in New Orleans are all but universal, as
I was assured on the spot by ladies who cannot be mis-
taken." Sometimes the men went on to marry white
women of their own class, making various provisions for
their parallel families. But others, as Frederick Law Olmsted
noted during a New Orleans visit during the 1850s, "form
so strong attachments, that the arrangement is never dis-
continued, but becomes, indeed, that of marriage, except
that it is not legalized or solemnized."[5] Such was the case
with Vincent Rillieux, who remained unmarried, and Con-
stance Vivant.

The usual image of the "*plaçée*" is that of a mistress de-
pendent on the largesse of her white patron. Vivant's own
wealth made her unlike many of the *plaçées* in this regard.
Indeed, what can be discovered of the life of Constance Vi-
vant belies the image of the courtesan—borrowed from the
novels of Balzac and Zola, and the paintings of Manet—that
so many successive chroniclers of the New Orleans demi-
monde have accorded women like her. Instead of the
anomalous figure of legend, without family or clear social
class, Constance Vivant belonged to a respected free black
family. As she formed a new household and family, her
husband in everything but name, Vincent Rillieux, Jr., bent
the laws of inheritance and matrimony in her behalf, ac-
cording her as many of the rights of a white woman in her
place as he could. And yet, she was presumably as excluded
from the family gatherings of her white relatives as she is
from their family records.[6]

The children of such mixed-race alliances struck many
observers as suffering a particularly poignant fate. Olmsted
spoke of the alienation of "the class composed of the illegit-
imate offspring of white men and colored women (mulat-
toes or quadroons), who, from habits of early life, the
advantages of education, and the use of wealth, are too
much superior to the negroes, in general, to associate with
them, and are not allowed by law, or the popular prejudice,

to marry white people."[7] "The quadroon girls of New Orleans are brought up by their mothers," Martineau reported with distaste, "to be what they [i.e., the mothers] have been, the mistresses of white gentlemen. The boys are some of them sent to France."[8]

As was Norbert Rillieux, at an early age. His father, Vincent, a wealthy engineer and inventor (and Edgar Degas's great-uncle), had designed a successful steam-operated cotton press for making bales of cotton; it was installed in a cotton warehouse on Poydras Street. Norbert also showed an unusual aptitude for engineering. By 1830, at the age of twenty-four, the precocious Norbert was an instructor in applied mechanics at the École Centrale in Paris, publishing a series of highly regarded papers on steam engines and steam power.[9]

And then, around 1831, Norbert Rillieux made an extraordinary discovery, one that transformed the sugar-refining process and contributed significantly to the sugar boom in Louisiana. Traditionally, sugar cane juice was reduced by a primitive and wasteful procedure called the "Jamaica Train," which required the tedious and back-breaking toil of many slaves, who, armed with long ladles, skimmed the boiling juice from one open, steaming kettle to the next.[10] Various attempts had been made, with vacuum pans and horizontal coils, to harness the energy of the hot vapors rising from the boiling juice. "It remained for Rillieux," as the sugar expert George P. Meade noted, "by a stroke of genius, to enclose the condensing coils in a vacuum chamber [which lowered the boiling point of the liquid] and to employ the vapor from this first condensing chamber for evaporating the juice in a second chamber under higher vacuum." Rillieux's cost-cutting innovation, comparable in its impact on the sugar industry to Eli Whitney's cotton gin, was the basis for all modern industrial evaporation.[11] The sugar produced by the vacuum chamber process was superior to that obtained from the open kettles, which, Olmsted

noted, "was always much burnt, and less pure"; the better-grade sugar was also obtained "at a much less expenditure for fuel."[12]

Failing to interest the French in his invention, Rillieux found eager clients among the wealthy planters and capitalists of his native Louisiana. In 1833 he was invited back to New Orleans by the planter and banking representative Edmund Forstall to be chief engineer of a sugar refinery that Forstall was constructing in the city. Forstall, as we noted earlier, had hired two young free men of color, Norbert Soulié and Edmond Rillieux (Norbert Rillieux's cousin and brother, respectively), to build the refinery, but a quarrel between Forstall and Vincent Rillieux ended the arrangement.

Norbert Rillieux remained in New Orleans, speculating in land and producing architectural drawings with his brother Edmond—several examples of their work, in pencil and water-color, exist among the Notarial Archives of New Orleans. Meanwhile, Norbert continued to perfect his vacuum-pan apparatus. In 1834 he approached Andrew Durnford, a Louisiana planter and free man of color, with a proposition. He would pay Durnford $50,000 for the use of his plantation, so that he could test his machinery. Durnford, whose mentor was John McDonogh, the eccentric white founder of Liberia, turned Rillieux down, saying that he could not "give up control of his people"—namely, his seventy-five slaves.[13]

Success came in 1843, when two planters, Judah P. Benjamin and Theodore Packwood, hired Rillieux to install an evaporator on Benjamin's Bellechasse Plantation, on the west bank of the Mississippi below New Orleans. By 1846 several other plantations in the state, including Duncan Kenner's Ashland Plantation, were using the Rillieux apparatus. In a competition that year, first and second prize for best sugar were awarded to Packwood and Benjamin, who were cited for having used "Rillieux's patent sugar boiling apparatus."[14]

The remarkable Judah P. Benjamin, the Jewish Confederate luminary who later served as Jefferson Davis's secretary of state ("the brains of the Confederacy," he was sometimes called, or, alternatively, as Mary Chesnut noted in her diary, "Mr. Davis's pet Jew"), became Rillieux's major supporter in Louisiana sugar circles, defending the Rillieux apparatus in a series of widely distributed articles in De Bow's popular commercial magazine. Benjamin wrote in 1846 that the sugar made by the Rillieux method was the best in Louisiana, its "crystalline grain and snowy whiteness . . . equal to those of the best double-refined sugar of our northern refineries"—already some North-South friction there. Norbert Rillieux himself defended what he called "the 3 Pan N. Rillieux Apparatus" against all competitors, especially with regard to fuel economy, in a tersely worded letter, accompanied by a chart, published in *De Bow's Review* in 1848.[15]

The irony that Benjamin, an apologist for Southern interests in Washington, became a spokesman for a technique that reduced the need for slave labor, and required skilled (and presumably non-slave) operators, was pointed out to him ten years later on the Senate floor, when Benjamin was a U.S. senator (and the first Jew in the United States Senate) for Louisiana. During a debate on slavery and Cuban annexation in 1859, Senator Dixon of Connecticut produced a tattered copy of *De Bow's Review* and confronted Benjamin with his own admission of the inefficiency of slave labor. Benjamin conceded that slaves could not be entrusted with the complex Rillieux apparatus, though neither senator acknowledged the irony that the inventor was himself descended from slaves.[16]

Judah P. Benjamin's friendship with Norbert Rillieux was evidently a close one, an unconventional intimacy unencumbered by domestic arrangements. The spectacular failure of Benjamin's marriage was known to everyone in the South. He had married a Creole belle called Natalie St. Martin in 1833. They were childless for ten years, and Natalie

quickly developed a reputation as a wayward wife, while Benjamin was suspected of impotence. "When the Benjamins finally did have a child," as his biographer Eli N. Evans notes, "the failure to do so earlier became his, not his wife's."[17] As an attempt to save his foundering marriage, he had built the splendid plantation of Bellechasse. But Natalie was no happier with Benjamin at Bellechasse than she had been in New Orleans, and she shocked her husband by announcing in 1844 that she planned to move to Paris, with their child. For the rest of his life, Benjamin paid an annual visit to his wife and daughter in France, and suffered the humiliation of hearing second- or third-hand about Natalie's latest infatuations.

Norbert Rillieux was a frequent guest at Judah P. Benjamin's "bachelor's quarters" on Polymnia Street in New Orleans. Benjamin's first biographer, Pierce Butler, reported that "frequently, for quite long visits, came the dried-up little chemist, Rillieux, always the centre of an admiring and interested group of planters from the neighborhood as he explained this or that point in the chemistry of sugar or the working of his apparatus."[18]

This remarkable pair, the great Jewish lawyer and the brilliant free man of color, might have posed for one of Degas's double portraits, where the contrasts of the subjects are as important as the similarities. Each had overcome extraordinary obstacles, and a mutually beneficial symbiosis developed between them. Benjamin, born on the island of Saint Croix in the British West Indies and raised poor on the Charleston waterfront, had arrived in New Orleans with five dollars in his pocket after being expelled from Yale under a cloud of suspicion. Determined to achieve the status—unheard of for a Jew—of wealthy planter and landowner (not to mention slaveowner—his plantation had 140 slaves), Benjamin used the apparatus of the free man of color to produce white—"snow-white," as Benjamin said—sugar, his pass into the ranks of the landed gentry. In return, the grateful Benjamin, instead of hoard-

ing his lucrative secret, advertised Rillieux's name and genius across the slaveholding South.

For at least ten years, Rillieux was a key figure in New Orleans manufacturing, and according to one contemporary was "the most sought after engineer in Louisiana."[19] But he was still, by Louisiana law, a "person of color." We don't know how Rillieux responded to race prejudice while in America. He couldn't be lodged in the "big house" at the plantations he visited, including Benjamin's Bellechasse, and one source claims he was housed in the slave quarters. It seems more likely, as a man whose father knew Rillieux reported, that his clients provided special housing for Rillieux, with slave servants.[20]

As an engineer, Rillieux was interested in things other than sugar. He applied himself to one of the perennial problems in New Orleans, that of drainage of the lowlands, and reportedly came up with a workable plan, which he presented to a group of investors headed by Laurent Millaudon. Rillieux's plan, according to his French secretary and partner, Horsin-Déon, was blocked in the state legislature by none other than Edmund Forstall, Rillieux's "sworn enemy." Charles Rousséve, an early historian of black life in Louisiana, claimed that the plan was a sewer system for the city—a successful sewer system was not installed until many years after the Civil War. According to Rousséve, "local authorities refused to accept" Rillieux's proposal because "sentiment against free people of color had become sufficiently acute to prohibit the bestowing of such an honor upon a member of this group."[21]

We don't know exactly when Rillieux returned to France. He had many reasons, among them the new restrictions imposed in 1855 on free people of color staying in New Orleans, including the requirement that they register with local authorities and secure the guarantee of a white sponsor. There was also a steep decline in the sugar industry during the Civil War. Horsin-Déon says that Rillieux left America "after the war, exhausted and asking for nothing

Norbert Rillieux, during his later years in Paris

but rest," but other sources mention his presence in Paris as early as 1861.[22]

Back in Paris, Rillieux became passionately interested in Egypt, perhaps after constructing a refinery there. Duncan Kenner, making one of his frequent journeys to France, visited Rillieux in 1880 and was surprised to find him deciphering hieroglyphics at the Bibliothèque Nationale.[23] When Rillieux was nearly seventy-five he "returned from the pyramids," as one French commentator remarked, and made several further refinements in various devices for the production of cane and beet sugar.

Rillieux was often described as a "*caractère difficile*," a gruff and plain-spoken man who did not suffer fools gladly. He was "an excessively frank man," Horsin-Déon's son remembered, "who said exactly what he thought and tolerated neither injustice nor duplicity." The editor of a technical journal in Paris mentioned Rillieux's criticisms of his rivals as "formulated with a vivacity quite in character with the irritable inventor."[24] A photograph taken in Paris during Rillieux's later years shows an imposing, light-skinned figure with forceful hands and intense features. He is dressed formally in a frock-coat and wears a full white beard.

Norbert Rillieux died when he was eighty-nine, and was buried in the cemetery of Père La Chaise, with the inscription "*Ici reposent Norbert Rillieux ingénieur civil [né] à la Nouvelle Orléans 18 Mars 1806/décédé à Paris le 8 Octobre 1894/ Emily Cuckow, Veuve Rillieux 1827–1912.*" Of his widow nothing is known, except that Rillieux left her enough money to live comfortably in the province of La Manche during her final years.[25]

Did Edgar Degas know of his mother's first cousin Norbert Rillieux? It hardly seems likely that he did not. Norbert Rillieux was, after all, among the most famous New Orleanians in nineteenth-century France. Degas himself was fascinated by new inventions and industrial apparatus, and socialized with such industrialists and entrepreneurs as his

friend Henri Rouart. The Rillieux name would have been a familiar one in such circles. Indeed, if we assume that Degas was indeed aware of Norbert Rillieux's achievements, the place to look for his ties to Norbert is perhaps not in his rare paintings of black subjects, but rather in the cousins' shared fascination with technology.

We have already noted Degas's excitement, expressed in a letter to Henri Rouart, about the new steam-powered streetcars designed by Émile Lamm that he saw in New Orleans. Lamm had been hired by Laurent Millaudon, the major developer of the new town of Carrollton and a close friend of the Musson family. Laurent Millaudon had also been a patron, thirty years earlier, of Norbert Rillieux. Millaudon had consulted with Rillieux about methods for draining the lowlands around Carrollton—presumably the source of confusion in later accounts of Rillieux and his drainage plans for the city.[26] One would like to know whether the Rillieux name came up when Millaudon discussed Lamm's innovations with Degas.

Not only did Degas stay abreast of the latest technological innovations, he was himself a technical innovator of genius in his painting, both in his brilliant use of peculiar points of view, unexpected croppings, and off-center compositions, as well as in his improvisatory approach to the artist's materials: mixing paint with various thinners, experimenting with printing techniques, and so on. As the Degas scholar Theodore Reff has observed, "there was in [Degas] something of the amateur scientist and inventor."[27] It is this aspect of Degas, the restless and irritable experimenter with new techniques and subjects, which most resembles Rillieux.

Even if we assume that the Musson-Degas family did not speak openly of Norbert Rillieux, out of embarrassment at the fact of miscegenation so close to home, the network of New Orleans families with French connections was so in-

terrelated that it is reasonable to assume that the name would have been mentioned among them. And Vincent, Jr., Norbert's father, was hardly shunned in the family. As late as 1873, the same year that Degas was visiting New Orleans, the prominent architect James Freret, whose grandmother was a Rillieux (a sister of Vincent, Jr.), proudly proclaimed his relationship with Norbert's father, the owner of the innovative steam-powered cotton press.[28]

Furthermore, two of Rillieux's major patrons, Judah Benjamin and Duncan Kenner, were well known to the Musson family. Benjamin and Michel Musson were in the same Whig circles around Zachary Taylor before the war, and the Benjamins were part of the "Louisiana colony" in Paris after it. On October 25, 1873, Degas's uncle Eugène Musson reported having had dinner with the Benjamins, and thanked his brother Michel for sending him information about Judah Benjamin.[29]

With Duncan Kenner, the man who found Rillieux deciphering hieroglyphics in 1880, the Musson ties were even more intimate. During the spring of 1834, as we have noted, he had visited the Musson-Degas family in Paris when Célestine Musson Degas was pregnant with her first child, Edgar. Kenner's travelling companion for part of that journey was the New Orleans architect Norbert Soulié, a free man of color who—such are the intricacies of New Orleans society—had just built a fine Creole cottage on Burgundy Street for none other than Constance Vivant, mother of Norbert Rillieux.

Duncan Kenner and Judah Benjamin were themselves close friends. During the early months of the Confederate legislature, when they served as delegates from Louisiana, they had shared a house together in Richmond, developing, according to Benjamin's biographer, "a special intimacy."[30] Though staunch Confederate loyalists and slaveholders, they both came to regard slavery as a problem for the Confederacy. After the shocking fall of New Orleans

in 1862, Kenner hit on the plan of swapping emancipation of the Southern slaves for much-needed recognition by the European powers. The idea was to show the world that the Civil War was not being fought over slavery, as Northern propaganda claimed, but rather to preserve Union domination over the South.[31] But two more years elapsed before Benjamin and Kenner persuaded a reluctant Jefferson Davis of the wisdom of issuing a Southern emancipation proclamation.

It was Duncan Kenner who was chosen to undertake the dangerous secret mission of conveying the plan to the French and British authorities. In December 1864, Kenner travelled overland, through Federal lines, from Richmond to New York. In disguise, and mainly on foot, he made his way across the state of Maryland, hiding in farmhouses and narrowly escaping detection. After boarding a ship in New York, Kenner was still not safe, and to avoid being recognized by fellow passengers he wore a fake beard and spoke only in French. But the whole extraordinary journey was in vain. By the time Kenner arrived in Europe in early 1865, it was abundantly clear to both the French and the English that the Confederacy had already lost the war.[32]

Before and after the war, Duncan Kenner was an ambitious and successful sugar-planter who "never hesitated to adopt the most scientific methods of perfecting the development of the cane and manufacture of sugar."[33] That would be reason enough for him to track down Norbert Rillieux in Paris in 1880. But the fact that both he and Rillieux were intimate friends of Judah Benjamin makes this visit of particular interest. It suggests that the friendship of these men, who sometimes showed a rare ability to overlook racial and ethnic differences, survived the Civil War, and was part of the complicated network of Louisianians connecting Paris to New Orleans.

In Degas's American family, issues of race were part of the daily texture of life. With illustrious black cousins in

Paris and Louisiana, he could not have painted black faces in New Orleans as mere local scenery, aspects of an exotic landscape quite foreign to himself. Nor could he entirely aestheticize blacks as mere "treasures as regards drawing and color." The effaced black nurse in *Children on a Doorstep (New Orleans)* seems emblematic of Degas's hesitation about the depiction of race.

That hesitation is given brilliant expression six years later in his painting of a black circus performer. The novelist and critic Edmond de Goncourt had visited Degas in his studio in 1874, a year after Degas's return from New Orleans, and found him "an original fellow . . . sickly, neurotic, and so ophthalmic that he is afraid of losing his sight; but for this very reason," Goncourt added, "an eminently receptive creature and sensitive to the character of things." "Among all the artists I have met so far," Goncourt noted in his famous journal, "he is the one who has best been able, in representing modern life, to catch the spirit of that life."[34]

The painter and the critic remained in touch, and five years later Degas invited Goncourt back to his studio. "I will have my negress there," he promised. The woman in question was the famous mulatto circus performer Miss La La, an acrobat of the Cirque Fernando who was also known as "the woman-cannon" and, in England, "the African Princess."[35] Degas attended the circus several times to see Miss La La perform, and, after making at least four preparatory drawings, completed an oil painting of her towards the beginning of 1879.

Degas depicted Miss La La from below as she is hoisted into the air by means of a rope clenched between her teeth. In one of the preparatory drawings, Degas drew the menacing piece of hooked machinery that she held in her mouth.[36] The scene is bathed in orange light, with the rich decor and gilded pediments of the ceiling carefully rendered. Miss La La herself is both graceful—one arm reaching upward, one reaching downward, with a delicately opened hand—and contorted. Her head is thrust back, with

Degas, *Miss La La at the Cirque Fernando*, 1879

her dark curly hair bushing to the side. Part triumphant ascension, part violent wrenching (or lynching), her abrupt and precarious upward journey, viewed from below, possesses an unnerving ambivalence. It is tempting to see in the painting a trace of Degas's own conflicted sense of his family intimacy with black people—a fitting response, in any case, to one more ambiguity of "modern life."

From the descendants of Don Vicenze Rillieux, the resourceful sea captain, came a remarkable number of innovative minds, including his son Vincent, Jr., inventor of a better cotton press, his grandson Norbert, a much greater inventor on several fronts, and his great-grandson Edgar Degas, one of the supreme inventors of modern painting. The American wing of Degas's family, especially the Rillieux branch, was far more interesting than has been thought, and surely as significant historically as the motley crew of European nobility—the Bellellis, the Morbillis, and the rest—that has received the most attention from Degas scholars. "Louisiana must be respected by all her children," Degas wrote Henri Rouart in December of 1872, "and I am almost one of them."

8

Nurses

Thus it is doubly difficult to write of this period [of Recon-
struction] calmly, so intense was the feeling, so mighty the
human passions that swayed and blinded men. Amid it all,
two figures ever stand to typify that day to coming ages—the
one, a gray-haired gentleman, whose fathers had quit them-
selves like men, whose sons lay in nameless graves; who
bowed to the evil of slavery because its abolition threatened
untold ill to all; who stood at last, in the evening of life, a
blighted, ruined form, with hate in his eyes; —and the other,
a form hovering dark and mother-like, her awful face black
with the mists of centuries, had aforetime quailed at that
white master's command, had bent in love over the cradles of
his sons and daughters, and closed in death the sunken eyes
of his wife . . .

W. E. B. DU BOIS, *The Souls of Black Folk*

MILK, as George Cable conceived it, was one key to
race relations in New Orleans. Since the white chil-
dren of the city had been nourished for generations at their
mammy's black breast, Cable reasoned, what in God's
name was the purpose of segregation? Weren't the races as
intimately related by this early practice as they could possi-
bly be? If "contamination" occurred whenever the races
congregated, as some segregationists argued, then the
white children of New Orleans were thoroughly contami-
nated, for, as Cable noted, they "pass from infancy to and

through the impressible and educable years of childhood still in the [black] nurse's care." Writing to the editors of the New Orleans *Bulletin* on the contested issue of school integration in September 1875, Cable maintained that "parents who have had their children nourished by Negro nurses cannot logically object to those children being taught by a polite and competent mulatto." The editors of the *Bulletin* were so scornful of what they called Cable's "lacteal argument" that they refused to print the letter.[1]

Along the tree-lined neutral ground of Esplanade, black nurses playing with white children were a common sight, as Cable's friend Edward King reported in the winter of 1873:

> The quiet which has reigned in the old French section since the war ended is, perhaps, abnormal; but it would be difficult to find village streets more tranquil than are the main avenues of the foreign quarter after nine at night. The long, splendid stretches of Rampart and Esplanade, with their rows of trees planted in the centre of the driveways—the whitewashed trunks giving a fine effect of green and white—are peaceful; the negro nurses stroll on the sidewalks, chattering in quaint French to the little children of their former masters.[2]

Though Degas, too, was fascinated by those negro nurses on Esplanade, nothing in his letters of that same winter is as pointed as this passage of Edward King's in its probing of the peace that reigned in the Creole neighborhoods of New Orleans. Was the harmony real or illusory, since those former "masters" were still, in a sense, masters? Was this true racial harmony or just a "whitewashing"—like those whitened tree trunks—of the same old tensions? King, in his painterly image of the rows of trees along the neutral ground of Esplanade, leaves the question open.

Those whitewashed trees reappear in a painting of De-

141

gas's, and King's passage allows us to shed some new light on it. The painting (in the Musée Fabre, Montpellier) shows a nurse feeding a baby at her exposed breast. Behind them an allée of young trees sweeps in a sharply receding inverted V to the horizon. The lower trunks of the trees are whitewashed, and the scene bears a striking resemblance, in scale and design and age of the trees, to the neutral ground of Esplanade, circa 1873. Though the painting has been given the provisional title *A Nurse in the Luxembourg Garden*, Jean Boggs has recently suggested that it may date from Degas's New Orleans sojourn, and that the depicted child was either Willie Bell, son of Mathilde and William Bell (and future distinguished judge), or one of René's children. She adds, however, that she thinks the background is in fact a painted backdrop, contrived perhaps in a photography studio.[3] Even if Boggs is correct about the artificial background, it seems unnecessary to argue, as she does, that the painting is a "nostalgic reminiscence of France," for the scene is thoroughly New Orleanian, as Edward King's passage makes clear. It may be that the backdrop was arranged to preserve Degas's eyes from the brilliant outdoor sun, while allowing him to paint the vivid Esplanade scene that attracted him.

Though the nurse in the Montpellier painting appears to be white, the image that Degas returned to again and again in his letters from New Orleans was that of white children in the care of black nurses: "Nothing pleases me more than the black women of all shades, holding little white children, so very white, in their arms . . ." These nurses were not just a spectacle in the street for Degas, they were part of the noisy and chaotic domestic scene at the Musson house on Esplanade. After enumerating the various children who came to greet him at the station, Degas adds in his first letter home, in passing: "This whole band is watched over by negresses of different shades."

Alone among the tempting subjects of the "black world,"

this scene of a band of children watched over by a black nurse actually made its way onto a Degas canvas, in the remarkable composition called *Children on a Doorstep (New Orleans)*. For a long time it was believed, for so Gaston Musson had informed John Rewald, that the depicted scene was the courtyard of the Millaudon plantation outside New Orleans, which Degas reportedly visited. Then James Byrnes, director of the New Orleans Museum of Art during the 1960s, recognized the carefully delineated house in the background as that of the Mussons' friends and neighbors the Oliviers, on North Tonti Street.[4] The scene, then, shows the large garden between the back of the Musson house and the Olivier house. Degas reported that the major problem, apart from the complexity of the composition itself, was to get his squirming subjects to sit still. "Nothing is as difficult as doing family portraits . . . ," he complained. "To persuade young children to pose on the steps is twice as tiring."

The peculiar perspective of the painting, with its Dutch recession back towards the expectant dog, the opened gate, and the distant house, allows Degas to experiment with the two juxtapositions that drew him to this material: first the contrast between white children and black nurses ("the children all dressed in white and all white against black arms"); and second, the challenging white-on-white possibilities of white clothes against white houses ("little white children, so very white . . . against white houses with columns of fluted wood)."

Like several other group portraits by Degas, *Children on a Doorstep* is both a genre scene and a family portrait. It is partly a landscape as well, at the threshold, literally, of interior and exterior. As such, it is Degas's only portrayal of outdoor New Orleans. The architectural detail of the composition, with its multiple frames of doorways, windows, and shutters, is so intricate that our attention is continually drawn away from the family cluster. There has been some debate about the identity of the human subjects (though

Degas, *Children on a Doorstep (New Orleans)*

A black nurse and white child
on Esplanade, by
J. Wells Champney, 1873

not of the Musson family dog, Vasco da Gama, who was named by Degas himself). The standing figure seems too old for the four-year-old Carrie Bell, while the sitting figure seems a bit too young for Joe (Josephine) Balfour De Gas, who was nine at the time. Still, it is fairly certain that the picture represents a group of children from the Musson extended family watched over by one of the many black nurses in the household. She sits on the left, with her back partly turned and her face almost invisible.

Why was Degas fascinated by this subject of white children and black nurses, so much so that he returned to it in letter after letter, and depicted it in one of his most ambitious New Orleans paintings? Degas was not alone in his surprise at the relatively integrated life of New Orleans. Such scenes of racial mingling shocked many visitors to the Reconstruction South. As the historian C. Vann Woodward observes: "A frequent topic of comment by Northern visitors during the period was the intimacy of contact between the races in the South, an intimacy sometimes admitted to be distasteful to the visitor. Standard topics were the sight of white babies suckled at black breasts, white and colored children playing together . . ." But the meaning of such scenes, Woodward notes, was not always clear to outsiders. "What the Northern traveler . . . sometimes took for signs of a new era of race relations was really a heritage of slavery times, or, more elementally, the result of two peoples having lived together intimately for a long time—whatever their formal relations were, whether those of master and slave, exploiter and exploited, or superior and inferior."[5]

Visitors were particularly impressed with racial mixing that occurred outside the daily round of work, especially the integrated rituals of carnival and church-going. "White and black join in the masquerading," Edward King said of carnival in 1873, while Robert Somers, an Englishman who visited the previous year, thought it "remarkable, considering the mixture of races and nationalities" in the city, "how

becomingly and with what mutual esteem and respect, all creeds and denominations here proceed on the Sabbath-day to worship God in their own forms." Frederick Law Olmsted, observing the city just before the war, made the same point as he entered the darkened Cathedral: ". . . on the bare floor, here are the kneeling women—'good' and 'bad' women—and, ah! yes, white and black women, bowed in equality before their common Father."[6]

Such interracial activity was not just window-dressing, a Sunday truce after weekday skirmishes. As one historian of black life in post–Civil War New Orleans has remarked:

> There was undoubtedly more intimacy between the races in New Orleans than in most Southern cities, be-cause Louisiana was one of the few Southern states which, only a decade after the Civil War, permitted in-terracial marriages, and which outlawed segregation in schools and places of public accommodation.[7]

A long history of antebellum miscegenation and a large population of economically successful free blacks gave race relations in New Orleans a feel different from that existing elsewhere in the United States. "Because of their historical intimacy with Negroes," John Blassingame argues, "most Louisiana whites manifested far less abhorrence for blacks than did their brothers in the North and far less than their rhetoric often implied."[8]

Degas had never before painted anything remotely related to this "intimacy" of the races, despite the provocation of such paintings as Manet's *Olympia,* with its naked white woman and fully clothed black maid, the latter bearing a West Indian turban.[9] Never, that is, unless one takes his *Interior* of 1869 (Philadelphia Museum of Art) as a depiction of race. Theodore Reff has convincingly identified the scene in the painting as the wedding night of Zola's heroine Thérèse Raquin and her lover (who happens to be a part-

time portrait-painter), after they've murdered her first husband. Reff has argued that *Thérèse Raquin*, Zola's first important naturalist novel, was itself influenced by Manet, "whose *Olympia* was evidently a source for the brutally direct portrayal of Thérèse and the motif of her black cat."[10]

It may also be relevant that Thérèse Raquin is herself of mixed race; Zola links her passionate sexuality with her African blood. (She combines, in a sense, the two women in Manet's *Olympia*.) If Degas was indeed thinking of Thérèse Raquin when he painted *Interior*, its extraordinary intensity may owe something to this subtext of racial tension and sexuality.

If so, its violent undercurrent could hardly be farther from the placid New Orleans scene on the doorstep, whose mood and subject are much closer to another major painting of this period, Degas's *Carriage at the Races*, mentioned earlier in relation to the Siege of Paris. We know that this painting was on Degas's mind in New Orleans, for he asks about it—"the one of the family at the races"—in a letter to Tissot. Its many links to *Children on a Doorstep* are intriguing. Consider, for example, the twin witness figures in the two paintings: the taller figure on the right (standing girl in *Children*, seated father in *Races*); and the alert dog in each. These figures, possible stand-ins for the artist-spectator, draw our attention from the recessive landscape, with its frontal houses in the distance, back to the action in the foreground. That action, in both paintings, involves children and their nurses.

In *Carriage at the Races* the nurse, holding the baby, is a wet-nurse. The veiled mother looks on as though she has been supplanted in her role as nurturer.[11] It is an extraordinary composition, with the ostensible spectacle of the cross-country horse race a mere stir in the background, while the real subject—to which everything, especially that hunched black dog, draws our attention—is the performance of nursing. The only critic to single out the painting

when it was shown at the first Impressionist exhibition of 1874 praised it for its "overall delicacy," as though this was a subject that particularly required it.[12]

If one meaning of *Carriage at the Races* is that this wide world of mown lawns and thoroughbreds, carriages and houses, depends on the protected institution of domestic motherhood, nursing, and child-rearing, *Children on a Doorstep* gathers a representative New Orleans landscape around the same themes, with race added to the design. *Carriage at the Races* should not be viewed as merely a model for *Children on a Doorstep*. Chance, aided by his own attraction to families, had brought Degas into close contact with mothers and their nursing babies: the Valpinçons in France, the René De Gas and William Bell families in New Orleans. But New Orleans as a place of nursing and motherhood was probably intensified for Degas by the fact that this was the birthplace of *his* mother.

A related painting from Degas's sojourn in New Orleans, the appealing *Pedicure,* shares some of these concerns. Bathed in the same greenish aquarium-like atmosphere that pervades the *Cotton Office,* it depicts a girl sitting on a sofa, one leg extended, having her toenails clipped. The girl is Joe Balfour De Gas, Estelle's daughter by her first marriage, who has also been identified among the unruly children who posed for *Children on a Doorstep*. In *The Pedicure,* Degas solved in an ingenious manner the problem of keeping an underage model still; he let someone else keep her from moving. No movement is tolerated in a pedicure; the punishment is a cut or broken nail. The painting reminds us how many of the New Orleans portraits find—to borrow a phrase from the art historian Michael Fried—appropriate "absorptive" poses for models: reading a newspaper, playing the piano, sampling cotton, and so on.

The Pedicure is an affectionate record of the luxurious practices preserved in the Musson house, even as their comfortable life-style was threatened by financial insecu-

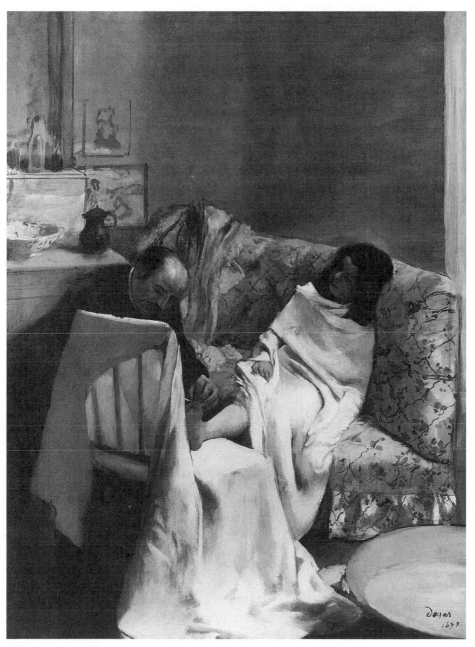

Degas, *The Pedicure*, 1873

rity. It is also a carefully structured and gently allusive allegory of artist and model. The balding chiropodist with the clippers is a stand-in for the artist, his pointed "modelling" tool just visible behind the white sheet. The sheet draped over the empty chair is his canvas, while the girl's loose dressing gown is the standard garb of the artist's model. (X rays show that Degas added the mauve garment on the sofa at a later stage, further accentuating the undress of the girl.) The diaphanous sheet hung over the easel-like chair serves as both medium and divider, marking off (as does the right-hand wall) the private realm of the pedicure-painting session. With its doctor-patient theme, *The Pedicure* is related to other portraits of injured women and their attendants—*The Invalid, Woman with a Bandage, The Nurse*—that Degas may have painted in New Orleans.[13] It also looks forward to the great series of bathing women of the 1880s, with the conspicuous tub and the gestures of grooming.

But there is something haunting and uncanny about *The Pedicure* as well. It arises from all the images of emptiness in the painting: the empty chair, the empty tub, the mirror that reflects nothing much, the balding head (accentuated by the mauve garment that frames it). Henri Loyrette has suggested that the child, "wrapped as if in a shroud," is "like a saint in a medieval or Renaissance work, whose death is being mourned by a faithful disciple."[14] Such an interpretation captures the palpable sense of mourning and loss in the painting.

The subject of children watched over by adult attendants—nurses, doctors, servants—seems to have triggered complex feelings in Degas, probably related, as I have suggested, to his own family losses. Even the convivial group in *Children on a Doorstep* has an aimless, melancholy mood. The black maid, cut off by the doorway, hardly commands the children's attention. There is an overall sense of waiting and expectation, reinforced by the alert dog and the standing girl.

* * *

In New Orleans, black nurses had a specific and fraught significance in the ongoing political life of the city, especially during Reconstruction. George Cable's "lacteal argument" against segregated schools is one indication of this. Another is Kate Chopin's New Orleans story "A Matter of Prejudice," in which she notes that Creole families regarded black nurses as conferring particular prestige, as a sort of continuation of antebellum arrangements, while white nurses were regarded with scorn.

The obvious irony is that nurses, and wet-nurses in particular, undercut the hierarchy of servant and underling by the privileged intimacy between black nurse and white child, amounting—as Degas suggests in *Carriage at the Races* and perhaps in *Children on a Doorstep* as well—almost to a supplanting of the mother. It is the milk of black women that nourishes the Creole child, black arms, as Degas noted repeatedly, that hold and protect it.

In *Children on a Doorstep,* Degas has gone to the heart of one set of New Orleans conundrums about intimacy between the races. What Degas notes in his letters and in this painting is the *fact* of integration, the intermixing of races. Until the Civil War, "Creole" meant anyone of either race born in New Orleans. This is why the drawing of the color line after the Civil War was so wrenching in New Orleans. It was not a demarcation of the status quo, or even a restoration of pre-war conditions; it was instead a violent unraveling of human relations that had taken a century to weave.

Children on a Doorstep is a picture of a fragile web of human ties in constant danger of being rent asunder. In this regard, the threshold in Degas's painting takes on new meaning. It is particularly appropriate for the liminal issue of race in New Orleans, circa 1873. The arrangements of Reconstruction were about to suffer their fiercest challenge, and the fathers in the house—Michel Musson and William Bell and René De Gas—were in the forefront of that challenge.

9

The Cotton Ballet

*I can see you waltzing around the office of the venerable
cotton brokers.*

<div style="text-align: right;">

EDWARD KING *letter to* GEORGE CABLE, *July 22, 1873*

</div>

B Y the first week in December, one month into his New
Orleans visit, Degas was feeling listless and bored, his
mood matched by the suffocating languor outside the
house on Esplanade. The season was unusually hot, even
for New Orleans. "We are having temperatures in Decem-
ber which we would be pleased to have in June," he com-
plained to Henri Rouart, "24 or 25 degrees [centigrade] at
least, not to mention a sirocco that kills you." He was feel-
ing like an outsider who couldn't go outside—because of
the heat and because of his failing eyes. "One has to be of
the country," he told Rouart, "or in the everlasting cotton,
otherwise beware." To make matters worse, he was suffer-
ing from a mild case of dysentery.

The city at that moment seemed in every way antagonis-
tic to his work: bad weather ("climate that must be unbear-

able in the summer and is somehow deadening during the other seasons"), bad light, restless sitters, and conversation that—as the harvest began to arrive by steamboat, and the commercial season lurched into gear—revolved around one subject and one subject only. Degas poured out his frustrations to Rouart:

> One does nothing here, it lies in the climate, nothing but cotton, one lives for cotton and from cotton. The light is so strong that I have not yet been able to do anything on the river. My eyes are so greatly in need of care that I scarcely take any risk with them at all. A few family portraits will be the sum total of my efforts . . . Oh well, it will be a journey I have done and very little else. Manet would see lovely things here . . .

The thwarted ambitious painter is audible in every phrase. The real subjects are outside, along the river, unreachable: the steamboats lined up for miles along the waterfront, with the black stevedores hauling cotton bales from the holds; the bustling French Market, with its mix of Italian, African, and Indian vendors. Someone with an appetite for the exotic, like Manet, who had done such fine things after visiting Brazil and Spain, would know what to make of New Orleans. Meanwhile, Degas was confined, like a prisoner with a blindfold, to the inside world of women in their parlors and men in their offices—all talking incessantly of cotton.

Degas was not the only visitor struck by this one-track obsession. Edward King noted that "in the American Quarter during certain hours of the day cotton is the only subject spoken of; the pavements of all principal avenues in the vicinity of the Exchange [around the corner from Michel Musson's cotton firm] are crowded with smartly dressed gentlemen who eagerly discuss crops and values."[1] King's friend, George Washington Cable, added a physiognomy of Carondelet Street, the address of Musson's firm:

There you see the most alert faces; noses—it seems to one—with more and sharper edge, and eyes smaller and brighter and with less distance between them than one notices in other streets. It is there that the stock and bond brokers [spilling out of the Cotton Exchange] hurry to and fro and run together promiscuously—the cunning and the simple, the headlong and the wary . . .

During bank hours, according to Cable, the sidewalks of Carondelet were "perpetually crowded with cotton factors, buyers, brokers, weighers, reweighers, classers, pickers, pressers, and samplers"—all participants in the cotton trade.[2]

Then something broke through the monotony for Degas, or rather the monotony itself became somehow intriguing, a subject worthy of a painter's attention. After his first flurry of letters, four within the three weeks right after his arrival, Degas, as we have noted, fell silent for more than two months, writing no more from December 5 to February 18. The obvious reason: he expected to be home soon. "I was going to reply to your good letter in person," he wrote Tissot. "I should have been in London or Paris about the 15th of January . . . But I remained and shall not leave until the first days of March." This meant he would stay in New Orleans right through the busiest weeks of the social season, the round of parties and balls culminating in Mardi Gras. It may be that Degas, avid for performance and cheated by the absence of opera during his visit, was persuaded to stay through Mardi Gras for this very reason.[3]

More important, however, Degas had found a New Orleans subject that excited him as a painter. All those mornings in the cotton offices—reading the papers, responding to his mail, trying to follow the endless speculative chatter in English about fluctuating cotton prices—had suddenly struck him not as a dull routine but as a subject, a vivid scene of modern life worthy of his best efforts. To his fellow painter Tissot he wrote excitedly:

After having wasted time in the family trying to do portraits in the worst conditions of day that I have ever found or imagined, I have attached myself to a fairly vigorous picture . . . *Intérieur d'un bureau d'âcheteurs de Coton à la Nlle Orléans, Cotton buyers office.*

Degas's description of the painting, in the letter to Tissot, emphasizes the varied activities of the participants:

In it there are about 15 individuals more or less occupied with a table covered with the precious material and two men, one half leaning and the other half sitting on it, the buyer and the broker, are discussing the sample.

Degas, who gives the title in English, thought that the painting would be just right for certain English buyers, especially those connected to the Manchester cotton trade.[4] It was actually purchased, during Degas's lifetime, by the Municipal Museum in Pau, the resort town in the French Pyrenees where Madame Lalaurie had met her violent death.

In addition to this "picture of the local vintage" (*tableau du cru*), Degas also mentions a second painting, "less complicated and more spontaneous, of a better art, where people are in summer dress, white walls, a sea of cotton on the tables." The work described is the sunlit sketch called *Cotton Merchants in New Orleans*, now in Harvard's Fogg Museum. Degas's excitement about the two paintings spills over into his assessment of his entire stay in New Orleans. "What a lot of good this absence from Paris has done me in any case, my dear friend. I made the most of it." The valuable commodity piled up along the wharves and on the tables becomes a metaphor for his own teeming brain: "I really have a lot of stuff in my head; if only there were insurance companies for that as there are for so many things here, there's a bale I should insure at once."

Suddenly, Degas is full of new resolve about his art, his

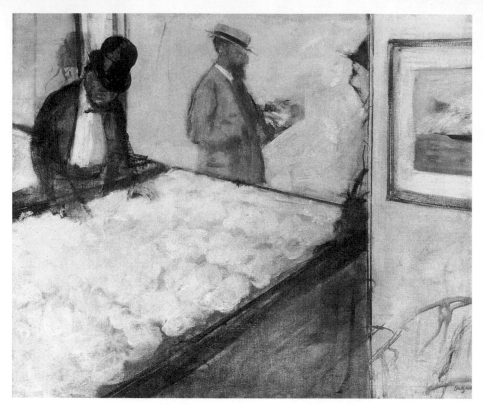

Degas, *Cotton Merchants in New Orleans*, 1873

career, his future. "I have made certain good resolutions which . . . I honestly feel capable of carrying out . . . If I could have another 20 years' time to work I should do things that would endure." Those prophetic words underscore what a critical moment the New Orleans sojourn was for Degas, a passage from one phase of his life to another. "I feel that I am collecting myself and am glad of it. It took a long time, and if I could have Corot's grand old age. . . . But my vanity is positively American!"

What was it about these two quite different paintings of cotton buyers—the one almost photographic in its retrieval of the look of a New Orleans cotton brokerage firm, the other "impressionistic" and suggestive—that crystallized Degas's sense of what New Orleans meant to him? How did these paintings help Degas to think about the progress of his career, his past achievements and his future promise? And what did Degas mean to say—and perhaps end up say-

ing inadvertently—in these marvellous and mysterious ballets of American business life?

A glance at the two paintings shows obvious similarities in content. In both pictures a well-dressed man in formal top hat and bowtie figures prominently. In both pictures a man leans over an angled table covered with billowing cotton. In both, a marine scene hanging on the wall, a picture within a picture, is cropped by the frame at the upper right corner of the painting, making a visual pun with the "sea of cotton" (Degas's phrase in the letter to Tissot) on the table. In both scenes our sense of space is complicated—in the *Cotton Merchants* sketch it is particularly difficult to decipher. And both pictures are built around a primary contrast of black and white.

But beyond these shared motifs, the pictures, in mood and finish, could hardly be more different. Indeed, they represent for Degas starkly diverging ways of depicting the same subject, and Degas conceived of them in precisely those ways. The ultrarealism, or "naturalism" as he would have called it, of the *Cotton Office* recalls Degas's great portraits of the 1860s. The painting looks back, in particular, to the portrait of the Bellelli family, the fruit of his previous major excursion, to Italy, and even farther back to his history paintings, with their complicated groupings of figures.

The unfinished *Cotton Merchants*, by contrast, with its quick handling of gesture and light, looks forward to Degas's Impressionist mode of the later 1870s and beyond. Its light, airy composition and genial use of color anticipate Matisse. For Degas, then, the *Cotton Office* is retrospective, a summing up of his career so far, while *Cotton Merchants*— "better art," as he calls it—is anticipatory, a declaration of independence from past lessons learned.

At first glance, the *Cotton Office* may seem little more than a snapshot of workers in an office, in typical attitudes of nine-to-five absorption. Degas was fortunate to come of age as an artist when photography offered ways to expand

our ways of seeing—new angles, new ways of "framing" the scene—instead of narrowing our vision as it does today. But the more one looks at the picture, the less photographic it appears, while the relations among the figures take on strange and uncanny aspects.

Several designs emerge as one stares at this carefully plotted painting. The old man seated in the front, with his white hair, spectacles, and antiquated hat, is echoed by the younger, jauntily dressed man seated behind him. Degas is subtly invoking the traditional imagery of the ages of man. The pressure of the present is represented by the opened newspaper, while the empty chair (since Roman times a traditional image of mortality) may suggest the old man's imminent death. Deathlike too are the funereal suits of the most prominent men in the picture; in the modern world, as Baudelaire famously remarked apropos our habitual black garb, "we are all in mourning for something."[5]

And what of that complicated mesh of architectural detail: windows opened to various heights; frames—of windows, doors, shelves, paintings; chair legs and table legs, and so on? All these criss-crossing lines remind us that Degas, during this period, was preoccupied with the challenge of depicting people in their usual settings. This idea, fully articulated by Degas's friend, defender, and occasional model, the influential art critic Edmond Duranty, lies behind this painting and many others in Degas's oeuvre of the late sixties and early seventies. As Duranty wrote in his major work, *The New Painting*: "We will no longer separate the person from the apartment setting. . . . Around him and behind him are furniture, a fireplace, wallpaper, a wall that reveals his fortune, his class, and his profession."[6]

For Degas, as for many visitors since, New Orleans was as striking for its architecture as for its inhabitants. His letters from New Orleans are packed with architectural detail as though his major aim in his letters and paintings was to place these people of New Orleans in relation to their rooms, their interiors. The resulting "architectural portraits," as one

might call them, are one of the many artistic possibilities he considered in New Orleans. *Children on a Doorstep, Woman Seated near a Balcony, The Song Rehearsal, A Cotton Office*—all these build up a profusion of architectural detail, as though one kind of "interior" could be made to suggest another.

An architectural detail shared by these New Orleans pictures, and particularly conspicuous in the *Cotton Office*, is the opened door or shutter along the left margin. Such frames within frames might serve as a private marker for Degas of his (and hence our) outsider status in this depicted world. These thresholds mark New Orleans as another world, adjacent to ours but preserving its mysteries, its ultimate difference. Similarly, the ubiquitous empty chair in these paintings, borrowed from Vermeer's interiors, marks a space that both invites and—since it is empty—excludes us.

A noteworthy achievement of the *Cotton Office* is how Degas has solved the problem of painting the outdoors of New Orleans without having to work outside. In *Children on a Doorstep* he situated himself so that he looked across the threshold, inside looking out. Some early watercolors from Italy, in which he painted views glimpsed from windows, used the same device. In the *Cotton Office* he finds at least four ways to bring the outdoors in. The illuminated window in the background, the last plane of the picture's recessions, lets in the dazzling light of New Orleans in mid-winter—"fiercely sunny," as an English visitor described it.[7] Likewise, the oppressive heat is signified by the shirtsleeves of the standing figure on the right, and by the wide-open windows.

Two other signs remind us of where we are. In almost all his New Orleans compositions, Degas includes local flowers and plants. Again we have the Englishman's testimony that in New Orleans "vegetation is endued with extraordinary force." In the two cotton paintings the plant is, of course, cotton itself—not quite local, since the closest large plantations were one hundred miles away, but certainly the plant on which the local economy depended.

Finally, the marine scene in the upper right corner—the

actual sea balancing the metaphorical "sea of cotton"—may also signify the ocean that separates Europe from New Orleans. As Degas wrote in the letter to Tissot describing the *Cotton Office*: "I should have been in London or Paris about the 15th of January," adding that "such a distance has become immaterial to me, no space must be regarded as great except the ocean."

The *Cotton Office* has inspired remarkably conflicting interpretations among art critics. Two of the most persuasive and influential "readings" of the painting, by Rudolf Arnheim and Carol Armstrong, seem in direct opposition. Arnheim finds in the painting an image of radical randomness, a depiction of the modern workplace as a site of "isolation and disorder" and illustrating "the atomization of society in an age of individualism."[8] Armstrong, on the contrary, sees in the painting a series of figures so similar in their "serial" appearance that they could all be poses of a single figure. She places particular emphasis on the paired or "echoed" heads of the men standing at the right and those seated and standing in the background.[9]

The paradox inherent in these conflicting views may be summed up in Degas's remark to George Moore: "One doesn't make a crowd with fifty figures, one makes a crowd with five."[10] Both Arnheim and Armstrong have accurately described the painting, for the *Cotton Office* has aspects of both the chaotic, atomized crowd *and* the controlled, friezelike design of repeated stances. With its carefully choreographed interaction of the seemingly random and the ceaselessly rehearsed, the painting suggests another art form altogether, the ballet.

The more we look at this painting, the more we have a dawning sense of a sort of performance in the making. Look, for example, at the luminous floor, pitched, almost *raked*, like a ballet stage. Here we can see what the poet

Paul Valéry meant when he praised Degas for his special genius in rendering floors. Degas, Valéry wrote, "is one of the very few painters who have given to the *floor* its true importance." By viewing a dancer from above, Valéry noted, Degas projected her form against the upward-tilting floor, "the way one sees a crab on the beach."[11] Just before his departure for New Orleans, Degas had made precisely this discovery in his first paintings of ballet rehearsals, paintings that were very much on his mind during his New Orleans sojourn.

Indeed, the early rehearsal paintings clearly affected the way Degas portrayed the cotton office and its inhabitants. The large office windows to the left, for example, look like mirrors for working at the barre (in the *Cotton Merchants* this wall *is* a mirror). The man on the far left, the most balletic of the figures, has assumed fourth position. The figures are grouped in the casual yet controlled configurations of a ballet rehearsal, while the seated man with the newspaper closely resembles some of Degas's portraits of ballet masters, positioned to inspect the "rats" (as the young dancers were called) at their routines. Even the ladder of shelves to the right, holding samples of cotton, has its counterpart in the scaled loges of Degas's ballet images. Like his best rehearsal paintings, the *Cotton Office,* despite its crowded subject, is surprisingly small, not much larger than the opened newspaper the seated man is holding.

What Degas has painted, in short, is a sort of *cotton ballet.* He has applied the techniques of painting ballet rehearsals—the wide, steeply sloping floor on which to deploy his "crablike" figures; the varied arm and leg positions of the dancers; the order amid apparent chaos—to this new scene. And what he learned in painting the *Cotton Office,* he applied in turn to his later ballet pictures, lucrative as bales of cotton, that he worked on immediately after his return to Paris. These paintings too have the raked floor and the seated white-haired master, positioned like the old man in

the foreground of *A Cotton Office* (his hands like pincers) or like the man reading the newspaper amid the commotion around him. As early as February 1874, Edmond de Goncourt found Degas working on ballet pictures, with a "ridiculous ballet-master serving as a vulgar foil" to the "graceful twisting and turning of the gestures of those little monkey-girls."[12]

But it was the Fogg painting of cotton merchants that turned out to be the most predictive of a new direction in Degas's painting. Indeed, the gap between the two cotton paintings represents precisely the two phases of Degas's dance paintings, as described by Theodore Reff:

> The nature of the change can easily be grasped by comparing . . . the rehearsal pictures of the mid-1870s with those of the later 1880s. The earlier ones, restrained and objective in appearance, show small figures in a large space, illuminated by a cool gray light falling from behind. . . . The later dance pictures seem, by contrast, more subjective in vision—and quite literally, in the sense that they encompass a narrower segment of the scene, viewed from a more specific position.[13]

What Degas discovered in painting the *Cotton Merchants* was a pregnant sense of spatial ambiguity that could evoke just the kind of subject matter that most interested him at this time.

"One must paint a painting as one commits a crime," Degas once remarked. Some of his greatest early paintings suggest crimes contemplated or regretted. His criminal world was not the low-life region of theft or open violence, as portrayed by Eugène Sue or Victor Hugo. He preferred the nervous, white-collar, modern kind of crime, illicit and on the sly. The bargain struck behind the curtain at the opera, behind closed doors in the brothel, on the steps of

the stock exchange—these were the transactions that fascinated him, and that he chose to paint during the 1870s.

The most astonishing thing about the Fogg *Cotton Merchants* is that it became the model, the template, so to speak, for a group of ballet paintings and pastels executed almost twenty years later. These are paintings in which spacious floors have given way to a cramped, almost two-dimensional sense of space, with dancers bunched in the wings and the performance itself a rather distant spectacle. In some of these pictures Degas placed a male figure in a top hat, an aristocratic patron preying on the "rats," and privileged to be welcome in the backstage world of dressing and undressing. This figure, often in silhouette, appeared repeatedly in Degas's work in the many monotype illustrations he produced, around 1878, for his friend Ludovic Halévy's insider's look at ballet life, the novel *La Famille Cardinal*. And Degas's double portrait of Halévy and his friend Albert Boulanger-Cavé, in the wings of the Paris Opera, borrows stances and spatial design from the Fogg *Cotton Merchants*; Boulanger-Cavé is cut off by the wing just as the figure is in the Fogg picture.

One reason Degas thought the *Cotton Merchants* was "better art" than the Pau painting may be that it captures the atmosphere of secrets transacted and overheard. The figure whose profile is cut off by an intervening wall—is he listening in? spying?—closely resembles the ballet patron sequestered behind the wings. If the Pau picture gives us a center-stage view of the cotton business, the Fogg picture makes us feel that we are backstage.

The most startling reprise of the *Cotton Merchants*, however, occurs in *Dancers, Pink and Green*, painted around 1890. Here, the precise scheme of the *Cotton Merchants* is used to powerful effect. Not only is the cut-off figure in profile similarly placed, but the red-haired dancer in the foreground leans forward, arms akimbo, in much the same position of the top-hatted figure in the *Cotton Merchants*.

Over both man and dancer another figure emerges over their right shoulder, a mirror image of their actions. And a pillar (a stage tree in the ballet composition) strengthens this vertical, double-headed figure. These parallels encourage us to look again at the two cotton paintings and to ask, this time, whether there is a comparable network of power and patronage, conspiracies and secret deals, at work in them.

2

So far, we have looked at the pictures with a more or less innocent eye, finding patterns and designs that require no special information about the sitters or the business firm depicted. But, as the anthropologist Claude Lévi-Strauss once remarked, "The painter is always mid-way between design and anecdote, and his genius consists in uniting internal and external knowledge."[14] A Cotton Office, as it happens, is packed with special meanings, both biographical and historical.

First, this is a family portrait. As such, it blurs the distinction between genre painting (typical figures in typical settings) and portraiture (likenesses of specific, identifiable people). A Cotton Office is one of the great depictions of modern business life, capturing the loose order of commercial transactions. But it is also a portrait of a specific group of prominent New Orleans businessmen, at a specific time in history. The varying titles Degas used for the painting—first calling it Interior of an Office of Cotton Buyers in New Orleans, then Portraits in an Office (New Orleans) before exhibiting it as A Cotton Office in New Orleans—betray his own uncertainty about whether he was painting a genre scene or a set of portraits. In fact, he was fusing the two genres.

The seated, bespectacled figure in the foreground is Degas's uncle Michel Musson, and this is his firm. Those spectacles, we remember, were the first thing Degas saw as he stepped down from the train in New Orleans. Musson is

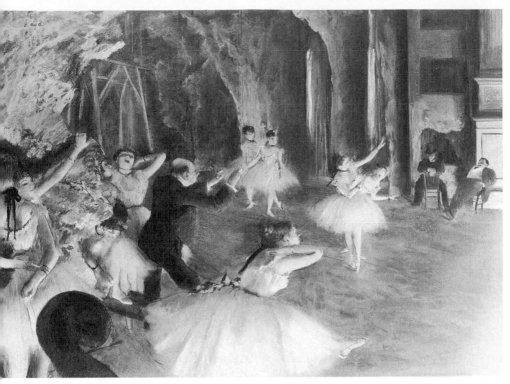

Degas, *The Rehearsal of the Ballet on the Stage*, c. 1874

Degas, *Dancers, Pink and Green*, c. 1890

dressed in mourning; the empty chair beside him may suggest, in addition to his own mortality, the recent death of his wife. His anomalous position, with his back turned to the activities of the firm as he idly fingers a sample of cotton, compounds the impression of isolation. Even as Degas worked on the painting, the Musson cotton firm (as Marilyn Brown discovered) had just collapsed; René De Gas, perusing the *Picayune* in the center of the painting, could be reading the bad news.[15] The complex and precarious choreography of the painting may allude to that fact.

Musson is surrounded by his nephews and sons-in-law. While René De Gas reads the paper, René's partner and brother Achille stands, with a dandy's casual attitude, to the far left. Musson's other son-in-law, William Bell, is seated on the table spread with cotton. In contrast to the busy scene, Musson's French nephews (this is not *their* firm) lounge about, doing nothing much. Musson's business partners, James Prestige and John Livaudais, are the two most prominent figures on the far right, one in white shirtsleeves, the other seated with a brown duster to protect his clothes from cotton fibers.

Several of the men in the picture are performing the specialized gestures of the cotton brokerage business: negotiating, bookkeeping, and so on. Musson himself is performing an action both specialized and technical, one for which a professional in a duster would normally be hired—like the melancholy man standing and staring behind the table. It is an activity as specific as the gestures of milliners and dancers to which Degas later gave such sustained attention, a gesture acquired by years of practice. Musson is testing a sample of cotton for such qualities as strength, resiliency, and texture; he is "classing" it, though he is hardly dressed for the part. In fact, he seems lost in thought, mechanically rehearsing the act of classing as he thinks of other things.

Through the gestures of the De Gas brothers, comfortable men at their ease, and of the men chatting around the table, Degas has given the office some of the casual *bon-*

homie of a café or bar, where reading a newspaper or just standing around is appropriate. But the more we look at the Musson figure, the more anomalous, puzzling and puzzled, he seems. His legs are chopped off by the lower edge of the frame, as though he is in danger of sliding out of the picture altogether—an apt image, perhaps, of the Creole loss of status after the Civil War. His top hat is surrounded and highlighted by cotton. His back is turned to the others—to the company, so to speak. Alone among them he seems to have no contact with anyone. He is literally "cut off."

But if things are going on behind Musson's back, he doesn't seem turned towards us either. In fact, he seems quite unaware of our presence. The empty chair beside him merely accentuates his isolation, suggesting that a conversation has ended and the chair's occupant has departed. Musson, as he is depicted here, is hardly the stern patriarch of the family or the *patron* of the firm. Instead, there is something almost maternal about the way Degas portrays him, hunched benevolently over his active fingers, like a woman knitting or appreciatively fingering fabric.[16]

And what of the other men in the picture? Do they conform to a "vision of America"—in Henri Loyrette's words about the picture—"as a faraway land of tranquil prosperity"?[17] I don't think so. The truncated body of Musson, the idle De Gas brothers, the grim-faced figure in the duster (who has the narrow olive countenance of Degas's early self-portraits), standing at the top of the table with another unoccupied man behind him—these begin to add up to a sense of superfluity, of waste. That beautifully painted waste-basket in the right foreground, balancing the empty chair to the left, strengthens the impression of futility.

Is it possible to see in this painting a picture of the "discouragement and despair" that visitors like Edward King discerned in the New Orleans business community in that troubled winter of 1872–73? "Ah! these faces, these faces; —expressing deeper pain, profounder discontent than were

caused by the iron fate of the few years of the war!"[18] Doesn't Degas's *Cotton Office* show us men unemployed, idly hanging around, staring, fingering cotton absentmindedly, one man looking with concern at the ledger, while another glances with disgust at the newspaper?

Edward King offered a local explanation for the crisis in New Orleans business: ". . . all the intense commercial ambition of New Orleans is neutralized by the incubus of a legislature which in no wise properly represents the people."[19] Later commentators have pointed to the worldwide depression that set in, like a killing frost, that winter of 1873, bringing down banks and businesses all over the Western world. But one of the many transformations brought about by the Civil War, as we have already noted, was that the cotton business itself was changing, and a casualty of this change was the cotton factor. Long the sole agent, banker, storekeeper, and confidant of the planter, the factor found himself after the war increasingly supplanted by small shopkeepers and other middlemen who set up their businesses closer to the old plantations, doing business with both the white planters and the black tenant farmers. The factors, seeing their once lucrative trade in jeopardy, blamed the usual suspects: the freed blacks (in the legislature and the countryside) and the small shopkeepers. Enough of the latter were from the North to make this seem like one more nasty result of occupation.

A few of these shopkeepers happened to be Jewish, giving rise to the widespread and much-exaggerated view, in New Orleans, that it was the Jews who had brought down the cotton business. Robert Somers, touring the South during 1870–71, reported acidly that "much of the storekeeping business is conducted by sharp, active young men of Jewish aspect" who had been "sent down by firms in New York and other large towns to sell goods at a profit of 100 to 200 per cent. to the more impoverished class of planters, and to advance money on cotton at the approach of the picking season at as much interest as they can extort."[20] In

the same vein, Olmsted wrote of the planters who, if their crop was bad, "must borrow money of the Jews in New Orleans."[21] And W. E. B. Du Bois claimed that "the rod of empire that passed from the hands of Southern gentlemen in 1865 . . . has passed to those men who have come to take charge of the industrial exploitation of the New South,— the sons of poor whites fired with a new thirst for wealth and power, thrifty and avaricious Yankees, shrewd and unscrupulous Jews."[22] Such widespread resentment of Jewish businessmen may well have fueled Degas's notorious anti-Semitism, which—except for the racial stereotyping in such behind-the-scenes pictures as his *Portraits at the Stock Exchange* (1878–79, Musée d'Orsay)—became virulent only during the Dreyfus affair twenty years later.[23]

One detail in Degas's painting suggests the lingering effects of the Civil War. The cut-off marine scene above the safe is one of the many popular depictions—Manet's at the Philadelphia Museum is the most famous—of the Civil War naval battle between the *Alabama* and the *Kearsarge*.[24] The juxtaposition of the battle scene and the safe suggests a link between the economy of New Orleans and the baleful results of the war. (Degas himself lost heavily on his investments in Confederate bonds.) Degas may also have known that some of the commercial rooms on Carondelet Street, like the one he depicted in his painting, were used as prisons for Confederate soldiers during the Civil War.[25]

During Degas's stay in New Orleans, the usual conspiratorial procedures of financial secrets and whispered deals were replaced, in certain cotton offices, by larger and more sinister designs. Several of the men Degas painted in the *Cotton Office*—Michel Musson and William Bell in particular, and probably René De Gas as well—were already taking part in a series of secret meetings of a whites-only organization that sought control of the Louisiana business and political world. Bell and Musson were leaders in the various terrorist disturbances and coup attempts that began a few weeks later, when Degas was still in town, and eventually

changed the course of Louisiana politics for a hundred years.

It is easy to think that the political engagement of Degas's models— Musson, Bell, and these other dispossessed Creoles—gives the *Cotton Office* its unsettling quality. Like the ballet pictures it resembles, the *Cotton Office* has its own somewhat sinister choreography. The men assume the various casual attitudes and gestures of their trade, along the raked floor and loge-like windows. But these future leaders of the Crescent City White League, co-conspirators as Degas must have known them to be, may indeed be rehearsing something—namely, the violence about to erupt around them.

10

Mardi Gras

The long green shutters are drawn.
Against what parades?
DONALD JUSTICE, *"Elsewheres"*

IN his restless pursuit of riches, René De Gas—cotton fac-
tor, wine merchant, commissions trader—had dabbled in
many schemes and scams, and travelled to many places,
but what profits did he hope to reap from *insect costumes*?
True, the people of New Orleans always appreciated a
clever disguise, especially around Mardi Gras time. But
why insects specifically? On his whirlwind tour of Europe
during the summer of 1872, when he established business
connections and drummed up support for the newly
founded New Orleans Cotton Exchange (since February he
had served on its Information Committee), René wrote his
wife, Estelle, that there was "a coup to be made in buying
the costumes in Paris. . . . They are all ravishing," he added,
"from the lady bug to the roach. They would be very pretty
for the procession"—the procession, René specified, "for
the Mystick Krewe of Comus." In the same letter, René an-

Tableau from the Comus ball, 1873

nounced that he had persuaded Edgar to accompany him back to America.[1]

New Orleans has always been a city of parades; its grand avenues seem empty without them. As early as 1871, Ralph Keeler, a visiting journalist from Boston, noted that Canal Street was about twice as wide as Broadway, and reported: "There is never a Sunday and scarcely a week-day in New Orleans, without a procession of some kind." He was astonished that there were "societies—one of them is called the 'Mystick Krewe of Comus'—whose sole object seems to be the production of costly pageants."[2] The Mardi Gras celebrations of 1873 were particularly ambitious, and expensive. But the aims of the secret krewe in 1873 went beyond mere entertainment, and served as a prelude for more sinister organized marches down Canal Street.

There were large resentments brewing in the house on Esplanade during Edgar Degas's visit, and they were to have far-reaching consequences for New Orleans and for the state of Louisiana. Two secret societies found safe haven among the Musson clan that winter of 1872 and 1873. In keeping with Degas's own impression of the city as Janus-faced, one secret society plotted festivity while the other plotted terrorism. Such was the social and political life of New Orleans during Reconstruction that the two conspiracies—the Mystick Krewe of Comus and the Crescent City White League—mixed methods, personnel, and locales.

Bad years tend to inspire good carnivals; the worse the times, the greater the need for escape and oblivion. Parades and pageantry flourished under the Reconstruction regime. "During these bewildering years immediately after the war," writes the historian John Brinckerhoff Jackson, "when countless institutions and relationships fell apart and vanished, there seems to have taken place in the South a resurgence of pageantry, of public festivities only re-

motely related to the past, a flourishing of community and ritual."[3]

Among such Southern pageants, Mardi Gras reigned supreme. The first Mardi Gras parade in New Orleans followed the depression year of 1837, when a group of "Americans" decided to show the locals how to put on a show. (A lasting feature of Mardi Gras in New Orleans is that, unlike the subversive traditions of European carnival, its leading celebrants tend to be establishment figures.) The annual Mardi Gras festivities were suspended by the occupying Union forces during the Civil War, and were slow to pick up after it. Resentment towards the lingering Federal troops was predictable; and a favorite costume was the carpetbagger. During the following years, nasty portrayals of Lincoln and Grant could be counted on, and the 1872 parade included "impersonators of the Ku Klux Klan on horseback." Despite such overt messages, Mardi Gras was as much a rest from politics as a continuation of it by other means. In 1867, though, a Federal official was murdered; he happened to be wearing a scarlet clown suit. Whether the offence was the costume or the political affiliation, the murder was a good excuse to curtail the celebration the following year.[4]

The worldwide depression of 1873, coupled with the tense political mood in New Orleans after the "stolen election" of the previous December, gave ample reason for misbehavior, and wide scope for the rowdy personage known as the Lord of Misrule. The theme of Mardi Gras that year was "The Missing Links to Darwin's Origin of Species." The need for animal costumes of all kinds prompted René De Gas's interest—as he sat with his brother Edgar at the Paris Opéra—in the insect costumes worn by dancers on the stage.

Planning had, as always in New Orleans, begun many months earlier. The Pickwick Club, an exclusive and secretive men's club limited to two hundred members, with a

clubhouse on Canal Street, was founded in 1857 with the specific purpose of putting on an annual Mardi Gras amusement, under the name "The Mystick Krewe of Comus." Each year its members agreed on a theme, had costumes made, and organized the event. Its membership rolls after the Civil War included the following names: René De Gas; William Bell; Bell's brother-in-law J. M. Witherspoon; Bell's business partner, Frederick Nash Ogden; Michel Musson's partner, James Prestige; and a neighbor of the Mussons—destined to play a depressing role in the Musson family—Léonce Olivier. Prestige, Witherspoon, and René De Gas marched in the parade of 1873—with Edgar Degas almost certainly in attendance.[5]

Political events in the city gave the "Missing Links" carnival of 1873 a special twist. It was to be assumed that the usual cast of Civil War villains would be lampooned at the baser rungs of the "descent of man," and so they were: Benjamin Butler, already relegated to the animal realm by his nickname, "Beast," was portrayed as a hyena, while the chainsmoker Grant—in René's insect section of the parade—assumed the guise of a tobacco grub. The contested election of 1872 added a fresh group of officials ripe for public humiliation. The Mardi Gras revelers, masked and unrecognizable, were fervent supporters of the renegade government of John McEnery, and were determined to make their views known.

It was the custom in New Orleans, since 1871, for all Mardi Gras revelers to gather at the Henry Clay statue at the foot of Canal Street late in the afternoon, and parade through the city until dark. The 1873 parade was made up of six divisions, and according to one estimate half the population of New Orleans participated in it. The first was the procession of Rex, headed by a huge red banner bearing the inscription MAKE WAY FOR THE KING!" "His majesty," according to the *Handbook of the Carnival* published the following year, "was robed in a brilliantly-hued Egyptian frock, sparkling

with jewels and fringed about with gold, while at its front he wore a golden breastplate, from whose burnished surface the sun reflected its rays with dazzling brightness." Federal troops, stationed in the barracks down the river from the French Quarter, escorted the King; they were disguised as "Arabian artillery and Egyptian spahis."[6] At the end of the first division the Boeuf Gras, a steer decked with apples and flowers, was led through the streets. A procession of "floats"—thus named because they were originally cotton floats from the Mississippi steamboats—depicted the "Seven Ages of Man." Another seventy-five carriages followed, filled with masked revelers. These made up the third division.[7]

A peculiar feature of Mardi Gras during the 1870s was the presence of advertisements in the parade; "Americans," quipped Edward King, "find it impossible to lay aside business utterly even on *Mardi-Gras*."[8] So the fifth division, led by the Lord High Sheriff of the Guilds, consisted of six thousand or so maskers carrying advertisements, signs, and banners inviting spectators to purchase such products as "Carter's Mucilage" and "Pelican Fertilizer." The last division of the parade, by far the longest, was a chaotic mass of masked pedestrians and vehicles—"every conceivable type . . . then invented"—led by the "Lord of the Unattached."[9]

The centerpiece of the 1873 carnival was the pageant presented by the Krewe of Comus on the evening of Mardi Gras, February 25, at the Varieties Theatre. When the Krewe left the theater afterwards to parade in the streets, there was considerable excitement, "as the spectators realized at once that the entire parade was political satire and an attack upon the federal administration, and that each of the 'missing links' represented a Republican official."[10] There were two floats, the rest of the Krewe marching on foot and wearing papier-mâché costumes with huge animal heads. Asses at the head of each group held aloft torch-lit

The Carnival—"White and Black join in its masquerading."

Costumed revelers around the Henry Clay statue,
by J. Wells Champney, 1873

signs bearing verses from a mock-heroic, satirical poem, in the vein of Alexander Pope, composed for the occasion, and lampooning the Republican regime.[11]

René De Gas's insect brigade made up the twelfth group in the parade, and its verses were particularly racy:

> Then insects come to cheer the flowery glade
> With tender dalliance 'neath the leafy shade.
> Bright buzzing *Flies* borne on the languid breeze,
> Keep time with *Locusts,* droning in the trees;
> *Grasshoppers* melt to lazy *Silk Worm* charms,
> The *Moth* seeks solace in the *Beetle's* arms;
> *Tobacco Grubs* essay the loftiest stalk,
> In love-sick search of the *Mosquito-Hawk* . . .

The underlying joke was miscegenation: promiscuous flies and grasshoppers dallied amorously with mates of other species. The Tobacco Grub was recognizably President Grant, on the "loftiest stalk." In the view of the maskers, the Grant regime was supporting the integrated government of the carpetbaggers, an arrangement that wits liked to refer to as "political miscegenation."[12]

The Comus parade that Mardi Gras night, illuminated by the calcium lights strung along Canal Street, was destined to be a short one. The Metropolitan police—essentially a Federal militia rather than a local police force—had agreed to escort the parade from the theater, and so they did, even after the marchers' hostile meaning became clear. But on Canal Street the revelers were met by a mob of angry men, some of them armed, who blocked the procession. The identity of these men remains elusive, although they were presumably supporters of the Republican administration. The parade broke up, without the customary march through the French Quarter. And that was the ragged end of the carnival of 1873.

One New Orleans newspaper, taking the revisionist view that the pageant had really been a satire on Darwin alone, sent the great man an editorial describing the parade, including a vigorous attack on the theory of evolution, and a souvenir booklet with the poem composed for the occasion. Darwin replied good-naturedly:

DEAR SIR:

As I suppose that Comus and the newspapers were sent in good faith, I thank you for your kindness and for your letter. The abusive article in the newspaper amused me more than Comus; I can't tell from the wonderful mistakes in the article whether the writer is witty, ignorant, or blunders for the sake of fun.

Yours faithfully,
CH. DARWIN[13]

But the armed men who blocked the Comus parade that year were hardly hot-headed defenders of the theory of evolution. Spectators detected the ugly edge to the festivities. Edward King, who watched the parade and the krewe's pageant, sharing his impressions with his friend and informant George Cable, observed that "the Americans masquerade grimly. There is but little of that wild luxuriance of fun in the streets of New Orleans which has made Italian cities so famous."[14]

If Mardi Gras had a grim aspect in 1873, however, it was merely a rehearsal for more sinister spectacles to follow. The volatile combination of barbed performance and armed men—and everyone in New Orleans carried firearms—was bound to explode sooner or later, with dire results. If history, as Karl Marx said, repeats itself, first as tragedy then as farce, New Orleans, in carnivalesque mode, reversed the order. The Mardi Gras of 1873 was a mere warm-up for another gathering at the Henry Clay monument and a dangerous march down Canal.

2

But first there was a peaceful interlude, like the soft promise of a New Orleans spring before the harsher realities of summer.

There had been several citizens' attempts to find a workable and peaceful alternative to the Republican "carpetbagger" regime, with its inflated taxes and financial stagnation. One of the most interesting was the "Unification Movement" of 1873, a coalition of New Orleans businessmen and well-to-do blacks who sought to build an interracial partnership around shared interests such as lower taxes and encouragement of black-owned businesses. Its supporters accepted integrated schools and public accommodations, and pledged protection of civil and political rights of blacks.[15] But Unification did not come out of nowhere, emerging full-blown from a sudden feeling of white generosity and black acceptance. Its seeds were planted over several decades.

The Civil War had given New Orleanians little to celebrate. Its early occupation by Federal troops deprived many of its citizens of the pride of having participated in the military drama of the war.[16] But the Civil War had taught Creoles and Americans an important lesson: it had shown them the advantages of cooperating against a shared enemy. Having learned to fight together, they used the years of Reconstruction to learn to conspire together. The pre-war division in white New Orleans was between French-speaking Creoles and English-speaking Americans. There was a corresponding split within the black community of New Orleans, between the Catholic and French-speaking free people of color and the slaves, many of whom were Protestant and anglophone. The post-war period brought a profound realignment. On one side were the ostensible victors: Republicans (some of whom were opportunistic "carpetbaggers" from the North), freed blacks, and a few

staunch New Orleans "Unionists." On the other side was the defeated majority: white Democrats, both Creole and Anglo-Saxon.

Caught between the two camps was the former caste of free people of color. Many of them had initially supported the Confederacy, either fighting in Confederate militias or making financial contributions. (Bernard Soulié, Norbert Soulié's brother, supposedly extended $10,000 in credit to the Confederacy—an investment more than a heartfelt gift, perhaps.)[17] After the war, these black "Creoles," many of whom were educated, wealthy, and socially prominent (and some of whom had, like the Soulié brothers, owned slaves themselves), were ambivalent about being grouped with the freed slaves.

A major strategy of Unification was to take advantage of this split in the New Orleans black community. The Unifiers' black support, as Eric Foner notes in his history of Reconstruction, "came largely from former free men of color who resented the carpetbaggers and believed 'unworthy' blacks had obtained office at the expense of more wealthy, intelligent and refined colored men."[18]

The ostensible aim of Unification was to "redeem" the state of Louisiana economically—"to save the People of Louisiana from being garrotted by the thieves and tyrants who now hold us by the throat," as the *Picayune*'s editorialist put it on June 25, 1873—and to show the Federal government that Louisiana could work out its racial conflicts peacefully. Whether its white leaders were visionaries or pragmatic cynics cannot be known with certainly at this late date; they were probably a combination of the two. Its black leaders, such as the brilliant physician and newspaper founder Dr. Louis Charles Roudanez, thought Unification offered some hope of reducing prejudice in the state.

The titular head of the Unifiers was the local Confederate hero General P. G. T. Beauregard, victor of Fort Sumter, whose primary interest in the movement was the possibil-

ity of winning black votes to the Democratic side.[19] The real draftsman of its ideas, however, was a prominent businessman and converted Jew called Isaac Marks. Unlike Beauregard, Marks was a genuine integrationist. Under his leadership, a "Committee of One Hundred," made up of half white and half black members, began meeting secretly during the spring of 1873, just after Mardi Gras. They signed a declaration of principles, which was published in the *Picayune* on June 17, 1873. Until that date the Unification membership had been a closely held secret.

Among the white signatories of the Unification manifesto —all of whom were well-known businessmen, doctors, and lawyers in the city—was Michel Musson. Among the blacks was Edmond Rillieux, Musson's first cousin. Edmond Rillieux, Norbert Rillieux's younger brother, was an extremely successful businessman and former slaveowner in the city. Rillieux served for a time as superintendent of the city water works, but he found his business prospects—as a builder and investor—more lucrative than public service.[20] For Michel Musson there must have been something uneasily literal about the idea of "Unification," as he looked across the room at his Rillieux cousin and plotted the joining of their business interests.

While Unification was extremely popular in New Orleans, where a relatively prosperous black middle class made interracial cooperation attractive to both sides, it failed to attract support in the rest of Louisiana. The failure of Unification opened the way for other, less peaceful "solutions."[21] It remained a failed dream in the South, an image of what might have been. As T. Harry Williams, the historian of the movement, concludes, "Here was a moment when possibly the record might have been changed, when another turn might have been taken."[22]

It was left to another member of the Rillieux family, the blind mulatto poet Victor Ernest Rillieux, to serve as elegist for the Unification Movement. A younger associate of the

black poets of *Les Cenelles,* Rillieux continued to write in French long after the war was over. Two decades after the downfall of Unification, as New Orleans—in the trial of Homer Plessy—became the scene of the official beginning of "separate but equal" Jim Crow laws, V. E. Rillieux wrote elegies for the two nominal leaders of the Unification movement: P. G. T. Beauregard and Aristide Mary. For the "Creole General" Beauregard, Rillieux had nothing but praise, punning on the general's name as he recorded his kindness towards veterans and widows (*"chez lui . . . on trouvait vraiment beau regard / Pour l'humble vétéran, pour la veuve soumise / Aux coups du dur destin . . ."*). Beauregard, the *"guerrier magnanime,"* was a *"Tendre époux, bon soldat et chevalier créole,"* whose name was sacred to all *"coeurs louisianais."* For Rillieux, Beauregard's support of Unification was proof of his "magnanimity."

Aristide Mary, the wealthy and talented former free man of color who was nearly nominated by the Republican Party for the governorship of Louisiana in the election of 1872, was the black leader of Unification, whose name headed the list of black signatories. Mary had decided to flee to France after the "redemption" of the state in 1877, when Louisiana endorsed the election of the Republican candidate Rutherford Hayes in exchange for an end to Reconstruction. But he stayed on, and was one of the sponsors of the streetcar protests that led to the Plessy case. Aristide Mary eventually put a pistol to his head and shot himself. Rillieux's poem is called "Une Larme" (A Tear). He praised Mary, who could easily have followed other free men of color to Europe, for staying in New Orleans during the hard years leading up to the Civil War and the difficult decades after it: *"Tu pouvais vivre en France / Riche, heureux entre tous; / Mais à la voix des tiens, courbés sous la souffrance / Tu revins parmi nous. / Patriote avant tout . . ."* "The voice of your own" has a certain ambiguity here, but at the end of the poem Rillieux is more specific, promising, *"Les pauvres, en grand nombre et ta race insoumise / Gardent ton souvenir!"* Brave words

for some of the darkest days for blacks in American history.

For V. E. Rillieux, both Beauregard and Mary were patriots, loyal to their true homeland, Creole Louisiana. In Rillieux's view, Mary, like Beauregard, was *"magnanime"*—a *"magnanime martyre"*—who had tried to bring about the great-souled dream of the Unification of blacks and whites in New Orleans. Now both men were dead, and so, Rillieux feared, was the dream, though his race remained *"insoumise,"* unsubjected.[23]

3

One of the ironies of New Orleans politics is that many of the supporters of Unification joined enthusiastically in the terrorist tactics of the New Orleans White League.[24] The irony is reduced if we remember that redemption and financial security, by one means or another, were the primary aims of such men; despite the equal rights rhetoric of Unification, the fate of blacks was probably of slim importance to them. One of these crossover businessmen was Michel Musson.

In the wake of Unification, the three men living at 372 Esplanade—Michel Musson, William Bell, and René De Gas—came under the charismatic sway of Frederick Nash Ogden, a colossal figure in Reconstruction New Orleans. Ogden was William Bell's close friend and business partner for almost ten years, from 1866 to 1875, in the firm of William A. Bell & Company. The firm did business in materials for bagging and tying bales of cotton—iron ties, rope, twine, and the like—and occupied various addresses along Union Street, in the major neighborhood of cotton factors and commission merchants. We can safely assume that Edgar Degas met Fred Ogden, as he frequented the workplaces of his brothers and uncle.[25]

Ogden was, from the start, a passionate foe of Unifica-

tion. According to one eyewitness and supporter, he was "the first man of prominence to raise his voice against this proposed Covenant with Hell, and those who remember him can readily picture in their minds his violent, explosive and convincing eloquence."[26] Ogden's striking physical presence—he was five feet eight inches tall, heavyset, with red curly hair and a ruddy complexion—compounded his rhetorical power.[27] He had made a name for himself as a young captain in the Louisiana campaigns of the war, and was taken prisoner after the fall of Vicksburg. One of Ogden's exploits as a cavalry officer, when he led a charge against superior forces, had so impressed George Washington Cable that he considered using it in his novel about the perfect Confederate soldier and gentleman, *The Cavalier.*[28]

Ogden, a direct descendent of a North Carolina governor and son of a Baton Rouge Creole woman, created the White League of New Orleans. According to one of its members, the name of the organization was a deliberate repudiation of Unification: ". . . in vehement protest against political miscegenation it was called the 'White League.'"[29] Others have suggested the name came from the reputed existence of carpetbagger-organized "Black Leagues."

The origins of the White League in New Orleans reach back to 1868 at least, when the secret Chalmette Club—and its spinoff, the Crescent City Democratic Club, of which Ogden was president—developed some ideas about a better way to rule the city and the state. The founding of the Crescent City White League was the culmination of a series of secret meetings held throughout 1873. The League was officially established—and made public—on July 1, 1874, with William Bell elected treasurer. The League published its positions in the local papers, especially in the sympathetic *Picayune*. It was useless, the League manifesto proclaimed, "to repeat the old story of brutal violence stalking at midnight in the draggled shroud of judicial authority [a

reference to the election of 1872], and under the execrable oligarchy of the most ignorant and profligate negroes, leagued with the most dangerous class of rapacious whites, the scum of society." The White League, trying to answer some of the aims of Unification, argued that blacks would in fact prosper under their paternalistic regime: "Where the white rules, the negro is peaceful and happy; where the black rules, the negro is starved and oppressed."[30]

Unlike the Unifiers, however, the White League had weapons to back its ideas. Early on, it had won the support of the First Louisiana Regiment, a military organization made up almost entirely of former Confederate soldiers, as well as a few draft-dodgers with something to prove, like Oscar Chopin, Kate Chopin's husband. During the summer of 1874, Oscar drilled with the regiment under the command of Colonel John G. Angell. Angell, a Confederate veteran and dentist, was a dramatic figure with a dark beard and an English accent. Oscar joined Company B of the regiment, its sixty men led by Captain Frank McGloin, a twenty-eight-year-old lawyer and former neighbor of the Chopins. McGloin, a poet and later a popular novelist, had published a racist poem in the *Picayune* of April 20, 1873, titled "The Origin of Man" (with the typo "May" in the newspaper); dated March 31, the poem was probably inspired by the Comus "Missing Links" pageant.[31]

In addition to the soldiers in the First Louisiana Regiment, the White League could also call upon its own members as a military apparatus. The White League regarded itself as a militia organized to defend the rightful government of the state—namely, the renegade administration of Governor McEnery. Colonel Frederick Ogden, soon promoted to General by McEnery, was officially in charge of all the military operations of the League.

Even before the formation of the White League, Frederick Ogden had led some terrorist forays to protest the elec-

tion results of 1872. Edgar Degas may well have been present for the "Battle of the Cabildo," on March 6, 1873, when a group of lightly armed men tried to seize the police station on Jackson Square. After chaotic skirmishes in the streets around the square and the Cathedral, a cannon was brought to bear on the insurgents, who quickly dispersed. On the insurgents' side, one man was killed by grapeshot and fourteen or fifteen wounded while two Metropolitan police were injured. The next day, while curious citizens noted that the trees in the square were "fairly riddled with bullets," the Metropolitan police used the abortive attack as a pretext to take possession of the alternative state government in Odd Fellows' Hall, including Governor McEnery's office.[32]

It was clear to the White League, whose members insisted on the Second Amendment guarantee of the right to bear arms, that more force was needed. A secret arms shipment from New York, destined for the League arsenal in New Orleans, brought matters to a head. The regime of Governor Kellogg got wind of the arrival of the steamer *Mississippi* and, backed by the Metropolitan police, vowed to prevent the unloading of its cargo. A mass meeting was called for the next day, September 14, 1874, at the Henry Clay monument. There, in the shadow of the "Great Compromiser," as George Cable quipped, "the people rally to hear the demagogues in days of political fever, and the tooth-paste orator in nights of financial hypertrophy."[33] The meeting was announced on long strips of paper posted along the curb at every intersection in the city.[34]

Frederick Ogden, in consultation with his closest aides, had already conceived a plan to attack the Metropolitan police, who had meanwhile formed a defensive line along the river. The meeting at the Clay monument had other purposes, to rally the support of the populace and perhaps inspire the Kellogg regime to step down. The meeting was a huge one, approximately five thousand white men, according to some estimates. A hush fell as a few well-dressed

White League rally at the Henry Clay statue, September 14, 1874

men emerged through the French doors of the Crescent Billiard Hall, across from the monument, and stood on the balcony above the crowd. Judge Marr proposed, from the balcony, that Michel Musson be the presiding officer of the occasion, and the proposal was carried by a roar from the crowd.[35]

The choice of Musson for this honorific position—probably through the joint influence of Ogden and Bell—shows how completely those old New Orleans antagonists, the "Americans" and the Creoles, had banded together after the war. Musson was in many ways the perfect embodiment of the Creole and "American" alliance. Though descended through both parents from Creole families, he had shown throughout his career a willingness to work with Americans in order to advance his own fortunes. Before the Civil War, he had chosen to live in the Garden District, the exclusive reserve of American families, and he had married off one daughter to a prominent American businessman, William Bell. He had used his childhood friendship with the Whig president Zachary Taylor to thrive in the postal service, and in both the cotton and insurance business he had American associates. As a further sign of his assimilationist tendencies, he sometimes signed his first name—when he moved in "American" circles—"Michael."[36]

From his position on the balcony Musson could see across the street the granite building (with its signs for "Moody's Shirts") that his father, Germain, had built at the corner of Royal Street and Canal. As he looked on, several speakers approached the podium, including three prominent doctors from the Orleans Infirmary, characterized by one historian as "the immortal Bruns; that marvel of nervous energy, Brickell; and sturdy Cornelius Beard." All of them called for Kellogg's abdication, and for all men between the ages of eighteen and forty-five to join Ogden's militia immediately.[37] Dr. Beard, especially, whipped up the passions of the crowd. "Go home!" he shouted. "Arm your-

selves and prepare to hold your city against Kellogg and his hirelings; to make it an armed camp and never leave it until the last one of them has been driven from its limits."[38]

A delegation headed by Dr. Samuel Choppin (the fourth partner of the Orleans Infirmary) was sent to Kellogg's office to demand his resignation. Choppin—the dashing president of the exclusive Boston Club, of which William Bell was secretary—had made a name for himself ten years earlier when he stood under the Henry Clay monument and called, in French, for Creoles to enlist in the Confederate Army, and led the assembled crowd in singing the *Marseillaise*. Duncan Kenner—finding himself again in the role of tardy dealmaker, just as he had during the last months of the Civil War—joined the meeting at City Hall in a vain effort to negotiate between the two parties, and stave off a violent confrontation. Kellogg refused to step down, and Ogden prepared to attack.

By ten in the morning of September 14, Oscar Chopin's Company B had already occupied the Crescent Billiard Hall, in preparation for the rally at eleven. As the speakers harangued the crowd around the Clay monument, armed White Leaguers began to occupy strategic points in the city. The side streets along Canal were barricaded by streetcars turned sideways; the huge slabs of cast iron used to cover the open sewers of the city were propped against the cars as armor plating. With its barricaded streets, New Orleans, as several witnesses noted, resembled Paris during the Commune.[39] As Dr. Samuel Choppin's committee went to secure Governor Kellogg's resignation, Company B had a similar mission, to demand that the New Orleans mayor, Louis Wiltz, surrender. When Wiltz refused, Frank McGloin sent eleven men into the building, positioning the rest of his men around the Clay statue, in preparation for the march down Canal and the inevitable clash with the Metropolitan police.

James Longstreet, the former Confederate General, was the state official in charge of preventing the unloading of the *Mississippi*. He had at his disposal about five hundred Metropolitan police, a hundred more armed police, and three thousand or so black militia. He was facing Ogden's forces of some 8,400 men. Longstreet's line, with its back to the river, stretched all the way from Jackson Square to Canal Street.[40]

The actual fighting did not begin until late in the afternoon and it did not last long. Ogden's men marched down Canal and neighboring streets, taking positions along the levee, where they hid behind cotton bales and sugar barrels. Then, shouting the high-pitched rebel yell of the Confederacy, they charged the Metropolitan police, who couldn't hold the line. The triumphant White Leaguers advanced to the river and seized the arms they were after. By the next morning, they held City Hall, the statehouse, and—the work of McGloin's Company B—the arsenal.[41]

Casualties were light under the circumstances. The Metropolitan police bore the brunt of the attack and suffered the most: eleven killed, of which six were white, and sixty wounded. The Ogden forces suffered twenty-one dead and nineteen wounded.[42] Ogden himself had his horse shot from under him, and was slightly wounded.

The White Leaguers' march down Canal from the Clay monument turned out to be as much of a public spectacle as Mardi Gras along the same route. Thousands of onlookers perched on roofs, balconies, and the upper windows of Canal, while others watched from boats on the river:

> A regatta of the Carrollton Rowing Club had been set for that afternoon, and many persons, refusing to believe that trouble impended, prepared to attend. In the early afternoon they went to Canal Street to take the river steamers which would convey them [up the river] to Carrollton. In Canal Street they discovered

the Metropolitans drawn up awaiting attack. The steamboats, crowded with men, women and children, lingered in the river until the conflict was over, in order that their throngs of passengers might enjoy the spectacle.[43]

The White League had triumphed, at least for the few days it took President Grant to order fresh Federal troops to the area and demand that the insurgents relinquish control of the city. Achille De Gas angrily wrote from Paris complaining of the *"tyrannie des radicaux"* in New Orleans, and—in a revealing confusion of Left and Right—compared Grant's suppression of the White League to the suppression of the Paris Commune. In its quixotic victory, the White League had made one thing clear, however. As Grace King, whose brother fought with the League, remarked: "The citizens submitted [to Federal authority] even cheerfully. They had proved their point; the carpet-bag government could be placed and kept in power by the United States soldiery, and in no other way whatever."[44] This demonstration of power was of paramount importance three years later, when the Compromise of 1877 brought about the restoration of "home rule," and Reconstruction in Louisiana came to an official end.

4

Meanwhile, René De Gas was making the rounds again, collecting money—not for himself this time, but for a worthy cause. The insect outfits had served their purpose, and a more costly piece of costuming was in order. The Musson household had shown great enthusiasm for General Ogden's cause: Michel Musson, William Bell, and René himself had served in the League, and Mathilde Bell joined in relief efforts for the families of the dead and wounded.[45] Now it was time to honor Ogden's achievement.

But Ogden, who saw himself as a soldier in the Cincinnatus mold, refused public employment as a reward for his service. He turned down a request that he stand for sheriff—Michel Musson signed the public letter asking that he accept the nomination.[46] Only a more symbolic honor would be appropriate, and it is recorded in a newspaper clipping—its source unidentified—that Ogden pasted in his personal scrapbook:

At a special meeting of the Washington White League [a division of the New Orleans White League], held on Friday, Sept, 23rd, 1874, the following preamble and resolutions, offered by R. De Gas, were unanimously adopted:

Whereas, The heroic conduct of Gen. F. N. Ogden, during our late revolution, has aroused in every heart feelings of gratitude and admiration, and

Whereas, It belongs to his soldiers to show their appreciation of his valor and devotion to the people's cause,

Be it Resolved, That a sword of honor be presented to him in the name of the officers and men under his command.

Resolved, That a committee of five be appointed to raise the necessary funds by subscription among the White Leagues of this city.

In conformity with the above, the following committee was appointed:

R. DE GAS, *Chairman*
[and four other names]

René evidently raised the "necessary funds"—$1,100, to be exact—for the sword, with its scabbard "of solid silver and the top of the handle surmounted with a superb amethyst."[47] After Ogden's death, his widow presented the sword to the Louisiana State Museum in New Orleans, where it remains today.

PART THREE

11

Grandissimes

—New Orleans.
> *A courtesan, not old and yet no longer young, who*
> *shuns the sunlight that the illusion of her former glory be*
> *preserved. The mirrors in her house are dim and the frames*
> *are tarnished; all her house is dim and beautiful with age.*
> *She reclines gracefully upon a dull brocaded chaise-longue.*

WILLIAM FAULKNER, *"New Orleans" (1925)*

JOHN Dickson Bruns, New Orleans doctor of medicine and former Charleston man of letters, had bailed out of the Unification Movement in a hurry, choosing, so to speak, division instead. He had signed on, with Michel Musson and the rest, as one of the original "Committee of One Hundred," but by July of 1874, as the White League came out of secrecy, Bruns wrote angrily to a friend:

> Last summer one hundred of us, representing fairly *all* the grades of public and social status, humbled ourselves into the dust in an effort to secure the cooperation of the colored race in a last attempt to secure good government, and failed. . . . To this complexion it has come at last. The niggers shall not rule over us.[1]

The play on the word "complexion" is typical of Bruns's barbed wit.

197

A former surgeon in the Confederate Army, Bruns had been a close friend since childhood of the poet Henry Timrod, author of the famous "Ethnogenesis" (or "Birth of a Nation"), proclaiming the founding of the Confederacy in February 1861:

> Hath not the morning dawned with added light?
> And will not evening call another star
> Out of the infinite regions of the night,
> To mark this day in Heaven? At last, we are
> A nation among nations; and the world
> Shall soon behold in many a distant port
> Another Flag unfurled!

After Bruns's "emigration to the west" (as Timrod called his friend's post-war move to New Orleans), Bruns retained close ties to literary Charleston, sending frequent book reviews to the Charleston *Courier*. After Timrod's early death, Bruns was called upon to deliver a memorial lecture in Charleston in 1870; his "Lecture on Timrod" remains one of the best assessments of that neglected poet's achievement.

As the White League began to mobilize its forces during the summer of 1876, Bruns's literary talents were immediately put to good use. If Timrod was known as the "poet laureate of the Confederacy," Bruns became, in effect, the laureate of the White League, drafting official statements and propaganda for the newspapers, speaking at the rally beside the Henry Clay statue, and delivering the Address at the first anniversary ceremony in September 1875.

Bruns's 1875 address to the White League, like the century-old Declaration of Independence from which it took much of its rhetoric, is an eloquently elaborated fantasy of the white man as victim. The white citizens of Louisiana, according to Bruns, had borne humiliation and crime for so long, and so virtuously, that they could stand no more abuse without surrendering their manhood. The democratically elected government of 1872 had been refused its rightful seat; the citizenry was as a result taxed without

representation; black leagues and militias were drilling in the streets; and the constitutional right to bear arms had been denied to whites. There was nothing for General Frederick Nash Ogden's well-regulated militia to do, Bruns concluded, but to seize the arms that were rightfully theirs and, in honorable self-defense, attack the "usurping" blacks and Northern carpetbaggers. Bruns spares not a word, in a dozen closely written pages, for the humiliations inflicted for more than two hundred years on blacks.

Dr. Bruns was a member of General Ogden's inner circle, and in his medical capacity served as the official surgeon general of the White League. His three colleagues of the Orleans Infirmary, all famous in their time, were also leaders of the League: the dashing surgeon Samuel Choppin, the oculist Cornelius Beard, and the gynecologist Warren Brickell. Like Bruns, Beard and Choppin had signed the Unification manifesto, only to regret it later.

New Orleans literary circles were neither wide nor deep, and it was perhaps inevitable that Bruns would come to know George Washington Cable, a promising younger writer who had solid connections with New Orleans newspapers and cotton offices. They first met through Bruns's medical practice; as early as 1871 Dr. Bruns was treating Cable's invalid wife. Their acquaintance deepened through the 1870s, even as Bruns was moving from Unification principles to the stronger medicine of the White League.

Cable, for his part, made no secret of his distaste for the White League, or of his support for civil rights for blacks. The illustrator J. Wells Champney—who had accompanied Edward King on his trip to New Orleans in late 1872, when King "discovered" Cable—consoled Cable on November 16, 1874, just after the Battle of Liberty Place: "My sympathies are with you in your political sufferings; I sincerely wish you a satisfactory and speedy solution to your miseries."[2] And Cable published a strongly worded letter to the New Orleans *Bulletin,* on September 26, 1875, defending the integrated public schools of New Orleans.

But the friendship of Cable and Bruns weathered their political differences. It was Bruns who, after the success of Cable's book of stories *Old Creole Days,* urged his friend to try his hand at a novel. More than twenty years later, Cable remembered the encouragement of his "sanguine friend." "I can still hear him calling down the stairway from the door of his office: 'Begin it! Never mind how it's to come out; you have abundant invention; trust to that.'"[3] "To be emboldened by his compliments was easy," Cable added, "for he was a distinguished physician, of high literary attainments, and had been the friend of . . . Timrod." Cable deflected suspicions that Bruns might appear in fictional guise in his writings. "I never put more than a hint or two of him into any fictional character," he insisted, while conceding that Bruns's partner and fellow White Leaguer Dr. Brickell, "a man of more picturesque idiosyncrasies," had served as the model for Dr. Sevier, the kindly, eponymous hero of Cable's second novel.

John Dickson Bruns was Cable's closest literary friend and mentor, and oversaw the composition of each section of *The Grandissimes,* offering detailed advice, stylistic and thematic, along the way. Dr. Bruns died in 1883, a couple of years after the publication of Cable's novel. "Death early took from me the generous prompter of my stimulating delusion," Cable wrote. The partnership of Cable and Bruns may come as a surprise to Cable's Northern admirers, who have considered him a liberal, even a progressive voice in Louisiana culture. But if we can understand how a man like Bruns could love *The Grandissimes,* and the role he played in its genesis, we may come a bit closer to the true heart—and art—of the book.

From the time of its publication in 1880, *The Grandissimes* has been widely recognized as one of the greatest of all American novels, with such able critics as Edmund Wilson and Newton Arvin defending its merits. And yet the novel is perennially in danger of being forgotten. Its neglect can

be attributed to several impediments. First, Cable made heavy use of dialect in his Creole speakers, some of it quite difficult to decipher. In Cable's parlance, "pigshoe" is picture, "Hev'ryt'in'" is "Everything," and "'E godd his 'ead strigue" means he was struck in the head. Such language distances Cable's characters from us, even as it contributes to the impression that the novel is merely a patch of local color. Second, Cable's women characters—his white ones, that is; his black women are another story—are in the hackneyed romance tradition. William Dean Howells thought them delightful; to modern readers they are likely to seem a bit insipid. Third, the narrative is of an extraordinary complexity, the interwoven strands of which require a second or third reading to grasp entirely. Add to these difficulties the sheer amount of Louisiana history that Cable includes—from the early exploration of the wilderness, to details of the Louisiana Purchase and the ensuing disputes over land titles—and the result is more challenging than the average reader may have bargained for.

There is another, more pervasive difficulty. *The Grandissimes* is an elaborate portrait of New Orleans during the year immediately following the Louisiana Purchase of 1803, with a rich cast of characters related by ties of blood across racial lines. But the novel is also, as Cable freely admitted, an allegory of Reconstruction, a carefully coded portrait of New Orleans during the 1870s. Cable's editors at *Scribner's* had no idea, Cable remarked later, "that the work I should by and by send them was going to have a political character. But that was now [in 1878] well nigh inevitable. It was impossible that a novel written by me then should escape being a study of the fierce struggle going on around me, regarded in the light of that past history—those beginnings—which had so differentiated the Louisiana civilization from the American scheme of public society."[4]

The fierce struggle Cable referred to was the antagonism between the only factions he really cared about—namely, the moderate ideas put forward during the Unification

movement, and the divisive and violent ideology of the White League. As for the regime of Northern carpetbaggers and Southern freedmen, Cable dismissed it out of hand: "As far as I knew I had not a friend on earth in the Republican party. I sought none. Yet I lacked not friends," the former clerk in cotton firms remembered. "There was scarcely a dozen prominent merchants and financiers in New Orleans with whom I was not at least cordially acquainted."[5] These merchants hold center stage in *The Grandissimes,* just as they did in the battles over Unification. And it was in large part to persuade such close friends as John Dickson Bruns that they had taken a wrong turn, into the terrorism of the White League, that Cable wrote his first and greatest novel.

Despite its byzantine elaborations, the central plot of *The Grandissimes* is relatively simple. "It was to be little more than the very old and familiar one of a feud between two families," Cable remarked ten years later, "the course of true love fretting its way through, and the titles of hero and heroine open to competition between a man and his friend for the one and a mother and daughter for the other. Upon this well-used skeleton," Cable concluded, "I essayed to put the flesh and blood, the form and bloom, of personalities new to the world of fiction."[6] The last phrase is crucial. In the best traditions of literary realism, Cable was making room at the table for characters never before seen in novels.

Cable placed a young immigrant from the North, the pharmacist Joseph Frowenfeld, as a participant-observer at the center of things, a sort of detective for the intricate and mysterious world of New Orleans circa 1803. Frowenfeld must decode the "hybrid city," as Cable calls it, made up of Creoles and "Americans," slaves and free people of color, scoundrels and saints. The "course of true love" must triumph over the traditional enmities of the city; Cable's heroes are those who, like Frowenfeld and his good friend Honoré Grandissime, can see beyond inherited hatred.

202

The Romeo and Juliet of Cable's novel are Honoré himself, the Creole head of the Grandissime business empire, and Aurora Nancanou, a beautiful young Creole widow. Honoré lives in sumptuous splendor in the Grandissime mansion on Esplanade, with its "round, white-plastered brick pillars which held the house fifteen feet up from the reeking ground; . . . the lofty halls, with their multitudinous glitter of gilded brass and twinkle of sweet-smelling wax-candles; the immense encircling veranda, where twenty Creole girls might walk abreast." Aurora Nancanou, by contrast, rents a tiny apartment on Royal Street. They first meet at a masked ball only to find, on unmasking, "that he was a Montague to her Capulet." The family feud began a few years earlier when Honoré's uncle, the fiery old Agricola Fusilier, killed Aurora's husband in a duel over a gambling debt, and assumed title to the Nancanou fortune in the bargain.

If hate, expressed in the ancient New Orleans ritual of the duel, is one engine of the plot, illicit love—New Orleans fashion—is another. When the penniless Aurora and her daughter Clotilde arrive in the city, they find that their landlord is Honoré Grandissime. The man who goes by that name, however, hardly resembles the handsome man at the ball. It turns out—and Cable extracts much narrative confusion from the fact—that there are *two* Honorés: the white businessman who loves Aurora, and his half-brother, the darker-skinned Honoré Grandissime, free man of color (or f.m.c.). The latter is described as "the most remarkable figure . . . in this little city of strange people:"

A strong, clear, olive complexion; features that were faultless (unless a woman-like delicacy, that was yet not effeminate, was a fault); hair *en queue*, the handsomer for its premature streakings of gray; a tall, well knit form, attired in cloth, linen and leather of the utmost fineness; manners Castilian, with a gravity almost

oriental,—made him one of those rare masculine fig-
ures which, on the public promenade, men look back
at and ladies inquire about.

While the half-brothers are sons of the same white fa-
ther, the darker Honoré's mother was one of those tragic
quadroon concubines of old New Orleans, deserted when
her mate and patron married a white woman. The f.m.c.
Honoré is educated in Paris, like his white half-brother, and
on his return to New Orleans becomes a wealthy landlord.

The complicated weave of Cable's plot doubles events in
the white world with corresponding complications among
his black characters. As the white Honoré falls in love with
Aurora, the f.m.c. pines for the beautiful Palmyre, a former
slave companion of Aurora and a voodoo priestess (mod-
elled on the legends surrounding Marie Laveau, queen of
New Orleans voodoo). But Palmyre, alas, only has eyes for
the *other*, the white Honoré. Frowenfeld, meanwhile, falls
in love with Clotilde, Aurora's daughter; his rival in love is
Dr. Keene, who nurses him back to health after an attack of
yellow fever, and nurses Honoré f.m.c. when he is, literally,
dying of love for Palmyre.

So much for the erotic web of the novel. At the center of
this interlocking set of relationships—and it is one of his
most daring narrative decisions—Cable places the story of
Bras-Coupé, a noble African chieftain who is brought to
America, sold for a high price to the Grandissimes, and then
refuses to do slave labor. Finally, Bras-Coupé agrees to
work as overseer if in return he can have the hand of
Palmyre, whom he loves. Palmyre agrees to go along with
the arrangement, meanwhile—for while she admires, al-
most worships, Bras-Coupé, she does not love him—plan-
ning an escape route. Bras-Coupé, enraged by the
deception and wild with drink, strikes his master and re-
ceives the punishment decreed by the old Code Noir or
Black Code. He is hamstrung and shorn of his ears; it is
Agricola, the duellist, who performs the punishment. Bras-

Coupé returns to the plantation a proud but broken man, and Palmyre watches over him till he dies of a broken heart.

The story of Bras-Coupé was actually one of the first pieces of fiction Cable wrote. It was deemed too violent and grim for *Scribner's* readers when Cable first sent it to Edward King in 1873. But in the center of *The Grandissimes,* where it is told (another of Cable's narrative risks) by four different speakers, the story provides a powerful counterweight for the romances that swirl around it. Though an obvious emblem of the horrors of slavery, "turning into flesh and blood," as Cable remarks in the novel, "the truth that all slavery is maiming," the story of Bras-Coupé is sufficiently ambiguous in its twists and turns—with Palmyre's guilt, for example, and Bras-Coupé's drunkenness—that the Grandissime cousins, with no particular sympathy for blacks, love to tell the story to one another as they lounge on their Esplanade veranda.

As for the rest of the plot, a few strands will have to suffice. New Orleans, as Cable sees it, is a city always on the verge of violence. The American occupation of the city, under the forces of Governor Claiborne, makes the Creoles uneasy. Honoré Grandissime believes that cooperation with the American "usurpers" is the only way for the Creoles to survive. Agricola represents the opposite faction, and carries most of the Grandissime clan with him. Honoré makes a series of decisions that enrage the Creoles, but confirm that he embodies, as his name suggests, the true concept of "honor," as opposed to the mishmash of machismo and bigotry that goes by that name in Agricola's circle. He befriends the "American" invaders Claiborne and Frowenfeld; he returns the Nancanou land and fortune to the rightful owner, Aurora, thus bankrupting the Grandissime firm. To make up for his loss, he sets up a business partnership with none other than his own wealthy half-brother, the pariah f.m.c. Honoré, under the name Grandissime Brothers. Thus, the

divided Grandissime house is once again united, to the horror of Agricola and his henchmen.

Meanwhile, Palmyre is carrying on her own private war against Agricola for his treatment of Bras-Coupé. Dressed as a man, she attacks him in the street at night, and sends the slave-woman Clemence to place voodoo charms around his house. The Creoles respond, trashing Frowenfeld's pharmacy and the f.m.c.'s house, and—in the most horrifying scene in the novel—ensnaring Clemence in a bear-trap. Clemence has served in the past as nurse to many of the Grandissime children, and a few of them, now grown women, plead for her freedom. The Grandissime men release Clemence and tell her to run for her life: "It was so funny to see her scuttling and tripping and stumbling." Then they calmly shoot her in the back.

The allegorical components of this extraordinary novel are clear enough. In the white Honoré Grandissime and his rival Agricola, Cable found vivid representatives for the Unification Movement and the White League. Everything Honoré says and does marks him as a "unifier," and his partnership with his African-American half-brother is precisely the sort of business cooperation planned by the Unification signatories. (Cable surely knew that the Unification Movement included such real-life members of the same family, divided by race, as Edmond Rillieux and Michel Musson.) Agricola, by contrast, acknowledges only one unity among the people of New Orleans. "H-my young friend," he informs Frowenfeld, "when we say 'we people,' we *always* mean we white people." His explanation is a fair representation of prevailing white opinion in New Orleans:

> The non-mention of color always implies pure white; and whatever is not pure white is to all intents and purposes pure black. When I say the "whole community," I mean the whole white portion; when I speak of the "undivided public sentiment," I mean the senti-

ment of the white population. What else could I mean? Could you suppose, sir, the expression which you may have heard me use—"my down-trodden country" includes blacks and mulattoes?

In the face of such views, Cable's portrayal of the free people of color of New Orleans is particularly heartfelt. He implicitly compared their antebellum fate under Governor Claiborne, when they were technically free but denied many rights of full citizenship, to the plight of the freedmen under Reconstruction. He makes Frowenfeld his spokesman: "It seems to me," the pharmacist tells the f.m.c., "that you—your class—the free quadroons—are the saddest slaves of all." His analysis is devastating:

> Your men, for a little property, and your women, for a little amorous attention, let themselves be shorn even of the virtue of discontent, and for a paltry bait of sham freedom have consented to endure a tyrannous contumely which flattens them into the dirt like grass under a slab. I would rather be a runaway in the swamps than content myself with such a freedom.

But if Cable's sympathy with blacks in his novel is patent, and his rejection of the terrorist methods of Agricola explicit—"Shoot the black devils without mercy!" Cable noted drily, was "the whole Creole treatment of race troubles"— how could a White League ideologue like Dickson Bruns admire the novel and find nothing in it, beyond a few details of phrasing, to object to? How could Bruns miss the meaning of Cable's insistence on "the double damage of all oppression"—to both the victim and his oppressor?

First of all, Bruns would have agreed with Cable's view, so stated in *The Grandissimes*, that Louisianians must find their own solutions, without meddling from "Americans" or other Yankee outsiders. As the white Honoré puts it, "I would *compel* this people to govern themselves." Second, Bruns and many of the White Leaguers made a clear dis-

tinction between the former free people of color on the one hand, many of them educated, civilized in their comportment and French-speaking, and the freed slaves on the other. It was with former free blacks—like the Roudanez brothers, Aristide Mary, Edmond Rillieux, and the rest— that the Unification pact (which Bruns had signed) was drawn up. By placing at the center of his narrative such "almost white" characters as the darker Honoré and Palmyre, and making Bras-Coupé an exceptional slave in every way—the very type of the "noble savage"—Cable made it easy for such readers as Dr. Bruns to forget the reality of slavery and the degradation of the freed slaves after the war.

As the installments of the novel began to appear in *Scribner's* in November, 1879, Cable asked Bruns to read over the opening sections with "a cricket's eye"—critically, that is—and Bruns dutifully sent Cable a letter following the appearance of each number.[7] Bruns was particularly enthusiastic about the Bras-Coupé material, writing Cable in March 1880: "I read the brilliant episode of Bras-Coupé last night with intense pleasure. I have not a word of criticism except for one little preposition too much." Bruns pointed out that having dormer windows look "to westward" was tautological, since westward means "to-ward the west." Cable removed the word "westward" in his beautiful description of Bras-Coupé's first view of the city, with its "little forts that showed their whitewashed teeth" and the "round-topped dormer windows and a breezy belvedere looking out upon the plantations of coffee and indigo beyond the town."

On one occasion, however, Bruns's advice went far beyond the merely stylistic. Cable had evidently asked for—or Bruns had volunteered—"professional" guidance of a medical kind for a key moment in the book, when the white Honoré and Dr. Keene pay a call on Honoré f.m.c. The dark Honoré's house has recently been violated by the Agricola

faction, and his love for Palmyre has been rejected. He languishes, alienated and unwell, in his "closed and darkened" drawing-rooms.

The possibilities of the scene seem to have touched Bruns profoundly. The Charleston man of letters produced an extraordinary document, which has lain, unread and perhaps undeciphered, among Cable's papers in the Tulane University Library. What Bruns wrote is essentially a draft of the scene that Cable eventually placed in his fifty-second chapter, giving it the title "Love Lies A-Bleeding." Here is the opening of Bruns's manuscript:

> When the Doctor was called in to see our friend, the F.M.C., he found him on a lounge. Tho a polite man he did not rise, but stretched out his hand languidly, & rather motioned with his head to a chair than invited the M.D. to take a seat. The MD did so however noting mentally as he shook the invalid's hand that it was pale, cool, moist, & that the nails were lightly *bluish*. He was emaciated, with dark rings under the eyes, & the bluish tinge of the inner lip—natural to the mulatto. . . . He lay on his back, with one knee drawn up & the hand hanging laxly over the back of the sofa. . . . [The Doctor] managed undetected to feel the pulse [which] was frequent, *irregular*, weak, (gaseous is the scientific term) with an occasional intermission.

Bruns proceeded to feel his way, with eerie objectivity, into the f.m.c.'s body and mind. He devoted several paragraphs to more symptoms of the lovelorn: the f.m.c.'s preference for newspapers over books ("the short paragraphs did not fatigue him"); his irregular eating habits (resulting in "flatulence" and "diarrhea attended with cramps"); his occasional consumption of whisky ("that accounted for his eyes which were dirty yellow, & for the pasty tongue, which was covered with a thick white film"); his avoidance of exercise ("Did he walk? No! or ride? no!"), and his consequent sleeping problems. Dr. Bruns was particularly at-

tentive to the f.m.c.'s insomnia. He "had no desire to take exercise, felt *tired* always, so tired that frequently he could not sleep, would keep turning from side to side, often dragged his mattress out on the balcony & lay there or on the floor, or tried different beds about the house, & always got up in the morning languid, & with that undefined sense of having had bad dreams that he did not understand . . ."

Bruns's diagnosis was that the f.m.c. suffered from "an irritable heart," with a slight murmur "that was not *organic*" (hence, apparently psychological). "What must he do" then? Bruns's prescription, aside from sleeping on the right side or back: "Why he must get up & get out of there—he must ride—horseback or carriage, get a boat . . . eat his meals at regular hours . . ." The doctor would "send him a chalybeate tonic." "If he were a French Doctor," Bruns added jokingly, "this must all be accompanied with much grimace etc etc which you so well understand."

Cable must have been impressed by Bruns's expertise and eloquence, for he incorporated into *The Grandissimes* much of Bruns's document, more or less verbatim, including the diagnosis and prescription for the free man of color's malaise. "There is . . . no incurable organic derangement," Cable's Dr. Keene remarks, just "a little heart trouble easily removed," concluding that "there is absolutely nothing the matter with him but his unrequited love." Keene prescribes the "chalybeate tonic" (an iron solution, presumably for loose bowels) mentioned in Bruns's document and recommends—again *pace* Bruns—that he "get up and get out."

Cable carefully placed the f.m.c. in his "sumptuously furnished" rooms, whose luxurious decor is as expressive of its inhabitant as a courtesan's bedroom: "motionless richness of upholstery, much silent twinkle of pendulous crystal, a soft semi-obscurity—such were the characteristics." Like Bruns, Cable gave particular and loving attention to the f.m.c.'s sleeping arrangements, and returned again and again to his bed:

They entered, and the figure of Honoré Grandissime, f.m.c., came into view in the centre of the farther room, reclining in an attitude of extreme languor on a low couch, whither he had come from the high bed near by, as the impression of his form among its pillows showed. He turned upon the visitors his slow, melancholy eyes, and, without an attempt to rise or speak, indicated, by a feeble motion of the hand, an invitation to be seated.

All this is drawn from Bruns, but given an even more sensual finish. The doctor takes the black man's "limp and bloodless hand, which had not responded to the doctor's friendly pressure but sank idly back upon the edge of the couch"; it was "cool and moist, and its nails slightly blue." "'Lie still,' said the doctor, reassuringly, as the rentier began to lift the one knee and slippered foot which was drawn up on the couch and the hand which hung out of sight across a large, linen-covered cushion."

The mood of the passage is more like Manet's *Olympia* than one might expect from a doctor's house-call. For Cable and Bruns, the somewhat effeminate figure of the f.m.c. assumes the classic position of repose, his languid and sensual body stretched out upon a chaise longue, in which artists— from David and Goya to Manet—had traditionally depicted the courtesan.

It is the mulatto's *body* that Bruns took it upon himself to invent, out of his own medical experience with blacks, and from his own rich fund of imagination and fantasy. Cable may well have wanted Bruns to feel his way into Dr. Keene's role, a fringe character in the novel who, while straddling factions, is clearly closer to Agricola's bigotry than to the white Honoré's magnanimity. Instead, it was the sensuality, the "languor" of the uncanny f.m.c. that captivated Bruns—and captivated Cable as well. The doctor and eloquent spokesman for the White League gave Cable

permission, so to speak, to evoke this mysterious and exotic man's body, just before sending him to die, for love, in the Seine.[8]

It is fascinating to be privy while Cable and Bruns—each encouraging the other—together invent this new figure in American literature, the "tragic mulatto." A boundary figure, the f.m.c. uncannily blurs the distinctions between black and white, female and male, French and American. Both murderer and suicide, he even stands at the border of life and death. The hapless trajectory of the dark Honoré is the first of many such portrayals in American fiction of the tragic man of mixed race. Cable's characterization of the dark Honoré as an androgynous figure of languid and perhaps homoerotic sensuality passed more or less directly to Cable's friend Mark Twain, in his portrayal of Tom in *Puddn'head Wilson*, through James Weldon Johnson's "ex-colored man," and on to Faulkner's effeminate and "oriental" Charles Bon in *Absalom, Absalom!* (We should not be surprised to find Bon, a New Orleans mulatto, "reclining in a flowered, almost feminised gown, in a sunny window in his chambers—this man handsome elegant and even catlike . . ."). Cable could truthfully say of his own Honoré f.m.c. that such a figure was indeed "new to the world of fiction."

At the moment when "unification" is achieved in *The Grandissimes* by the white Honoré's "public recognition of kinship" with this dark half-brother, Cable mentions the white world's shock "that the uncircumcised and unclean— even an f.m.c.—was about to be inducted into the Grandissime priesthood." It is a revealing analogy, if we modify the equation. Almost white, almost free, "oriental" and effeminate, at once wealthy and a social pariah, the free man of color in his literary depictions occupies much the same place as the Jew in literary Europe. (The first article of the eighteenth-century "Code Noir," or Black Code, demanded the expulsion of the Jews from New Orleans.) Jews and free men of color were difficult to detect; they often *looked*

like white citizens, and passed for such. It was against the radical "otherness" of Jews and free people of color that proper Englishmen and proper Louisiana Creoles respectively sought to define their own uneasy identity.

For George Washington Cable, in his attempt to depict the essential "hybridity" of New Orleans, the free people of color had an obvious and even "representative" fascination. They embodied the very mixture that was New Orleans. For Dr. John Dickson Bruns, spokesman for the White League of New Orleans, the free people of color were also of paramount importance, but for nearly opposite reasons. Their very "otherness"—nearly invisible to the ordinary eye, but perfectly manifest to the practiced eye of the surgeon—clarified the identity of the white people of the city.

12

The Haunted House
(1874)

A song? What laughter or what song
Can this house remember?

ROBERT GRAVES,
"The Haunted House"

T HE Lalaurie mansion on Royal Street, which had stood
in ruins when Harriet Martineau saw it in 1836, was re-
stored to its former grandeur by the time of the Civil War,
when—such was its size and strategic location—it briefly
served as Union headquarters for General Benjamin But-
ler.[1] In keeping with the concept of "reconstructing" the
city, the structure had a new use by the early 1870s. The
house in which slaves were tortured was now a high school
for girls—an integrated school, for New Orleans was un-
usually progressive in its experiments with biracial educa-
tion. From 1871 to 1877, as a recent historian has written,
"at a time when school desegregation was virtually nonex-
istent in other southern communities and quite uncommon
north of the Ohio, sizeable numbers of white and black
children attended the same public schools in New Or-
leans."[2]

214

Meanwhile, the "haunted house" had entered New Orleans lore, a scary story for children to go to bed by. As early as the 1840s, according to Eliza Ripley, everyone knew the house was haunted. Ripley, a close childhood friend of the Longer sisters—one of whom married Michel Musson, while another married Samuel Bell, William's brother— remembered a school in the house before the war:

> At the haunted house (I wonder if it is still standing and still haunted?) on Royal Street, Mme. Delarouelle had a school for *demoiselles*. . . . I don't think the madame had any boarders, though the house was large and commodious, even if it was haunted by ghosts of maltreated negroes. The school could not under those circumstances have continued many years, for every child knew it was dangerous to cross its portals. Our John [a slave] told me he "seed a skel'ton hand" clutching the grated front door once, and he never walked on that side of the street thereafter. He even knew a man "dat seen eyes widout sockets or sockets widout eyes, he dun know which, but dey could see, all de same, and they was a looken out'en one of the upstairs winders."[3]

"With such gruesome talk," Ripley concludes, "many a child was put to bed in my young days." She sees no contradiction in adding a bit of racist humor to the cruel tale. Nor does she seem aware that the house became a school again after the war, and that the young girls who studied there were destined to become players in the further horrors of the haunted house.

"True stories are not often good art," George Cable mused as he assembled the seven tales for his book *Strange True Stories of Louisiana*, which he had collected during the 1880s. "The relations and experiences of real men and women rarely fall in such symmetrical order as to make an artistic whole." Buoyed by the success of *The Grandissimes*,

Cable had continued to amass arcane lore from the history of his native state. Readers of the novel and acquaintances sent him material that they thought Cable might "work up." Perusing some of these anecdotes and documents, Cable had to admit that "good stories happen oftener than once I thought they did."

Cable heard one such good story while visiting a friend in New Haven, Connecticut, in the spring of 1883, as he was making arrangements for the lecture tour that he and his friend Mark Twain would embark on the following year. His host, Dr. Francis Bacon, recounted the bizarre story of Salome Müller, a white German immigrant girl who, through a series of misunderstandings, was sold into slavery, and only freed after her case was taken to the Supreme Court. "Salome Müller, the White Slave," became one of the finest and most popular tales in the book.

Cable liked collaborators in his work: expert advisers like Dr. Bruns, who could tell him what symptoms a love-lorn free man of color might betray. He was delighted when Dora Richards Miller, an aspiring writer from New Orleans, sent him her account of an episode she had witnessed while teaching in a girls' high school in New Orleans in 1874. She had written the story earlier, but had put it aside for fear that its publication might cost her her job. Cable knew the school from his own days of covering educational turmoil for the *Picayune*, and, like everyone in New Orleans, he knew the building.

The integrated Lower Girls' High School on Royal Street (as opposed to the all-white "Upper Girls" uptown) was where the prominent black Creoles of the downtown neighborhoods sent their teenage daughters, making the school, as Miller informed Cable, "the stronghold of the aristocratic colored element in New Orleans."[4] It was these men, these fathers—many of them former free people of color—who had most strongly agitated for integrated schools in the first place, and had managed to make them

the law in the Louisiana state constitution of 1868. Nonetheless it took three more years of political maneuvering by the state government and constant agitation by blacks to bring practice in New Orleans—where whites outnumbered blacks three to one—into line with the law.

Initially there was massive white anger at "mixed" schools. "Great God, I wonder that the spirits of our dead do not rise up to jeer and scoff us when such degradation of soul is witnessed," one white supremacist thundered. "Me thinks I see Lee, Jackson, and a host of their compeers standing upon the eternal shore with faces veiled in shame and sad tears rising at the sight of their people so fallen."[5] All-white private schools flourished for a time, but after this initial period of adjustment, school desegregation progressed smoothly, from early 1871 through the summer of 1874, when there were at least nineteen integrated public schools in New Orleans.[6]

To the Lower Girls' High School, during that peaceful time, George Cable, as a young newspaper reporter for the *Picayune,* was sent to observe the public examinations of the pupils:

> I shall never forget the day . . . when I sat in its lofty drawing-rooms and heard its classes in their annual examination. It was June, and the teachers and pupils were clad in recognition of the special occasion and in the light fabrics fitted to the season. The rooms were adorned with wreaths, garlands, and bouquets. Among the scholars many faces were beautiful, and all were fresh and young. Much Gallic blood asserted itself in complexion and feature, generally of undoubted, unadulterated "Caucasian" purity, but sometimes of visible and now and then of preponderating African tincture. Only two or three, unless I have forgotten, were of pure negro blood. There, in the rooms that had once resounded with the screams of Madame Lalaurie's little slave fleeing to her death, and with the hoot-

ings and maledictions of the enraged mob, was being tried the experiment of a common enjoyment of public benefits by the daughters of two widely divergent races, without the enforcement of private social companionship.[7]

Cable was impressed with the order, decorum, and serenity of the scene. He later wrote in "My Politics": "I saw, to my great and rapid edification, white ladies teaching Negro boys; colored women showing the graces and dignity of mental and moral refinement, ladies in everything save society's credentials; children and youth of both races standing in the same classes and giving each other peaceable, friendly, effective competition . . ."[8]

Cable's distinction between the public realm and the social realm—the "common enjoyment of public benefits . . . without the enforcement of private social companionship"—was key to his views of integration. In a much-noticed letter published in the white supremacist *Bulletin* in September 1875, Cable defended the practice of "mixed" schools, noting that such interracial public institutions in no way forced the children to socialize privately across the color line. "Our children will do as we did when we were in school. They will select and confer free companionship upon certain playmates, according to their own and their parents' ideas of mental caliber, moral worth, and social position, and the rest of the school may go its way." Cable signed his letter "A Southern White Man."[9]

But the peace that had so moved Cable as he visited the Lower Girls' High School was violently disturbed one morning in the middle of December 1874.

What caused the change in mood? The short answer is Liberty Place, the pitched battle fought on Canal Street three months earlier, on September 14, 1874. The more complicated answer must take into account the reaction against the Unification movement of 1873, the plan for

biracial business cooperation that had specifically endorsed school desegregation. The historian Roger A. Fischer summarizes the tensions of this moment:

> The peaceful progress toward public school desegregation was shattered suddenly and violently during the winter of 1874. . . . Alarmed by the threat to white supremacy posed by Unification, segregationists revived some old "Democratic clubs" during the summer of 1873. They were organized into a new paramilitary structure known as the "White League" headed by New Orleanian Frederick Ogden, designated by one League member as "the first man of prominence to raise his voice against this proposed Covenant with Hell."[10]

That the issues raised by Unification were still very much alive in the winter of 1874 is evident in an episode involving former Governor Warmoth, who wrote a letter to the *Picayune* on December 23, reminding readers of the Unification platform and its wide support in New Orleans, and specifically of its position on mixed schools. Three days later a man attacked Warmoth in the street with a cane. They fell to the ground, at which point Warmoth removed an ivory-handled "spring-knife" from his pocket and stabbed his assailant several times in the back. The wounded man was taken to the nearest doctor, who happened to be Cornelius Beard, the old White Leaguer and orator; but the wounds proved fatal. Warmoth meanwhile speculated that his attacker, whom he did not know, was an associate of Edwin Jewell, editor of the *Bulletin,* with whom Warmoth was about to fight a duel. Thus, with canes and pistols and switchblades, did proper gentlemen of New Orleans settle their differences during the 1870s.

What triggered the next outbreak of White League activity was the attempt by a small group of black girls to participate in the public exams at the elite, and all-white, Upper Girls' High School. All the old reactionary feelings about

the sanctity of white womanhood came into play as school officials were attacked by angry armed men, and one man— accused of "insulting" the girls—was tracked down and whipped with a cowhide on Canal Street. When a similar attempt was made to desegregate the Boys' High School, the White League took action. A vigilante "boys commit- tee" was organized under White League tutelage, with the specific aim of going from school to school and evicting any black students found there. This they proceeded to do, and when they met with resistance, there was fighting in the streets. On December 15, 1874, after "purging" without in- cident the Lower Girls' High School in the Lalaurie man- sion on Royal Street, where twenty or so black girls were evicted, they proceeded to the Keller School, where a large group of blacks awaited them.[11] In the rioting that ensued, a black man was killed, and later that night a black church uptown was fired upon.

The next day the boys, with the usual rabble of armed men at their backs, returned to Lower Girls' to "remove six Negroes overlooked the day before." Then the "boys com- mittee" officially ceased its actions, though "a mob of men and boys who had gathered to cheer them on visited sev- eral more grammar schools."[12] On December 20, a letter appeared in the *Picayune,* signed by the leaders of the boys' group, officially renouncing their activities and expressing gratitude to General Fred Ogden for his sage advice in ask- ing them to desist. "We . . . state that the boys took no part in the disturbance at the Keller School," the signatories claimed. "We should like it to be understood that our com- mittee did not visit any schools on Friday but that of the Lower Girls' High School. Gen. Ogden will please accept the thanks of the committee for his kind advice, which we in- tend following."

Why the detente? Because the White League thought it had achieved its aim when, on December 19, the school board announced that it would reconsider the issue of de-

segregation of New Orleans schools.[13] To prevent further violence, the schools closed a week early for Christmas vacation. It was assumed, erroneously as it turned out, that when they reopened there would be no black students in white schools. There were, to be sure, fewer black children in the mixed schools from 1874 to the official end of integration in 1877. The children and their parents were justifiably afraid of further violence. As Fischer summarizes the whole episode: "If the white sumpremacists never lost their basic aversion to mixed schools throughout the reconstruction period, black activists and their white sympathizers never abandoned their indomitable determination to make the experiment work."[14]

With this narrative of education and racial strife, George Cable decided to close his history of the haunted house on Royal Street, included in his *Strange True Stories of Louisiana*. By that time Cable had moved his family from a raised cottage in the Garden District of New Orleans to the New England college town of Northampton, Massachusetts. Cable claimed that he migrated north for the sake of his invalid wife's health, but his growing unpopularity in New Orleans must have encouraged him to make the move. Cable built a house near Smith College, which his daughters, as day students, attended for free. He named his street "Dryades Green"—an exotic moniker among the sober Elm and Maple streets of the neighborhood—after Dryades Street in New Orleans.

Finding himself so distant from his sources, Cable welcomed the collaboration of Dora Miller, who had witnessed the events at the Lower Girls' High School in December 1874. Miller didn't just send Cable the facts, however; she sent a whole carefully written narrative of the White League "invasion" of the school, much of which Cable used verbatim, merely toning down some of the language. Here, for example, is his introduction to the school episode:

One bright, spring-like day in December, such as a northern March might give in its best mood, the school had gathered in the "haunted house" as usual, but the hour of duty had not yet struck. Two teachers sat in an upper class-room talking over the history of the house. The older of the two had lately heard of an odd new incident connected with it, and was telling of it. A distinguished foreign visitor, she said, guest at a dinner-party in the city the previous season [i.e., 1873, when Degas was visiting], turned unexpectedly to his hostess, the talk being of quaint old New Orleans houses, and asked how to find "the house where that celebrated tyrant had lived who was driven from the city by a mob for maltreating her slaves." The rest of the company sat aghast, while the hostess silenced him by the severe coldness with which she replied that she "knew nothing about it." One of Madame Lalaurie's daughters was sitting there, a guest at the table.

Miller had written that the unidentified "distinguished foreigner" suddenly "turned to his hostess and said, 'Tell me where to find the house in which that celebrated tyrant lived who used to *roast* her slaves.'"[15] Cable continues:

When the teacher's story was told her companion made no comment. She had noticed a singular sound that was increasing in volume. It was out-of-doors— seemed far away; but it was drawing nearer. She started up, for she recognized it now as a clamor of human voices, and remembered that the iron gates had not yet been locked for the day. They hurried to the window, looked down, and saw the narrow street full from wall to wall for a hundred yards with men coming towards them. The front of the crowd had already reached the place and was turning towards the iron gates.

For Cable this image of an angry mob at the iron gates is the historical "rhyme" connecting the twin stories of Mme. Lalaurie and Lower Girls'. In both cases the mob is out to punish what it considers a crime against nature: in the one case the torture of slaves, in the other the "contamination" of white girls by black. But of course Cable's sympathies are with the first mob and entirely against the second.

It is worth noting what Cable excludes from his narrative as well. He says nothing about the events at Upper Girls', for example. And although Miller made it quite clear that the mob was headed by the boys' vigilante "committee"— "the procession," she wrote, was "led by the Senior class of the boys High School, but there [were] others with them"—Cable eliminates all mention of the boys. For him the invasion is by the White League pure and simple; he has no doubt that the "boys committee" was just a convenient propaganda device for the White League leadership:

> A band of men were coming up the winding stair with measured, military tread. . . . the leader of the band of men reached the stair-landing, threw his coat open, and showed the badge of the White League . . . "We have come," said the White Leaguer, "to remove the colored pupils. You will call your school to order."

Whether there was ever, in fact, such an official "badge" prompted a heated exchange of letters when the story was first published in *Century* magazine.

In the rest of his narrative, Cable concentrated on something ignored entirely by newspaper (and by later historical) accounts of the school episode, but highlighted in Dora Miller's version. This was the challenge the White Leaguers faced in telling which students were black and which were white. This difficulty had always, since the publication of *Old Creole Days*, been Cable's line on "hybrid" New Orleans society in general. This time, Dora Miller gave him a perfect

embodiment of his case in the figure of Marguerite, one of the pupils in the school.

As the two teachers first look down the spiral staircase to the entrance three stories below, they see "the men swarming in through the wide gateway and doorway by dozens."

> While they still leaned over the balustrade, Marguerite, one of their pupils, a blue-eyed blonde girl of lovely complexion, with red, voluptuous lips, and beautiful hair held by a carven shell comb, came and bent over the balustrade with them. Suddenly her comb slipped from its hold, flashed downward, and striking the marble pavement flew into pieces at the feet of the men who were about to ascend. Several of them looked quickly up.
>
> "It was my mother's comb!" said Marguerite, turned ashy pale, and sunk down in hysterics.

As the White Leaguers order the students to assemble for a call of the roll, Marguerite is carried to a remote upper room, the bedroom of a kindly janitress, and formerly one of Mme. Lalaurie's slave quarters.

The roll call has an aspect of grim comedy. As "accusations of the fatal taint were met with denials and withdrawn with apologies," the "inquisitors," as Cable calls them, so eager to preserve their military efficiency, "began to blunder."

> One dark girl shot up haughtily at the call of her name—
>
> "I am of Indian blood, and can prove it!"
>
> "You will not be disturbed."
>
> "Coralie——," the principal next called. A thin girl of mixed blood and freckled face rose and said:
>
> "My mother is white."
>
> "Step aside!" commanded the White Leaguer.
>
> "But by the law the color follows the mother, and so *I* am white."

224

"Step aside!" cried the man, in a fury. (In truth there was no such law.)

"Octavie——."

A pretty, Oriental looking girl rises, silent, pale, but self-controlled.

"Are you colored?"

"Yes; I am colored." She moves aside.

A girl very fair, but with crinkling hair and other signs of negro extraction, stands up and says:

"I am the sister of the Hon.——," naming a high Democratic official, "and I will not leave this school."

"You may remain; your case will be investigated."

And so the hideous ritual continues, while the girls who are ordered into the street "sobbed and shrieked and begged: 'Oh, save us! We cannot go out there; the mob will kill us!'" They are ordered to leave nonetheless.

When the White Leaguers' business is complete, and they have left the premises, calm descends on the scene. Then the teachers remember the blue-eyed, blonde-haired Marguerite. Another surprise awaits them—one that the reader by now perhaps suspects. "Do you think," one of them asks the janitress, "that mere fright and the loss of that comb made this strong girl ill?" "No," answers the janitress. "I think she must have guessed those men's errand, and her eye met the eye of some one who knew her." "But what of that?" asks the teacher. "She is 'colored.'" "Impossible!" "I tell you, yes!" Though, as the janitress adds, "the only trace of it is on her lips." She explains:

Her mother—she is dead now—was a beautiful quadroon. A German sea-captain loved her. The law stood between them. He opened a vein in his arm, forced in some of her blood, went to court, swore he had African blood, got his license, and married her. Marguerite is engaged to be married to a white man, a gentleman who does not know this. It was like life and

225

death, so to speak, for her not to let those men turn her out of here.

So ends Cable's story of the haunted house on Royal Street, with nothing but a brief coda about its later incarnation as first a "colored" high school after the Democratic (and White League) victory of 1877, and then as a conservatory of music. Later still it served as a haven for homeless men and, as the French Quarter descended into squalor and disrepair, a bar, aptly named the Haunted House Saloon.

From that versatile structure on Royal Street, George Cable summoned a formidable array of ghosts: Madame Lalaurie and Madame Martineau, Frederick Ogden and his henchmen, the tortured slaves and the terrorized students. At the end of the story, the broken shell comb is what one remembers, the broken comb and its many meanings—the cherished inheritance from the quadroon mother, the fact of fragility, the threat of violation, the ambiguities of whiteness. The falling comb is itself a frail ghost of the little slave-girl who hurled herself from the balustrade, choosing death rather than facing Mme. Lalaurie's wrath.

13

Revenants

. . . a new birth of freedom . . .
ABRAHAM LINCOLN, *November 19, 1863*

NOTHING in Kate Chopin's life in New Orleans quite
prepares us for the ubiquity of ghostly presences and
revenants in her stories of Louisiana. Her imaginary world,
the world as we experience it in her stories and novels, is
one in which men counted dead reappear without warn-
ing, women are reunited with lost children, and voices are
audible from beyond the grave. And yet, except for the
ghost of Robert McAlpin—the harsh, up-country Louisiana
slave-driver who was supposedly the model for Stowe's Si-
mon Legree, and whose grave provides an unlikely trysting
site for two lovers in Chopin's first novel, *At Fault*—ghosts,
properly speaking, rarely invade Chopin's fictive world. In-
stead, she uses all her ingenuity to introduce ghostly figures
without violating the laws of the real—and presumably
ghostless—world.

One of Chopin's favorite ploys is to use hidden letters as

a way for the dead to speak. In her best known story, "Désirée's Baby," a fiery Creole planter is filled with rage when his wife, the foundling Désirée, gives birth to a mulatto child. Certain that the "taint" is hers, Armand hounds his wife into killing herself and the child. As he tosses everything of theirs onto a huge bonfire, in a great ritual of purification and oblivion, Armand discovers a cache of old letters in a desk drawer, including a remnant of one from his mother to his father. "Night and day," she had written, "I thank the good God for having so arranged our lives that our dear Armand will never know that his mother, who adores him, belongs to the race that is cursed with the brand of slavery."[1]

Most of Chopin's stories of revenants (and the fact is hardly surprising in a Southern writer) involve the Civil War in some way; they treat of veterans who are assumed dead and return—actually or in fantasy—months or years later. These are stories about the haunted South, the continuing toll of the war long after the official cessation of hostilities. Chopin registers the complex psychological effects of the war on veterans and the families of veterans, as well as on those who—like her husband, Oscar Chopin— fled the South to avoid military service, and returned with their own burdens of guilt and atonement. In such stories, Chopin plays on the double meaning of the word "revenant": the benign sense of one who returns from a journey; and the more unsettling meaning of a ghost who returns from the grave.

Two men failed to return to the O'Flaherty household when Kate Chopin, or rather Katie O'Flaherty, was a child in St. Louis. It is easy to imagine the excitement of the first occasion, the official opening—on November 1, 1855, All Saints' Day—of the Gasconade Bridge. The new bridge, establishing railroad connections with Jefferson City, justified St. Louis in its claim as the "gateway to the West." Military bands played jubilant marches. Speakers indulged in the

flatulent oratory of destiny made manifest in steel and steam. The West was opening here before the spectators' very eyes. The bunting-draped boxes were filled with engineers and financiers and politicians. The spectators of all ages lined the river, in anticipation of the chugging arrival of the star of the show, the train itself, decked in red, white, and blue. Dignitaries waved from the windows and smiled proudly at this wonder they had helped to bring into being: the Pacific Railroad, named for its destination.

Public disasters have their own peculiar rhythm. Everything goes according to plan—the laughing children, the winding train, the cheering crowd—only to be interrupted by a suspended freeze frame (that is how it is remembered, in any case) as something begins to go hideously wrong.

The train moved confidently forward until it reached the first support over the river. Then it was as though a hangman pulled the lever. As the bridge gave way, the locomotive fell thirty feet into the river, and thirty cars followed it down, some of them dangling from the edge of the cliff. The *Missouri Republican* described the scene:

> As soon as the crash was over, a moment of painful silence ensued, and then issued from the wreck the groans of the wounded, the supplications of the imprisoned, the screams of the agonized, while here and there might be observed the upturned face of the dead, mangled and clotted with blood, or the half-buried forms of others whose spirits had passed away forever. To add to the horror of the scene, a storm of lightning, thunder and rain arose of the severest description.[2]

Thomas O'Flaherty was on the train that day, and he was one of the thirty men who died in the disaster. Kate O'Flaherty was five years old when she learned that her father wasn't coming home.

When the Civil War broke out, Kate's beloved half-brother, George O'Flaherty, joined the Confederate Mis-

souri Mounted Infantry and was quickly involved in the sporadic fighting in the state. On August 18, 1862, George and a friend from Arkansas were taken prisoner. They were held in the gloomy Gratiot Street Prison, in view of the O'Flaherty house in St. Louis. The Arkansas soldier fell ill with tuberculosis, and through the negotiations of a local doctor was sent to live in the O'Flaherty house, but he died after a few days. A month later George was freed in an exchange of prisoners at Vicksburg. On his return, he decided to make a quick stop to see the parents of the Arkansas friend. There he caught typhoid, and died on February 17, 1863, on Mardi Gras day. He was twenty-three, ten years older than his grieving sister Kate.[3]

Both disasters, but especially the incident on the bridge, seem to cast their shadows on Chopin's famous "The Story of an Hour." Three pages long, it is one of her most perfect stories. A young woman learns that her husband has died in a railroad disaster. She has a heart ailment, so the news is broken to her gently. She retires to her room and looks from her window at the open square below her, "all aquiver with the new spring life." Uncertain of her feelings, she stares at a patch of blue sky. "There was something coming to her and she was waiting for it, fearfully. What was it? She did not know; it was too subtle and elusive to name. But she felt it, creeping out of the sky, reaching toward her through the sounds, the scents, the color that filled the air." This "something," to the reader's surprise and her own, turns out not to be her misery, but rather her joy—"She did not stop to ask if it were or were not a monstrous joy"—at the freedom resulting from her husband's death. "And yet she had loved him—sometimes. Often she had not. What did it matter! What could love, the unsolved mystery, count for in face of this possession of self-assertion which she suddenly recognized as the strongest impulse of her being!"

Her worried sister Josephine, meanwhile, is kneeling by

the closed door, imploring her to open it, but Louise can't pull herself from the "very elixir of life" streaming through the window. Finally she opens the door, carrying herself "unwittingly like a goddess of Victory." But another door downstairs is being opened. "It was Brently Mallard who entered, a little travel-stained, composedly carrying his grip-sack and umbrella. He had been far from the scene of accident, and did not even know there had been one." His wife collapses. "When the doctors came they said she had died of heart disease—of joy that kills."

The sting in the ending (compounding the first surprise of the widow's joy) and the deft, painterly detail—her window view could be Monet's or Morisot's—show how well Chopin had learned the lessons of Maupassant, several of whose stories she translated. She was a life-long connoisseur of rickety marriages, and all her wisdom is on display in her piercing analysis of this thoroughly average one. The story is set in no identifiable city, though New Orleans, with its rich colors and scents, is strongly suggested. If there are hints of the Civil War here—in Brently Mallard's name "leading the list of 'killed,'" as opposed to "dead"; or in the remark that Louise "did not hear the story [of her husband's death] as many women have heard the same, with a paralyzed inability to accept its significance"—they are muted and tenuous.

When Kate Chopin writes explicitly about the Civil War, she is partial to the figure of the one who doesn't return, or returns in a form so changed as to be unrecognizable. One of her first published stories is "A Wizard from Gettysburg," written in 1891. Bertrand has been called home from his college because his father and grandmother can no longer pay his tuition from the meagre earnings of their war-devastated plantation. While riding his Creole pony, Picayune, he comes across a tramp under a hedge by the side of the road. "This is the State of Louisiana," mutters the tramp. "Yes, this is Louisiana," Bertrand confirms. "I've

been in all of them since Gettysburg," says the tramp, who has a gash in his foot and a bullet in his head. Bertrand takes him back to the plantation, cleans him up, and ministers to his wounds.

When the tramp overhears the rest of the family discussing their financial troubles, he begins repeating, like a mantra, "The war's over, the war's over! St. Ange . . . must go to school." (The tramp insists on calling Bertrand by his father's name, St. Ange.) Then the tramp drags Bertrand into the orchard, takes ten paces here and there, points to the ground and orders that Bertrand dig, "and he dug and dug, throwing great spadefuls of the rich, fragrant earth from side to side." Sure enough, there's a box buried in the dirt, "too deep for any ordinary turning of the soil with spade or plow to have reached it." The box is filled with gold. Along with the buried gold, the mystery (which we've already pieced together) comes to light. The tramp is Bertrand's grandfather, come back from the dead, despite "such sure proof of his death in that terrible battle." The parallel fantasies of corpses coming to life, and buried secrets brought to light, are deeply imagined here.

In "The Wizard," Chopin gives an interesting twist to her revenant theme, commenting—though it's not clear whether in Bertrand's mind or the narrator's—

> On that field of battle this man had received a new and tragic birth. For all his existence that went before was a blank to him. There, in the black desolation of war, he was born again, without friends or kindred; without even a name he could know was his own. Then he had gone forth a wanderer; living more than half the time in hospitals; toiling when he could, starving when he had to.

Chopin offers here an unexpectedly bitter and ironic commentary on the "new birth of freedom" passage in Lincoln's "Gettysburg Address": ". . . we here highly resolve that

these dead shall not have died in vain—that this nation, under God, shall have a new birth of freedom—and that government of the people, by the people, for the people, shall not perish from the earth." Chopin appears to be saying that the South can take no comfort from battles such as Gettysburg, which accomplished nothing so thoroughly as to wipe out the past of the South—its plantation houses, its young men, its wealth, its memories, its much-lamented "way of life."

Some of that same bitterness pervades "After the Winter," the last story Chopin wrote during 1891. The Easter moment of death and rebirth is embodied by a Civil War veteran called Michel, who, "in the early '60's . . . went with his friend Duplan and the rest of the 'Louisiana Tigers.' He came back with some of them." He returns only to discover that his child has died and his wife has been unfaithful to him: "There are women—there are wives with thoughts that roam and grow wanton with roaming; women who are stirred by strange voices and eyes that woo; women who forget the claims of yesterday." M'sieur Michel's response to these events is to turn his back on the society of men and literally go underground, in a grim hut with a single window and a door "so low that even a small man must have stooped to enter it." Michel's sparse furniture is rooted in the underworld: "M'sieur Michel had evidently begun the construction of his house by felling a huge tree, whose remaining stump stood in the centre of the hut, and served him as a table." (Like the "wizard" of Gettysburg, Michel knows the secrets of underground.)

Michel is a hunter, and his marginal existence prompts all manner of rumors, blurring his Civil War past and his violent, white supremacist present. "A broad felt hat shaded his bearded face and in his hand he carelessly swung his old-fashioned rifle. It was doubtless the same with which he had slain so many people . . ." The children of the town

relate "how this man had killed two Choctaws, as many Texans, a free mulatto and numberless blacks, in that vague locality known as 'the hills.'"

Three children, two white and one black, go in search of flowers to deck the church in town, and stumble upon Michel's house. One of them peers through the window, "morbidly seeking some dead, mute sign of that awful pastime with which he believed M'sieur Michel was accustomed to beguile his solitude." Michel returns to his hut and knows it has been somehow violated; like Hades bereft of Persephone, he notices the theft of his flowers, and hurries to town, where Easter is being celebrated, to complain. When he hears the familiar Easter music, and a mulatto child asks him to remove his hat, something happens in his soul, "the driving want for human sympathy and companionship that had reawakened in his soul." Chopin suggests that Michel's conversion entails a racial accommodation as well.

Intoxicated with the newly plowed earth, Michel finds himself wanting "to kneel and bury his face in it. He wanted to dig into it; turn it over. He wanted to scatter the seed again as he had done long ago, and watch the new, green life spring up as if at his bidding." Like a sleepwalker he returns to his former land, expecting overgrown weeds and underbrush; instead, everything is orderly and thriving.

A hand had been laid upon M'sieur Michel's shoulder and some one called his name. Startled, he turned to see who accosted him.

"Duplan!"

The two men who had not exchanged speech for so many years stood facing each other for a long moment in silence.

"I knew you would come back someday, Michel. It was a long time to wait, but you have come home at last."

The planter Duplan has provided for his friend's return. "Begin your new life," he tells Michel, "as if the twenty-five

years that are gone had been a long night, from which you have only awakened." The understated closing sentence points up the passage from death to life, and the persistence of death: "All the land was radiant except the hill far off that was in black shadow against the sky."

"After the Winter" is a children's story, meant for Easter publication; it was accepted but never printed in the popular *Youth's Companion.* With "A Wizard from Gettysburg," it is one of a group of "revenant" stories in which Kate Chopin suggests that the "return" from the Civil War could never be a simple matter of veterans coming home. The worlds of before and after the war could not be fit back together so seamlessly. (Writing about New Orleans, Mark Twain said that in the South, the war was what A.D. was elsewhere.) It takes M'sieur Michel twenty-five years to come home. Chopin suggests that more than "reconstruction" is called for; "rebirth," "reawakening," or even "resurrection" would be closer to her meaning.

One of the last written of these revenant stories is also the most obvious in its structure of a wish fulfilled. Soon after the publication of Stephen Crane's *Red Badge of Courage* in 1895, Chopin herself ventured a story of a frightened young soldier, "The Locket," her only "war story" in the conventional sense.[4] Ned, or Edmond, wears a necklace, which his Confederate comrades take to be a charm, "some kind of hoodoo business that one o' them priests gave him to keep him out o' trouble." Actually it's a locket from his Creole finacée. On the eve of battle, another private steals the locket and is killed. When the locket is returned to the rightful owner's fiancée, she assumes he is dead, only to be "awakened" from her mourning a few weeks later by the surprise arrival of her unscathed lover.

Octavie felt as if she had passed into a stage of existence which was like a dream, more poignant and real than life. There was the old gray house with its sloping

eaves. Amid the blur of green, and dimly, she saw familiar faces and heard voices as if they came from far across the fields, and Edmond was holding her. Her dead Edmond; her living Edmond, and she felt the beating of his heart against her and the agonizing rapture of his kisses striving to awake her. It was as if the spirit of life and the awakening spring had given back the soul to her youth and bade her rejoice.

In this passage Chopin uses the same themes of awakening and the rebirth of spring that she had exploited so effectively in "The Story of an Hour." All of them, including that passage about the journey "across the fields," will recur with greater subtlety and force in her novel *The Awakening*.

The revenant theme, inspired by the Civil War, spread into Chopin's other stories as well, especially those treating Creole life in and around New Orleans. In "La Belle Zoraïde," Chopin used the revenant theme to explore the social complexity of pre-war New Orleans. Chopin employs a "frame"—a structure of a tale within a tale—as the old slave Manna-Loulou, "herself as black as the night," recounts the tragic story of Zoraïde to lull her white mistress to sleep.

The story begins with an agreement between Zoraïde's mistress, Mme. Delarivière, and her good friend, Dr. Langlé, that Zoraïde, whose skin is the color of café-au-lait, is to marry the doctor's body servant M'sieur Ambroise, a "little mulatto, with his shining whiskers like a white man's, and his small eyes, that were cruel and false as a snake's." But Zoraïde only has eyes for le beau Mézor, whom she has seen dancing the Bamboula in Congo Square. "His body, bare to the waist, was like a column of ebony and it glistened like oil." They reach an understanding, and Mme. Delarivière is "speechless with rage.

> "That negro! that negro! Bon Dieu Seigneur, but this is too much!"
> "Am I white, nénaine?" pleaded Zoraïde.

"You white! *Malheureuse!* You deserve to have the lash laid upon you like any other slave; you have proven yourself no better than the worst."

When Zoraïde confesses that she is expecting Mézor's child, Mme. Delarivière and the doctor devise a crueller punishment than the lash. As always in Chopin's world, pregnancy and death are intertwined: "with the anguish of maternity came the shadow of death. But there is no agony that a mother will not forget when she holds her first-born to her heart, and presses her lips upon the baby flesh that is her own, yet far more precious than her own." But when Zoraïde asks to see her child, Madame tells her the child is dead—"a wicked falsehood," comments the narrator Manna-Loulou, "that must have caused the angels in heaven to weep. For the baby was living and well and strong. It had at once been removed from its mother's side, to be sent away to Madame's plantation, far up the coast."

The results of this stratagem to keep Zoraïde at her mistress's side, "free, happy, and beautiful as of old," are disastrous, as Zoraïde first descends into misery, then madness. A bundle of rags in the shape of an infant becomes her surrogate baby, and when Mme. Delarivière and Dr. Langlé decide remorsefully to restore the real baby to Zoraïde, she will have none of this poor revenant, suspecting another trick. "Nor could she ever be induced to let her own child approach her; and finally the little one was sent back to the plantation, where she was never to know the love of mother or father."

In "La Belle Zoraïde," Chopin displayed her deep knowledge of New Orleans. She had studied George Washington Cable's pioneering articles on the African-American dances and music of Congo Square. She is minutely attentive to skin-color gradations, so important in the caste-ridden society of New Orleans. Not only are the rivals for Zoraïde's affections a mulatto and the dark-skinned Mézor (the shared exotic syllable "zor" lets us know who will win), but the re-

turned baby is described as a "pretty, tiny little 'griffe' girl"—that is, three-quarters black. This material too comes from Cable, borrowed from various characters and tensions in his novel *The Grandissimes,* and given new emphases.

"La Belle Zoraïde" serves as a summary of many of the revenant twists and turns of earlier stories. As in "A Wizard from Gettysburg," the revenant goes unrecognized, and a "second birth" occurs. As in "Désirée's Baby," pregnancy and death are conjoined. But in "La Belle Zoraïde," the Creole city of New Orleans has itself become a character, an unpredictable mistress whose uneasy mix of sentimentality and cruelty (embodied here in Mme. Delarivière) leaves victims in her wake, particularly among those of mixed race who live so intimately with their white masters. In retrospect we can see how race runs like a thread through many of Kate Chopin's stories of revenants. At times, it seems as though the problem of race is itself the thing repressed, sent away, exiled, only to return, unexpectedly and unannounced.

14

Divided Houses

A house divided against itself cannot stand.
ABRAHAM LINCOLN, *1858*

In her novel *The Awakening*, Kate Chopin returned to the semi-tropical city—herself a "revenante"—in which she had spent the first nine years of her married life, from the end of the Chopins' European honeymoon in the fall of 1870 to their departure from the city, amid financial pressures, in 1879. During that time, she gave birth to five sons and one daughter. Although she was almost continually either pregnant or nursing a newborn, she found ways to explore the city. And it was these memories that she drew on for the setting and characters of *The Awakening*.

Like her fictional character Edna Pontellier, Kate Chopin loved to walk in the streets of New Orleans. "I always feel so sorry for women who don't like to walk," says Edna, "they miss so much—so many rare little glimpses of life; and we women learn so little of life on the whole." Kate Chopin took a particular interest in her husband's cotton

factorage business; his office at 65 Carondelet was on Factors' Row, the handsome building with multiple entrances on the corner of Carondelet and Poydras. Next door, number 63, was the address of the Musson firm.

On one occasion, Kate accompanied Oscar on a tour of the warehouse district by the river. The final entry in her New Orleans diary describes her "journey with Oscar through the district of warehouses where cotton is stored and when sold passes under presses of immense power, reducing bales to half their size for better storage aboard ship." They also visited the pickeries "where damaged cotton is bleached and otherwise repaired. The whole process of weighing, sampling, storing, compressing, boring to detect fraud, and the treatment of damaged bales is open to public view."[1]

Oscar's firm was sufficiently successful for the Chopins to move steadily uptown, from their first house on Magazine Street in the working-class neighborhood known as the Irish Channel, to a small house on Constantinople and Pitt Avenue. By the beginning of 1876 they were living at a better address on Louisiana Avenue between Coliseum and Prytania, in the Garden District. The charming Louisiana Avenue house, half of which they rented, is still standing, with its slate roof and galleries along the front and sides.

While *The Awakening* is not autobiographical in any strict sense, it does resume much of what we know of Chopin's experience in Reconstruction New Orleans, and provides an indelible portrait of the vibrant city that she had known during her marriage to Oscar. *The Awakening* is the story of Edna Pontellier, a Kentucky-bred woman of Anglo-Saxon background who, like Kate Chopin, has entered an ethnically "mixed" marriage with a somewhat older Creole from New Orleans called Léonce Pontellier, a prosperous cotton factor. While vacationing in the Gulf resort of Grand Isle, with its legends of the pirate and slave-trader Lafitte, she

finds herself among a vivacious circle of Creole vacationers, who elicit unexpected feelings from her:

> There were only Creoles that summer at Lebrun's. They all knew each other, and felt like one large family, among whom existed the most amicable relations. A characteristic which distinguished them and which impressed Mrs. Pontellier most forcibly was their entire absence of prudery. Their freedom of expression was at first incomprehensible to her, though she had no difficulty in reconciling it with a lofty chastity which in the Creole woman seems to be inborn and unmistakable.

This passage implies a truth worked out in the rest of the novel: if those who are loose in their speech are chaste in their behavior, beware of the opposite.

Edna is first drawn to Mme. Ratignolle, who announces—with a lack of prudery shocking to Edna—that she is pregnant. Mme. Ratignolle is, in Edna's view, the perfect "mother-woman":

> The mother-women seemed to prevail that summer at Grand Isle. It was easy to know them, fluttering about with extended, protecting wings when any harm, real or imaginary, threatened their precious brood. They were women who idolized their children, worshiped their husbands, and esteemed it a holy privilege to efface themselves as individuals and grow wings as ministering angels.

Edna neither worships her husband nor idolizes her children, who are watched over by a quadroon nurse.

Through Mme. Ratignolle she meets the young and handsome Robert Lebrun, who flirts with Edna and—in a richly imagined scene—teaches her to swim. Listening to another visitor, the haughty Mlle. Reisz, play a Chopin nocturne at the piano elicits tears from Edna; her emotional life is thawing within her.

On her return to New Orleans, and her well-arranged house on Esplanade, Edna feels increasingly dissatisfied with the life her husband expects from her. She embarks on a series of affairs of the heart and body, as she "awakens" to her own sexuality. Eventually, convinced there is no emotionally fulfilling life available to her, and feeling enslaved by her husband and children, she returns to Grand Isle on her own and swims far out into the Gulf of Mexico, never to return.

One way to read the novel is to trace Edna's attempts, in various locales, to find pockets of freedom in New Orleans comparable to the expansiveness she felt at Grand Isle. Interestingly, the visitors' cabins at the resort were former slave quarters, a premonition for what follows. The vivid opening line of the novel establishes the central image of the "bird in the gilded cage": "A green and yellow parrot, which hung in a cage outside the door, kept repeating over and over: '*Allez vous-en! Allez vous-en! Sapristi!* That's all right.'" The multilingual parrot, who speaks a little Spanish, a little English, and "also a language which nobody understood," is a fitting embodiment of the multicultural Louisiana world that Chopin is interested in representing, but he is also a stand-in for Edna Pontellier.

Edna feels caged in the swanky Pontellier mansion on Esplanade:

> It was a large, double cottage, with a broad front veranda, whose round, fluted columns supported the sloping roof. The house was painted a dazzling white; the outside shutters, or jalousies, were green. In the yard, which was kept scrupulously neat, were flowers and plants of every description which flourishes in South Louisiana.

Inside, "the appointments were perfect after the conventional type. The softest carpets and rugs covered the floors;

rich and tasteful draperies hung at doors and windows. There were paintings, selected with judgment and discrimination, upon the walls."

The house is perfectly maintained and furnished by Edna's finicky husband, Léonce, who is "very fond of walking about his house examining its various appointments and details, to see that nothing was amiss. He greatly valued his possessions, chiefly because they were his." Pontellier regards his wife as the most perfect of his possessions; one afternoon, after she has spent too much time in the sun, he looks at her "as one looks at a valuable piece of personal property which has suffered some damage."

The Pontelliers quarrel often, and have a particularly intense row over Edna's refusal to abide by the strict rituals of the New Orleans "calling day," and the consequent slights to the wives and daughters of some of Léonce's clients. The scene underlines both the precariousness of the Pontellier marriage and the fragility of Léonce's cotton factorage business. In a sort of trial separation, Edna moves to a small house around the corner that she calls her "Pigeon House." In the symbolic scheme of the novel, it is a bird house of her own, instead of a birdcage belonging to her husband. She takes up sketching and painting, activities dropped at the time of her marriage, and, while her friend Robert Lebrun is in Mexico on business, she looks elsewhere for companionship. When her affair with the *roué* Alcée Arobin turns sour, she feels constricted in the Pigeon House as well, and finds some comfort in the upstairs gabled studio of Mlle. Reisz, with its view, through grimy windows, of the "crescent of the river, the masts of ships and the big chimneys of the Mississippi steamers."

Chopin is a virtuoso at making rooms expressive of their inhabitants. Mlle. Reisz's quarters, with the oversize piano that crowds the apartment, and a diminutive kitchen, tells us much about this reclusive artist. It is as though Chopin is presenting Mlle. Reisz as Edna might sketch her, with the

piano pushing her to one side, but with a window behind her opening to the light and freedom of the moving river.

When even Mlle. Reisz's rooms feel too constricting, Edna takes refuge in a garden on the outskirts of the city, a "good walk" from the nearest streetcar stop and a place "too modest to attract the attention of people of fashion, and so quiet as to have escaped the notice of those in search of pleasure and dissipation." It was

> a small, leafy corner, with a few green tables under the orange trees. An old cat slept all day on the stone step in the sun, and an old *mulâtresse* slept her idle hours away in her chair at the open window, till some one happened to knock on one of the green tables. She had milk and cream cheese to sell, and bread and butter. There was no one who could make such excellent coffee or fry a chicken so golden brown as she.

The *mulâtresse* Catiche, whose garden this is, is one of the many benevolent figures of mixed race in the novel—the quadroon nurse of Edna's children is another—who make Edna's search for self-fulfillment possible. To this attractive boundary location—between city and country, between the black world and the white—Robert Lebrun also comes one day. He has returned from Mexico, where his love for Edna—an impossible love, as he sees it—has become clear to him.

It is one of Chopin's many achievements in her novel to show what can be unsatisfactory even in relatively good marriages. Though Léonce may be possessive and a bit insensitive, he's hardly a monster. But comfortable cages—gilded cages—are cages nonetheless. In recent years, *The Awakening* has become a feminist classic—a sort of American *Room of One's Own*—and is routinely read as the story of a courageous woman's fight against societal restrictions. But the nuanced ending of the novel leaves open the question of whether Edna's suicide is a triumphant liberation or

a cowardly capitulation, and no amount of interpretive pressure can reduce this stubborn ambiguity.

All but ignored in such debates are the manifold ways in which *The Awakening* is a novel profoundly shadowed by the Civil War. Indeed, the novel parallels, in surprising ways, some of the major themes of the nearly contemporary *Red Badge of Courage*. There can be no serious doubt that Chopin was familiar with Stephen Crane's best-selling novel. The writing careers of the precocious Crane and the late-blooming Chopin were almost exactly contemporaneous, spanning the 1890s.[2]

There is also the enticing matter of Union flags. When she was a girl of eleven, during the first year of the Civil War, Kate Chopin (or Kate O'Flaherty) made a name for herself in her native St. Louis when she angrily ripped down a Union flag that someone had placed on the front porch of her family's house. She was arrested by Union soldiers and almost imprisoned for her offence. For the rest of the war she was affectionately known in St. Louis as "the littlest rebel."

Henry Fleming, by contrast, in a culminating moment in Crane's novel, grasps the Union flag lovingly, almost erotically:

> Within him, as he hurled himself forward, was born a love, a despairing fondness for this flag which was near him. It was a creation of beauty and invulnerability. It was a goddess, radiant, that bended its form with an imperious gesture to him. It was a woman, red and white, hating and loving, that called him with the voice of his hopes.

But let us begin with less remote issues, and focus on Chopin's substantial (though routinely ignored) engagement with the Civil War in *The Awakening*. Early and late, Chopin's heroine, Edna Pontellier, draws her sense of self

from Confederate officers. This motherless woman is brought up by her father, a Kentucky colonel: "He had been a colonel in the Confederate army, and still maintained, with the title, the military bearing which had always accompanied it." As Edna chafes at her life with Léonce, her father makes a visit to New Orleans. In the colonel's society, Edna becomes "acquainted with a new set of sensations"; she takes her lead from her father in her first rebellious actions, attending the races with him—presumably at the newly opened track down Esplanade—and painting his portrait. When Edna gets her father to pose for her, he faces her pencil, "rigid and unflinching, as he had faced the cannon's mouth in days gone by." Edna's drawing pencil becomes, in this simile, a potential weapon, something to wield in her own private war for independence. As he poses, the colonel relates "somber episodes" from the "dark and bitter days" of the war, episodes "in which he had acted a conspicuous part and always formed a central figure."

When Edna moves out of her husband's house, seceding so to speak from their "union," it is the Confederate colonel who is invoked. Edna's lover, Alcée Arobin, refers to her act of setting up a house of her own as a *"coup d'état,"* and suggests that the guests assembled to celebrate should "start out by drinking the Colonel's health . . . on the birthday of the most charming of women—the daughter whom he invented."

The Civil War is a clear metaphor here for the civil discord in the Pontellier marriage. As Edna's rebellious guests disband, their voices jar "like a discordant note upon the quiet harmony of the night." Mme. Ratignolle's hope that the Pontelliers might be "more united" if they stayed home more often is obviously doomed. This is a house divided; secession is in the air.

Chopin marks both the beginning and the end of Edna's "awakening" with images drawn from the Civil War. Luxuriating amid the charms of Grand Isle, Edna remembers a summer day long ago in Kentucky, when she walked across

"a meadow that seemed as big as the ocean to the very lit-
tle girl . . . She threw out her arms as if swimming when
she walked, beating the tall grass as one strikes out in the
water." We are told that Edna's first passion, long before her
marriage to Léonce, was for a Confederate officer:

> At a very early age—perhaps it was when she traversed
> the ocean of waving grass—she remembered that she
> had been passionately enamored of a dignified and
> sad-eyed cavalry officer who visited her father in Ken-
> tucky. She could not leave his presence when he was
> there, nor remove her eyes from his face, which was
> something like Napoleon's, with a lock of black hair
> falling across the forehead.

According to Chopin's biographer, Emily Toth, this cav-
alry officer was based on Julius Garesche, uncle of Chopin's
best friend, Kitty Garesche. Julius, married to a woman
from Guadeloupe called Mariquitta (a name Chopin used
for the Spanish girl who flirts with Robert in *The Awaken-
ing*), was among the first graduates of West Point killed in
the war, when his horse was shot out from under him dur-
ing the battle of Murfreesboro.[3]

Such biographical detail is ultimately less important than
the weight Chopin gives her fictional cavalry officer in her
novel. Not only does his presence initiate Edna's awaken-
ing, so to speak, but he haunts her ending as well, as
though her death is to be conceived of as in some sense a
Civil War death. The last paragraph of the novel, which
records Edna's conflicted mood as she swims out into the
Gulf, is saturated with the Civil War:

> She looked into the distance, and the old terror flamed
> up for an instant, then sank again. Edna heard her fa-
> ther's voice and her sister Margaret's. She heard the
> barking of an old dog that was chained to the sycamore
> tree. The spurs of the cavalry officer clanged as he

walked across the porch. There was the hum of bees, and the musky odor of pinks filled the air.

One could show how Kate Chopin transfers Civil War themes of secession and independence into the domestic sphere, converting a public war about race and nationhood into a private war about gender. Such an analysis would have to register her careful avoidance, or oblique treatment, of racial issues—something else her novel shares with Stephen Crane's *Red Badge of Courage*. (That dog chained to the sycamore tree may be a subtle invocation of slavery.)

Chopin's interesting early story "Emancipation: A Life Fable" shows the way. In that brief sketch, written during Chopin's last year in New Orleans, a caged animal, whose needs and comfort are provided for, one day finds the cage door open. Despite having to hunt and suffer and thirst, the animal prefers uncomfortable freedom to anxiety-free bondage. One interpretation of the fable is that woman is a slave who, once emancipated, will prefer hunger and suffering to caged comfort.

But Chopin's use of Civil War themes goes beyond the metaphorical, especially in her characterization of Mlle. Reisz, one of Edna's tutors in achieving her independence. Reisz, the pianist and only serious artist in the novel, is for Edna the embodiment and voice of "courage." As Edna dabbles in her painting, Mlle. Reisz warns her that one must have the "courageous soul," or perish broken-winged in the effort. Mlle. Reisz's words echo in Edna's mind during her charged last moments alive. Four paragraphs from the end:

> She thought of Léonce and the children. They were a part of her life. But they need not have thought that they could possess her, body and soul. How Mademoiselle Reisz would have laughed, perhaps sneered, if she knew! "And you call yourself an artist! What preten-

sions, Madame! The artist must possess the courageous soul that dares and defies."

"What do you mean by the courageous soul?" Edna had asked Mlle. Reisz earlier. "Courageous, *ma foi!* The brave soul. The soul that dares and defies."

Now the question for every reader of Chopin's novel is whether Edna shows, by her final march into the ocean, that she has this courageous soul that dares and defies. The question for every reader of Stephen Crane's *The Red Badge of Courage* is whether Henry Fleming, by his final mad rush to grasp the flag, shows that he has indeed earned his red badge of courage.

Amid their momentary madness and mental confusion, both Edna and Henry "pass" for courageous warriors, as he madly seizes the flag and she "goes where no woman has gone before." Both characters, as their respective battles draw to a close, hold in mind a contrasting image of peaceful meadows. Edna: "She did not look back now, but went on and on, thinking of the blue-grass meadow that she had traversed when a little child . . ." Henry: "He turned now with a lover's thirst to images of tranquil skies, fresh meadows, cool brooks—an existence of soft and eternal peace . . ." And both authors insert enough irony to undercut a simple "courageous" reading of these final scenes.

Crane's *Red Badge of Courage* is itself a novel of "awakening." In the penultimate paragraph, Crane writes that Fleming "had rid himself of the red sickness of battle. The sultry nightmare was in the past." The ultimate irony for these two war novels is that for Henry Fleming, "waking up" is a matter of mere survival. He marches into the sunset with his body and his secret intact. For Edna Pontellier, by contrast, history is a nightmare from which she cannot—at least not in this life—awake.

If the martial ideal for American men during the 1890s is the practice of war, what is the comparable, life-risking

practice for women, their "moral equivalent of war," to borrow William James's phrase? Chopin has two contrasting answers. One is the life-sacrificing dedication to art, as embodied in Mlle. Reisz, who has renounced love, family, and companionship in the bold and relentless pursuit of artistic excellence. The other is the potentially life-sacrificing risks of childbirth, as embodied in Mme. Ratignolle. Chopin tracks the events of *The Awakening* against the nine-month pregnancy of Adèle Ratignolle, and interrupts Edna's tryst with Robert with the news of Adèle's labor, which to Edna looks more like torture. (*The Awakening*, as Emily Toth points out, is "virtually the only American novel of its era to describe a pregnant woman.")[4] Adèle is urged to carry on with "courage and patience."

The association of pregnancy and war had some foreground in Chopin's own life. Oscar Chopin, as we have noted, had spent the Civil War years in France. Like Henry Fleming in *The Red Badge of Courage*, Oscar had run from battle, only to be given, like Henry, a second chance, in the Battle of Liberty Place. In New Orleans, the Chopins counted among their neighbors and friends Oscar's White League commander, Captain Frank McGloin, a young lawyer and Magazine Street resident. And when the Chopins moved farther uptown, they were in General Fred Ogden's neighborhood: Ogden's house was at the corner of Louisiana and Coliseum, on the same block as the Chopin's house. The Chopins socialized with John Angell, a dentist and Confederate veteran who led the White League regiment that McGloin and Chopin belonged to.[5]

The violent events of September 1874 cast a shadow over some of Chopin's stories. Her invocations of the White League are oblique, but they do not seem accidental. "The Maid of Saint Phillippe," for example, is a story of foreign occupation and resistance. British troops are poised to claim the area around Fort Chartres, along the Mississippi, and the Creole inhabitants of Saint Phillippe prepare to flee the

area—all except the formidable Marianne, who stubbornly refuses to leave her late father's land. The dashing Captain Vaudry pleads with her to accompany him back to France and become his wife.

> "I love you; oh, I love you, Marianne!"
> "Do you not know, Captain Vaudry," she said with savage resistance, "I have breathed the free air of forest and stream, till it is in my blood now. I was not born to be the mother of slaves."

This eighteenth-century scenario of foreign occupation and freedom-loving Creoles suggests the Liberty Place episode, and the name "Vaudry"—Captain W. T. Vaudry was a prominent figure in the League—confirms it. Chopin wrote "The Maid of Saint Phillippe" in 1891, the year that a monument to the Battle of Liberty Place was erected on Canal Street. Vaudry's letters in praise of his White League comrades appeared in newspapers to celebrate the monument.[6]

Another White League luminary, Dr. Samuel Choppin, is mentioned in Chopin's "A Sentimental Soul," a story about the covert love of a Creole shopkeeper, Mamzelle Fleurette, for a married man, the fiercely Republican locksmith Lacodie. When Lacodie falls ill, Mamzelle Fleurette sees "Choppin's coupe pass clattering over the cobblestones and stop before the locksmith's door. She knew that with her class it was only in a case of extremity that the famous and expensive physician was summoned." It is tempting to see in this passage a miniature allegory for Liberty Place, as the famous Dr. Choppin carries off the corpse of Republican New Orleans. Both these stories announce themes given fuller scope in *The Awakening*. "The Maid of Saint Phillippe" equates motherhood with slavery, while "A Sentimental Soul" allows room for love outside of wedlock.

There is another tantalizing White League connection to *The Awakening*. While Oscar Chopin was fighting under Frank McGloin in the Battle of Liberty Place, and occupying the State House with his Company B, Kate was in St. Louis,

giving birth to their third child. He fought the battle, she labored on the home front. The salient points of this historical and biographical convergence are these: there were two competing seats of government, two "houses" if you will, in New Orleans, and two houses in Chopin's novel. This situation yields, in both novel and city, a *coup d'état*—Alcée Arobin's name for Edna's rebellion. A woman is in childbirth as battle rages. Might this scenario underlie the plotting of *The Awakening*, not in any explicit or allegorical sense, but palpably in the background nonetheless?

Edna's quest for independence is as quixotic, in the end, as the South's doomed attempt to separate itself from the Union. A house divided against itself cannot stand. Almost up to the date of publication, Kate Chopin planned to call her novel "A Solitary Soul." The music that erupts from Mlle. Reisz's piano, and that accompanies the ending of Chopin's novel, is the music of heroic hopelessness, of an alienation so intense that it becomes visionary.

> One piece which that lady played Edna had entitled "Solitude." It was a short, plaintive, minor strain. The name of the piece was something else, but she called it "Solitude." When she heard it there came before her imagination the figure of a man standing beside a desolate rock on the seashore. He was naked. His attitude was one of hopeless resignation as he looked toward a distant bird winging its flight away from him.

2

When exactly did René De Gas fall in love with America? And what did a new piano have to do with it?

On his extended visit to France during the summer of 1872, at the end of which he persuaded his brother Edgar to return to New Orleans with him, René took time off from his various business excursions—through England,

Belgium, and the Rhineland—to visit friends and family and amuse himself. On the ship over he had met a daughter of Pierpont Morgan, and—always eager for a lucrative connection—considered looking her up in London: she was, he wrote his wife, Estelle, *"riche à millions."* England he compared to a billiard carpet in a room where the ceiling leaked—not bad, though the joke was probably not original with René. In Paris in late August, he mentioned dining with a Mr. Briggs who was desolate about having left New Orleans. But Briggs's mulatto son Eddy—the offspring, evidently, of a *plaçage*-type relationship—was attending school near Bristol, where he was well accepted, since "prejudices about color don't exist in England."[7]

Music was much on René's mind. He reported to Estelle on September 6 that he had heard Bach played as never before by a Mlle. Pestalozzi of Zurich, whose father, he added, was in cotton. And he was sending confitures to New Orleans as well as a special present: a new piano. It was time to replace the large Chickering with a smaller Pleyel.

But who exactly was the piano for?

In New Orleans, Edgar Degas painted a luminous composition usually called *The Song Rehearsal.* Two women dressed in the kind of cotton muslin dresses Estelle wears in the National Gallery portrait are performing at an informal soiree in the Esplanade parlor. A tropical plant spreads its broad green leaves behind the head and shoulders of the woman on the left. The woman on the right shields her eyes, as though from the intense Southern light. The bright, spacious parlor in the Esplanade house seen from above, with a steeply sloped floor and long diagonal wall, is reminiscent of the *Cotton Office.* The faded salmon room is intensely rendered, with the panels of the large white door given detailed attention.

The accompanist, who resembles other pictures of René, sits at the piano, his head exactly centered along the middle of the door behind him. There is something eruptive about

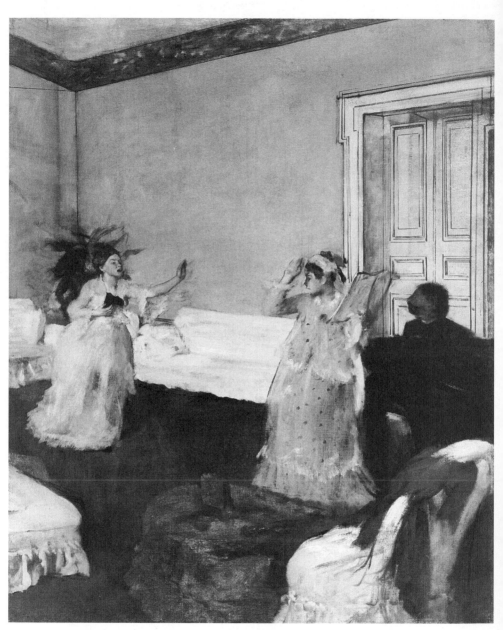

Degas, *The Song Rehearsal*, 1872–73

René's posture at the piano, as well as in the slight blur of his weasel-like profile. He looks towards the singers, the far one of whom raises her hand in a dramatic gesture. She holds no music. Degas was uncertain about a still life spread over a chaise longue in the foreground. Eventually, to open up the space of the room, he cut the chaise back to a chair, with a splash of red—a shawl perhaps—thrown over the back. Degas apparently took some preparatory drawings and the unfinished painting back with him to Paris, where he reworked the composition, trying to get the triangular balance of figures and space just right.

Immediately after Edgar's departure, the name Mme. Olivier began to appear in the family correspondence. She was the neighbor whose white house on Tonti, a few hundred feet behind the Esplanade house and gardens, looms on the horizon, its pitched roof jutting sharply upward, in Degas's *Children on a Doorstep*. Her husband, Léonce Olivier, was a cotton merchant and a member of the Pickwick Club; he participated in the 1873 Mardi Gras with René, presumably dressed as one of "Darwin's Missing Links" in the Comus parade. Mme. Olivier was a music teacher who gave piano lessons to the De Gas children in the Esplanade house.[8]

On March 13, 1873, a week after Edgar's departure, René wrote to his uncle and father-in-law Michel Musson (who was temporarily away from New Orleans) telling him about a fire in a neighboring house. René reports, citing no evidence, that the fire was set by a black man. He mentions Mme. Olivier's presence at the scene. A year later, on October 7, 1874, René's stepdaughter, Joe Balfour, informed her grandfather that her family has had dinner with Mme. Olivier *"et sa bande."*

We don't know exactly when René De Gas fell in love with America—América Durrive Olivier, that is. But like the Parisian romance of René and Edgar's parents, René's new love evidently bloomed in the garden between the two houses. In retrospect the fire next door takes on symbolic

significance. It is quite possible (as the Degas scholar Jean Boggs has recently suggested) that René's marital discord was already evident to Edgar.[9] Edgar's sympathetic portraits of Estelle might register René's infidelity among her other sorrows.

René De Gas deserted his wife and children during the spring of 1878. He and América Olivier fled New Orleans together, on April 13, never to return. They eventually settled in Paris. Edgar, indignant at their misconduct, broke off all contact with his brother for almost a decade.

Let us look at the *The Song Rehearsal* again, in the light—or darkness—of these events. Degas has cleared the salmon room, simplified it, so that we focus our attention on the three figures. The operatic gestures of the two singers—thrusting and parrying—are granted the whole length of the room. A third arm, painted over, is still visible just below the right-hand singer's extended left arm, as is a slightly different position of her raised hand.

Why all this uncertainty? Is it possible that as Degas tinkered with the painting back in Paris, it began to take on a private (and retrospective) meaning for him? That it came to be a painting signifying the plight of his brother René, caught between the two women in his life, and cowering behind Mme. Olivier and the piano that linked him with her? (His internal division is marked by the divided door behind him—his escape route as well.) Let us assume, as James Byrnes suggested, that the isolated singer is the nearly blind Estelle; she holds music in the preparatory drawings, but not in the final painting.[10] She raises her left arm towards the other two figures, in a gesture that seems midway between farewell and accusation—the ambiguity registered in the shadow of a second hand slightly forward of the extended left hand. The posture of the woman to the right is defensive, her hand raised in protection.

The tropical plant was Degas's way of anchoring the painting in New Orleans.[11] He had always associated flow-

ers with Estelle, signifying her pregnancy. But the expressive plant in *The Song Rehearsal* also seems to hold Estelle there, fixing her in her corner of the world as her husband and his lover slide guiltily away from her.

Are we pushing this too far? Isn't Impressionist painting supposed to resist such anecdotal interpretation? Didn't Monet, Renoir, and the rest learn to paint pictures devoid of obvious narrative meaning? True enough. But Degas during the early 1870s experimented with paintings that flirted with narrative, such as the composition, called *Sulking*, of an unhappy couple in an office (Metropolitan Museum of Art) and the even more histrionic *Interior* (Philadelphia Museum of Art). Since *Interior*, painted just before the New Orleans trip, has been convincingly linked to a literary episode from a Zola novel, it seems reasonable enough to tie *The Song Rehearsal* to a real-life event of comparable drama in the Degas family. We should remember, as well, that Degas wrote from New Orleans that he was only doing "family portraits."

Estelle's suffering was not yet over. Blindness, widowhood, exile, desertion—she had experienced them all. Then on September 21, 1878, Estelle's sister Mathilde Musson Bell—the woman Degas painted sitting on the balcony—died at age thirty-seven. Two weeks later, on October 4, the obituaries for Estelle's daughter Jeanne De Gas, dead at age five of yellow fever, appeared in the New Orleans newspapers.

Michel Musson expressed his fury at René in a flurry of legal documents regarding child support and the like, and in his immediate decision to change the last names of his grandchildren—whom he eventually adopted—from De Gas to Musson. He pleaded with Edgar to denounce his own brother, causing a needless further rift in the family. Meanwhile, Musson's finances were in increasing disarray, forcing him to give up the Esplanade house and move to smaller quarters on Rampart Street. His letters of the spring

of 1879 betray the gulf of paranoia into which he was descending.

As if one feud were not sufficient, Musson managed to pick a fight with his other son-in-law, William Bell. While Bell was away on a business trip, he placed his children under the temporary care of his sister. When the children did not, as was their custom, stay with Musson for one Sunday dinner, Musson, on no evidence, assumed that this was the result of Bell's explicit instructions, to deprive him of his grandchildren's company. Musson wrote an insulting letter to Bell's sister, Mrs. Norton; her son Mortimer N. Wisdom responded in kind. In even more abusive language, Musson attacked Wisdom, and proceeded to draft a challenge to a duel. Musson's seconds were to be the "bearers of the note": the White League leaders General Frederick N. Ogden and Dr. Cornelius Beard. (Wisdom was also a member of the White League, so these rituals of "honor" were, so to speak, all in the family.)

When William Bell returned to New Orleans, he tried to patch things up by appealing to Désirée Musson. Michel Musson intervened, claiming that the only difference between René De Gas and William Bell was that "the former has acted *criminally*" and that Musson would "shoot him on sight if he ever does return here." He added that he was not impressed that Bell was "hiding behind [Désirée's] petticoats."[12] To Musson's credit, he apparently did not send the challenge to Wisdom. Even he seems to have realized that such rituals had become obsolete. But the rupture between the Musson family and the Degas brothers was complete. Neither Edgar nor René ever returned to Louisiana.

It is odd, so late in the story, to find the old White Leaguers making a curtain call, as though the "solutions" of Liberty Place might still be appropriate so many years later. The alliances of love and loyalty struck in the house on Esplanade, during those intense months of 1873 and 1874, were mere ghosts as Musson contemplated the ruins of his life and family.

Michel Musson died in the spring of 1885. "For a long period," wrote the *Picayune* obituarist on May 5, "Michel Musson was weighed by family cares and afflictions, this contributing in the end to his departure from this earth."

Esplanade: A Coda

You may see [the Creoles'] grandchildren, to-day, anywhere within the angle of the old rues Esplanade and Rampart, holding up their heads in unspeakable poverty, their nobility kept green by unflinching self-respect, and their poetic and pathetic pride revelling in ancestral, perennial rebellion against common sense.

GEORGE CABLE, *The Grandissimes*

O N a gray afternoon in late March, I took another walk down Esplanade. It was the third or fourth time I had gone to pay my respects to the Musson house. As I approached the upper edge of the French Quarter, I paused for a moment in front of a detached townhouse between Burgundy and Rampart, on the right side of Esplanade. The architect James Freret, grandson of Eugénie Rillieux, built this modest frame house in 1881 for his cousin Estelle Musson. It is a cheerful little house, with a roof overhanging the obligatory second floor balcony. Its modesty contrasts with the Greek Revival mansion across the avenue, the former joint residence of General Beauregard and his brother-in-law John Slidell, the political boss and Confederate diplomat who was Judah Benjamin's mentor. By the time Estelle moved into this neighborhood, it no longer had its pre-war glamour. But it must have been a convenient location for

the blind Estelle and her children, on the edge of the Quarter and just around the corner from her father's last residence on Rampart Street.

I had let the great decrepit avenue, with its parade of shade trees and decaying houses, lull me into a daydream in which fiction and history rhymed effortlessly. I told myself that I might even now, without knowing it, be walking by the remains of Léonce Pontellier's "very charming home on Esplanade." And somewhere off to the right, between Esplanade and "that sorry streak once fondly known as Champs-Élysées," was surely hidden the great "mother-mansion" of the Grandissimes. Its encircling veranda was so wide, George Cable said, that twenty Creole girls might walk there abreast. . . .

I was shaken from this pleasant reverie by the thundering overpass of Interstate 10, which cut a wide swath through the old Claiborne Avenue, eliminating many of the Creole cottages once inhabited by free people of color. As I reached Galvez Street, I remembered that here, along the right side of Esplanade, stretched the considerable property of Paul Cheval, a free man of color who had a house here during the early nineteenth century.[1]

A few minutes later, when the noise from the interstate had subsided, I was crossing Miro Street, and I knew I was approaching my goal. This is where Bayou Road—the old Shell Road where Mme. Lalaurie fled for her life—crosses Esplanade, forming a green triangle. In the middle of that triangle there is a white statue, in vaguely Greek garb, atop a great terra-cotta Baroque base. The statue is identified as the Goddess of History, and the little piece of land has been dedicated, since 1886, to the Creole historian Charles Gayarré, nemesis of George Washington Cable.

The upper boundary of Gayarré Park is Tonti Street. The Goddess of History, if she turned her head, could see number 2306 Esplanade, the Musson house where Edgar Degas lived during his sojourn in New Orleans.

But I had learned something about that house since my

previous journey down Esplanade. Someone had passed on the interesting piece of information (a recent discovery, apparently) that there wasn't just one Degas-Musson house, but two, side by side. Of course I knew that part of the house was gone—"sliced away," as the writers in the *New Orleans Architecture* series put it.[2] What I didn't realize was that it hadn't gone very far—maybe fifty feet or so. There it stands, like a plainer sister, next door to the house with the historical marker, and with an unfortunate porch tacked onto its facade (and obscuring the kinship of the houses). Nobody knows exactly when the house was divided in half, or why. Feuding heirs? Higher rentals for two houses rather than one? Whatever the reason, the Musson house on Esplanade had suffered a fitting fate for a divided house. It could now serve as an emblem for the bad luck that always seemed to attend marriages between members of the Musson and Degas families.

The divided Musson house, 1997

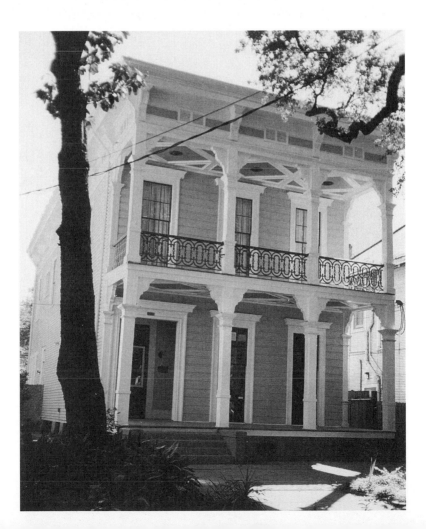

Acknowledgments

I first became interested in Edgar Degas's sojourn in New Orleans when I saw the Degas retrospective of 1988 at the Metropolitan Museum in New York. Two scholars of nineteenth-century French art have been of particular help to me in making sense of Degas: Robert L. Herbert, my colleague at Mount Holyoke College, and Marilyn R. Brown, of Tulane. At a later stage, it was a pleasure to be in touch with Hollis Clayson and Theodore Reff.

Professor Lawrence Powell of Tulane suggested that I look into the Unification Movement, and directed me to the correspondence of George Cable and John Dickson Bruns. I also received useful advice from Plater Robinson, of the Southern Institute for Education and Research at Tulane, and Professor Joseph Roach, then in the Tulane Theater Department and now at Yale.

Much of the research for this book took place in the Historic New Orleans Collection, where John Magill was a source of steady insight and information, and in the Special Collections and the Louisiana Collection of the Tulane University Library. I received key documentation from Jack Belsom at the Archdiocesan Archives of New Orleans, Randy Reed at the Louisiana State Archives in Baton Rouge, Sally K. Reeves, archivist of the New Orleans Notarial Records, and Wayne Evremond of the Louisiana Division of the New Orleans Public Library.

I wish to thank some of the many friends who made me feel welcome in New Orleans: Valerie Martin, John Cullen, Candy and Jack Weiss, Christine Wiltz, Joseph Pecot, Richard Ford, Tom Piazza, Judith and Thomas Bonner, Patricia Brady. Back home, my colleagues at Mount Holyoke, especially the historians Daniel Czitrom and Joseph Ellis, listened patiently to my finds. Nicholas Bromell made helpful comments on an early draft of the book.

Three editors—Leon Wieseltier of *The New Republic,* Joseph Epstein of *The American Scholar,* and J. D. McClatchy of the *Yale Review*—published sections of the book, which benefited from their care and their questions.

From the outset of this project, Melanie Jackson and Harry Ford, my agent and editor respectively, expressed unfailing enthusiasm and confidence. A fellowship from the National Endowment for the Humanities

and a faculty fellowship from Mount Holyoke College gave me the time I needed. The book would not have gotten started or ended without the support of Mickey Rathbun.

CHRISTOPHER BENFEY
Amherst, Massachusetts
May 1997

Notes

To avoid undue pedantry, I have not provided page citations for Degas's five letters from New Orleans, which can be found in Marcel Guérin, editor, *Degas Letters*, translated by Marguerite Kay (Oxford: Bruno Cassirer, 1947). Occasionally I have modified the English versions, or adapted them according to other translations. No page numbers are given for the readily available fictional works of George Washington Cable and Kate Chopin.

ESPLANADE: AN INTRODUCTION

1. An exception is Marilyn R. Brown's work on Degas, especially her *Degas and the Business of Art: A Cotton Office in New Orleans* (University Park, Pa.: College Art Association/Pennsylvania State University Press, 1994). John Rewald's article, "Degas and His Family in New Orleans," first published in August, 1946, in the *Gazette des Beaux-Arts*, was the pioneering work on the subject.

2. Benjamin H. B. Latrobe, *Impressions Respecting New Orleans*, edited by Samuel Wilson, Jr. (New York: Columbia University Press, 1951), 165–6. For details on Degas's family, here and elsewhere, I have relied on the two standard biographies: Roy McMullen, *Degas: His Life, Times, and Work* (Boston: Houghton Mifflin, 1984) and Henri Loyrette, *Degas* (Paris: Fayard, 1991).

3. Loyrette, *Degas*, 18. On Degas's New Orleans cottage see Roulhac Toledano, et al., *New Orleans Architecture, Volume VI, Faubourg Tremé and the Bayou Road* (Gretna, La.: Pelican Publishing Co., 1980), 22.

4. Loyrette, 20.

5. On Kenner, see below, Chapters One and Seven.

6. Valéry, *Degas, Manet, Morisot*, David Paul, translator (New York: Pantheon, 1960), 71. Immediately following the passage, Valéry records Degas's first morning in New Orleans, when he was awakened by a workman shouting, "Auguste!"—an echo, though Valéry doesn't point this out, of Célestine's complaint.

7. Jeanne Fevre, *Mon Oncle Degas* (Geneva: Pierre Cailler, 1949), 29.

8. Jean Sutherland Boggs et al., *Degas* (New York: The Metropolitan Museum of Art, 1988), 48. See also McMullen, 25.

9. Boggs, 50. For Degas's Italian sojourn, see also McMullen, chapters 4 and 5.

10. On Degas's relations with the Millaudon family, see James B. Byrnes, "Edgar Degas, His Paintings of New Orleanians Here and Abroad," included in the catalog *Edgar Degas: His Family and Friends in New Orleans* (New Orleans: Isaac Delgado Museum of Art, 1965), 61–71.

11. The bourgeois Degas family, descended from a provincial baker called "Degast," could claim no noble descent. See McMullen, 8.

12. "What impression did my dance picture make on you," he wrote James Tissot from New Orleans, "on you and the others?" *At the Races* and *Dance Class at the Opera* were exhibited on November 2, 1872, in London. Boggs et al., 60.

13. On Degas's developing reputation, see Carol M. Armstrong, *Odd Man Out: Readings of the Work and Reputation of Edgar Degas* (Chicago: University of Chicago Press, 1991), especially Chapter Five, "The Myth of Degas."

14. Grace King, "The Old Lady's Restoration," in *Balcony Stories,* edited by E. Catherine Falvey (Albany, N.Y.: NCUP, Inc., 1994), 62.

15. Frederick Law Olmsted, *A Journey in the Seaboard Slave States* (New York: Dix & Edwards, 1856), 593–4.

16. Ambroise Vollard, *Degas: An Intimate Portrait,* translated by Randolph T. Weaver (New York: Dover, 1986), 48.

SOULIÉ

1. Kenner's diary entries are drawn from *A Man of Pleasure—And a Man of Business: The European Travel Diaries of Duncan Farrar Kenner, 1833–1834,* edited by Garner Ranney (Lafayette, La.: Center for Louisiana Studies, University of Southwestern Louisiana, and New Orleans: Hermitage Foundation, 1991). The published version of the diary gives, on page 112, the name "Masson" among a group of Parisian acquaintances, but the manuscript at the Historic New Orleans Collection, which the owner of the document, Robert Judice, kindly gave me permission to view, clearly reads "Musson."

2. Garner Ranney, editor of the Kenner diary, is unable to identify Henry Degas, and notes that a Frederic Degan was the United States consul in Naples from 1805 to 1809 (119, n. 53).

3. Kenner, *A Man of Pleasure,* 48–9, 50.

4. Ibid., 104, 109.

5. For information on Norbert Soulié, see Edith Long, "Creole Cottage Blooms under Scott Touch," in the *Vieux Carré Courier* (March 17, 1967), 2. In his *Guide to Architecture of New Orleans—1699–1959* (New York: Reinhold, 1959), Samuel Wilson, Jr., mentions that "the names of Norbert Soulié, who worked with Henry S. Latrobe, architect, and Louis Pilié, architect and New Orleans city surveyor, are mentioned in finan-

cial statements of the [Evergreen] plantation" (54). The Artists' File at the Historic New Orleans Collection contains this and other data on Soulié's work. I am grateful to Mr. John Magill of the Collection for pursuing information on Soulié for me. See also Benjamin Latrobe, *Impressions Respecting New Orleans*. The introduction by Samuel Wilson, Jr., describes the Latrobes' activities in New Orleans.

6. Edith Long, "Creole Cottage," 2.

7. On the Cheval family holdings along Esplanade, see Mary Louise Christovich et al., *New Orleans Architecture, Volume V: The Esplanade Ridge* (Gretna, La.: Pelican, 1995), 104, 107, 123. Edith Long mentions that Constance Vivant acquired a strip of property "from her kinswoman [actually sister] Luison Cheval, called Vivant."

8. See Theodore Seghers, notary, March 2, 1832. New Orleans Notarial Archives. Sally Reeves, the archivist, helped me track down these materials.

9. In the Musson-DeGas Family Papers, Tulane Special Collections, there is a reference to the *Year Book of the Louisiana Society Sons of the American Revolution* (New Orleans: 1919–1920), 106, where mention is made of the children of Don Vincente Rillieux: "The son, Vincente Rilleaux [*sic*], was killed in a duel."

10. Kenner, *A Man of Pleasure,* 107. Norbert Soulié did not "vanish," as Edith Long claims, either in Sweden or on the road to Moscow. A lifelong bachelor, he lived well into his seventies in Paris. He died on November 30, 1869, leaving to his brothers and nephews the astonishing sum of $62,033.16. A record of his will is in New Orleans city records, now housed in the New Orleans Public Library.

HAUNTED HOUSE (1834)

1. Harriet Martineau, *Retrospect of Western Travel* (London: Saunders and Otley, 1838), two volumes. All references in the text may be found in the following pages of volume one: 263–76.

2. Grace King, *Creole Families of New Orleans* (1921; Baton Rouge: Claitor's Publishing Division, 1971), 373. "Nine children were born of the marriage of Placide Forstall with Delphine Lopez," King writes elsewhere in her book. "To belong to good society in New Orleans is to know them and their connections" (361–2). The full story of the Macarty family remains to be told, or rather, discovered. One would like to know, for example, how Cecee Macarty (whose mother, Henrietta Prieto, was a sponsor at Edmond Rillieux's baptism) became the largest slaveholder among the free blacks of New Orleans. The middle name of the black lawyer, D. B. Macarty, was Bartholomé, the name of Madame Lalaurie's father. D. B. Macarty oversaw the business interests of the black members of the Soulié and Rillieux families.

3. Dora Richards Miller, draft of haunted house story, in George Cable Papers, Tulane Library Special Collections. See Chapter Twelve, below.

4. New Orleans Notarial Archives, Octave de Armas, 30 August 1831. I have taken George Cable's word on this.

5. Cable, "The 'Haunted House' in Royal Street," in *Strange True Stories of Louisiana* (1888; reprinted Gretna, La.: Pelican, 1994), 192–232.

6. George Washington Cable pursued the earliest research on Congo Square. See *Creoles and Cajuns: Stories of Old Louisiana*, Arlin Turner, editor (Garden City, N.Y.: Doubleday Anchor, 1959). Also Jerah Johnson, "New Orleans's Congo Square: An Urban Setting for Early Afro-American Culture Formation," in *Louisiana History* 32, no. 2 (Spring 1991), 117–57.

7. Kate Chopin, *The Awakening* (1899), chapter XX. Inside the house an altercation is taking place between a white character and a black woman in his family's employ.

8. Cable, "Jean-ah Poquelin," in *Old Creole Days* (1879), first paragraph of the story.

9. Eugene Genovese, *The World the Slaveholders Made* (Hanover, N.H.: Wesleyan University Press/University Press of New England, 1988), 123.

10. Cf. Note 2, above. Dr. Lalaurie did fight a duel in 1870 after getting into an argument about the talents of an opera contralto he was smitten with. See Robert Tallant, *The Romantic New Orleanians* (New York: Dutton, 1950), 211.

11. Valerie Kossew Pichanick, *Harriet Martineau: The Woman and Her Work, 1802–76* (Ann Arbor: University of Michigan, 1980), 88–9. "Martineau approved miscegenation and condemned social discrimination, but why, one cannot help wondering, did she think of Ailsie as her probable servant rather than as her possible child?" (89).

12. Papers on the Lalaurie family in Tulane Special Collections.

13. Edmund Wilson, *Patriotic Gore: Studies in the Literature of the American Civil War* (New York: Oxford University Press, 1962), 565.

TELL

1. Cable, *Creoles of Louisiana*, 267.

2. Gerald M. Capers, *Occupied City: New Orleans under the Federals, 1862–1865* (Lexington: University of Kentucky Press, 1965), 60. For the Lalaurie mansion as Union headquarters, see *New Orleans City Guide* (Boston: Federal Writers' Project of the Works Progress Administration for the City of New Orleans, 1938), 249: "During the years of the Civil War the house was used as Union headquarters."

3. Capers, *Occupied City*, 63.

4. James M. McPherson, *Battle Cry of Freedom: The Civil War Era* (New York: Oxford University Press, 1988), 552.

5. Capers, 67.

6. Ibid., 69.

7. Joe Gray Taylor, *Louisiana Reconstructed, 1863–1877* (Baton Rouge: Louisiana State University Press, 1974), 4.

8. Capers, 71.

9. Ibid., 75.

10. On the Southern Emancipation Proclamation, see Craig A. Bauer, *A Leader among Peers: The Life and Times of Duncan Farrar Kenner* (Lafayette, La.: University of Southwestern Louisiana/Center for Louisiana Studies, 1993), chapter X, and below, Chapter Seven.

11. See McMullen, *Degas,* 111. Here and elsewhere I have quoted McMullen's translations of letters.

12. Ibid., 110.

13. Ibid., 111.

14. See Loyrette, *Degas,* 180, 300 *("la bien-aimée Désirée").*

15. Among Estelle's nearly illegible letters on translucent paper there is one, dated August 12, 1863, in which she laments the fall of Vicksburg and the fate of *"notre pauvre Sud."* See also Boggs et al., *Degas,* 106: "He was undoubtedly struck by their accounts of 'atrocities.' . . ."

16. For the various influences and anachronistic details of *Scene of War,* see Boggs et al., *Degas,* 105–7.

17. Quentin Bell first discerned this right-left tendency in Degas's work. The miserable couple in the enigmatic *Interior* (c. 1868, Philadelphia Art Museum), long known as "The Rape," assume similar "civil war" postures. See Bell, *Degas, Le Viol* (Newcastle-upon-Tyne: Charlton Lectures on Art, 1965).

18. The curators of the *Degas: Beyond Impressionism* show at the Art Institute of Chicago (fall, 1996) drew specific attention to *After the bath,* c. 1893–5 (Private Collection) as a reprise of one of the figures in *Scene of War.* See Richard Kendall's catalog of the show (New Haven: Yale University Press/Art Institute of Chicago, 1996), 244. And cf. Boggs et al., *Degas:* "One is struck . . . by how amazingly the figures here [in *Scene of War*] foreshadow all the female nudes yet to come. The women in this picture . . . strike the same immodest attitudes as the women Degas would later depict in the act of bathing, drying themselves, combing their hair, or sleeping" (107).

19. Gary Tinterow and Henri Loyrette, *Origins of Impressionism* (New York: Abrams/Metropolitan Museum of Art, 1994), 48: "Degas concealed contemporary meanings in historical settings. Thus, *La Fille de Jephté* can be seen as a critique of Napoleon III's foreign policy in Italy." This section, on history painting, was written by Loyrette.

20. Hélène Adhémar, "Edgar Degas et la Scène de guerre au Moyen Age," *Gazette des Beaux-Arts* (November 1967), 295–8.

21. See Tinterow and Loyrette, *Origins,* 48: *"Scène de guerre au Moyen Age* is an allegorical treatment of the American Civil War and the Northern soldiers' cruelty toward the women of New Orleans."

22. Woodward, "The Irony of Southern History," in *The Burden of Southern History,* revised edition (Baton Rouge: Louisiana State University Press, 1968), 190.

23. See Marilyn R. Brown, *The DeGas-Musson Family Papers: An Annotated Inventory* (New Orleans: Howard-Tilton Memorial Library, Tulane University, 1991), 48–49. I use Brown's translations of much of this material.

24. C. L. R. James, *Black Jacobins: Toussaint L'Ouverture and the San Domingo Revolution,* second edition (New York: Vintage, 1963), 29.

25. For the "flight of 1809" see Cable, "Café des Exilés" in *Old Creole Days;* and *Creoles of Louisiana,* 157.

26. Paul F. Lachance, "The Foreign French," in *Creole New Orleans: Race and Americanization,* edited by Arnold R. Hirsch and Joseph Logsdon (Baton Rouge: Louisiana State University Press, 1992), 105, 117.

27. Cable, *Creoles of Louisiana,* 157.

28. Details about Germain Musson's career are drawn primarily from McMullen's account, 5–7.

29. M. Brown, *DeGas-Musson Family Papers,* 48.

SIEGE

1. Daniel S. Rankin, *Kate Chopin and Her Creole Stories* (Philadelphia: University of Pennsylvania Press, 1932). Dated entries from Chopin's diary may be found in this volume.

2. Emily Toth, *Kate Chopin* (New York: Morrow, 1990), 95. I have relied on this volume for biographical information on Chopin.

3. See Toth, *Kate Chopin,* 122. Oscar Chopin's father, Dr. Jean Baptiste Chopin, "ran his Red River plantations with an iron hand and became famous for brutality toward his slaves. Local folklore confused him with Robert McAlpin, who had owned the land before him and who was sometimes said to be the model for Simon Legree in *Uncle Tom's Cabin.*"

4. *Pages from the Goncourt Journal,* edited and translated by Robert Baldick (New York: Penguin, 1984), 173.

5. Valéry, "Degas, Dance, Drawing," in *Degas, Manet, Morisot,* 9.

6. McMullen, 190.

7. Alfred Cobban, *A History of Modern France,* volume two (New York: Penguin, 1965), 207. For Goncourt on the elephants, see *Pages from the Goncourt Journal,* 179.

8. Loyrette, *Degas,* 260.

9. McMullen, 260.

10. See Cobban, *A History of Modern France,* 208.

11. Boggs et al., *Degas,* 168: "It was during the Commune and at Ménil-Hubert," according to the grown-up Hortense Valpinçon, the oldest child of the Valpinçons, that Degas painted her—when she was nine—in another picture evoking the peace of the countryside (Minneapolis Institute of Arts). This is another of Degas's off-center portraits, but Hortense seems less pushed to the edge of her life than poised for quick escape. Degas's pleasure in the subject is evident in the lovingly

painted still life of patterned table and embroidery, an island of domestic tranquility.

12. Madame Morisot quoted in Boggs et al., 59.

13. See M. Brown, *DeGas-Musson Papers,* 50.

THREE SISTERS

1. A. Oakey Hall, *The Manhattaner in New Orleans* (New York: J. S. Redfield, 1851), 112.

2. The whitewashing, as John Magill of the Historic New Orleans Collection suggested to me, may well have been an insecticide. Photographs of Esplanade before the Civil War show these whitewashed trees.

3. For a description of the Musson house, see Mary Louise Christovich et al., *New Orleans Architecture, Volume V: The Esplanade Ridge,* 109–11. When the house was sold in 1877, it was described in a newspaper advertisement as "that elegant and spacious residence, for many years occupied by M. Musson" (111).

4. Fevre, *Mon Oncle Degas,* 30.

5. McMullen, 139.

6. McMullen suggests that for Degas, New Orleans was "a sort of antebellum time capsule" (233). Charles Dudley Warner, visiting the city a decade later, noted that "In no other city of the United States . . . is the old and romantic preserved in such integrity and brought into such sharp contrast to the modern." See Warner's *Studies in the South and West* (New York: Harper, 1889), 42.

7. The "Musson granite buildings" are mentioned in Hall, *The Manhattaner,* 54. An illustration of the plush interior of the E. A. Tyler store, in the Musson building, is reproduced in Christovich et al., *New Orleans Architecture, Volume II, The American Sector* (Gretna: Pelican, 1972), 173.

8. McMullen, 235.

9. See James B. Byrnes, "Edgar Degas, His Paintings of New Orleanians Here and Abroad," in *Edgar Degas: His Family and Friends in New Orleans* (New Orleans: Isaac Delgado Museum of Art, 1965), on Bell as "an official of the Race Track Board" (76). Also, see Nancy Stout, *Great American Thoroughbred Racetracks* (New York: Rizzoli, 1991), 76: "In 1872, the year the racetrack was officially established, a person following Esplanade north from the French Quarter would have travelled . . . through nearly empty marshland and come upon a farmhouse, now 2306 Esplanade Avenue, whose fields directly survey the racetrack. This farmhouse is where Edgar Degas stayed. . . . It is hard to believe that an artist so interested in the French turf did not take note of the activities at the newly formed racetrack, in full view from the farmhouse. The entire area, besides the farmhouse, consisted only of the grandstand, a few buildings, the racetrack, the Lüling Mansion, and the St. Louis III Ceme-

tery just beyond." The Lüling Mansion is described in detail in Christovich et al., *New Orleans Architecture, Volume V: The Esplanade Ridge,* 134–5. *Jewell's Crescent City Illustrated* (unpaginated) has an illustration of the mansion after it became the Jockey Club. For the relation of the Mussons and the Lülings, see Grace King, *Creole Families,* 389: "Not to know the names of the married Longer ladies is regarded in the Creole city as proof of unpardonable social ignorance. Eulalie became Mrs. Samuel Bell; Adèle married Florian Herrmann; Odile, Michel Musson . . . Helena [actually Elena], Charles Lüling." Since Samuel Bell was William Bell's brother, Michel Musson had a brother-in-law and a son-in-law who were themselves brothers. I haven't traced Florian Herrmann's possible kinship with Mrs. Emma Heilbuth, *née* Hermann, whom Achille De Gas married in 1881 in New York. There is correspondence between the Musson and the Lüling families in the DeGas-Musson family papers at Tulane.

10. On prostitution in New Orleans after the Civil War, see Herbert Asbury, *The French Quarter: An Informal History of the New Orleans Underworld* (New York: Alfred A. Knopf, 1936). "By 1870 . . . bordellos of every degree of viciousness, from the ten-dollar parlor-house to the fifteen-cent Negro crib, were running wide open on such important streets as Gravier, St. John, Chartres, St. Charles, Basin, Union, Royal . . . ; except in the outlying parts of the city, there was scarcely a block in New Orleans which did not contain at least one brothel or assignation house" (352). On the matter of Degas's reputed impotence, or homosexuality, Robert L. Herbert notes countervailing evidence in a letter of August 1889, from Degas to his friend Giovanni Boldini, before their trip to Spain together. Degas told Boldini where he might buy condoms, since "there can be seductions, in the first place for you, but even for me, in Andalusia." See *Degas inédit, actes du colloque Degas* (Paris: Musée d'Orsay, 1989), 418, cited in Herbert, "Degas & Women," *The New York Review of Books* (April 18, 1996).

11. William H. Williams, "The History of Carrollton," *Louisiana Historical Quarterly* 22 (1939). "In 1872 a . . . small fireless locomotive was invented and perfected under the patronage of [Laurent Millaudon's Carrollton Railroad] company, by Émile Lamm, which was adopted as a substitute for horse power, on the upper suburban part of the road; while horse cars were continued on the lower end extending into the city. . . . The invention having been made, and the locomotive constructed in the shops of the Carrollton Railroad, it seems not inappropriate to mention it . . . as an improvement specially identified with this road and with the town of Carrollton" (196). See also Marilyn R. Brown, *Degas and the Business of Art,* 122–3, note 25: "The streetcar invention in question [in Degas's correspondence with Rouart] was probably the ammonia gas engine invented and patented in 1872 by New Orleanian Émile Lamm. . . . Lamm's use of ammonia gas would have been of interest to Rouart, whose ice machine employed compressed liquified ammonia gas." The Carrollton Railroad later became the St. Charles streetcar line.

12. William Saunders, *Through the Light Continent; or, The United States in 1877–8* (London: Cassell, Petter, & Galpin, 1879), 67–8.

13. Brown, *Degas and the Business of Art,* 123. Brown notes that the president of the ice factory during the early 1870s was H. C. Millaudon, "presumably of the same family that was friendly with the Mussons" (123, note 27).

14. On the Rouart-Degas relationship, see Rebecca R. DeMuth, "Edgar Degas, Henri Rouart: Art and Industry," M.A. thesis, University of Pittsburgh, 1982. Marilyn Brown cites DeMuth's demonstration that the Louisiana Ice Works is the factory depicted behind Rouart's hat in Degas's 1875 portrait of his friend (125).

15. *DeGas-Musson Family Papers, "le Grrrrand Artiste,"* 20, 50.

16. Robert Tallant, *Romantic New Orleanians,* 172–3.

17. Edward King, *The Great South,* (New York: Harper's, 1875), 30.

18. Grace King, *Balcony Stories* (1893: Albany: NCUP, 1994), 1.

19. Jacques Derrida, *Memoirs of the Blind: The Self-Portrait and Other Ruins,* translated by Pascale-Anne Brault and Michael Naas (Chicago: University of Chicago Press, 1993), 2.

20. On Degas's eye problems, see Richard Kendall, "Degas and the Contingency of Vision, *Burlington Magazine* 130, no. 1020 (March 1988), 180–97.

21. Theodore Reff quotes this remark (reported by George Moore) in *Degas: The Artist's Mind* (New York: Metropolitan Museum of Art/Harper & Row, 1976), in the context of a discussion of Degas's painting of the circus performer Miss La La (170–1). See below, Chapter Seven.

22. Edward King, *The Great South,* 28–29.

OLD CREOLE DAYS

1. Edward Larocque Tinker, *Creole City, Its Past and Its People* (New York: Longmans, Green & Co., 1953), citing Twain. Also Mark Twain to William Dean Howells, February 27, 1885.

2. Quoted in Joseph G. Tregle, Jr., "Creoles and Americans," in Hirsch and Logsdon, editors, *Creole New Orleans: Race and Americanization,* 131.

3. Details of Edward King's life are drawn from *The Dictionary of American Biography.*

4. *The Great South,* 31–33.

5. See Taylor, *Louisiana Reconstructed,* 241–55, and Eric Foner, *Reconstruction: 1863–1877* (New York: Harper & Row, 1988), 550–1. Also, *The Great South,* 92.

6. *Great South,* 34.

7. Ibid., 51.

8. Ibid., 53.

9. Arlin Turner, *George W. Cable, A Biography* (Durham: Duke University Press, 1956), 52.

10. Turner, 54.

11. Ibid.

12. The paperback edition of *Old Creole Days* currently available is published by Pelican Publishing Company, Gretna, Louisiana, 1991.

13. Cable was a passionate foe of the Louisiana Lottery, and lobbied against it.

14. On *Les Cenelles,* see Edward Maceo Coleman, editor, *Creole Voices: Poems in French by Free Men of Color* (Washington, D.C.: Associated Publisher, 1945). See also David C. Rankin's doctoral thesis, "The Forgotten People: Free People of Color in New Orleans, 1850–1870" (Johns Hopkins, 1976). An unpublished essay by Floyd Cheung of Tulane University, "*Les Cenelles* and Quadroon Balls: 'Hidden Transcripts' of Resistance and Domination in New Orleans, 1803–1845" (1996), raises interesting questions about the audience for these poems. A similar hesitation around the word designating *plaçage* may be found in Alice Dunbar-Nelson's story "Sister Josepha." A couple offers to adopt the abandoned child Camille, who lives in a convent. "You must understand, madame," the Mother Superior remarks, "that we never force children from us. We are ever glad to place them in comfortable—how you say that?—quarters—maisons—homes—bien!" See Gloria T. Hull, editor, *The Works of Alice Dunbar-Nelson,* volume 1 (New York: Oxford University Press, 1988), 159. On Dunbar-Nelson in relation to other New Orleans writers, see Violet Harrington Bryan, *The Myth of New Orleans in Literature* (Knoxville: University of Tennessee Press, 1993).

15. Tregle, 177.

16. Ibid., 179.

17. Tinker, 219–20.

18. Tregle, 181–2.

19. Turner, 119.

20. Mark Twain, *Mississippi Writings* (New York: Library of America, 1982), 485.

RILLIEUX

1. Marilyn Brown interprets the black-white scheme of the painting as having a racial resonance. See *Degas and the Business of Art,* 42.

2. See Sidney Kaplan, citing John Walton Caughey, *Bernardo de Gálvez in Louisiana 1776–1783* (Berkeley, 1934), in notes added to George P. Meade's article "A Negro Scientist of Slavery Days," *The Negro History Bulletin* (April 1957), 161, 163.

3. For the Brennan's connection, see James B. Byrnes, "Edgar Degas, His Paintings of New Orleanians," 96, n. 18. The information came from the architectural historian Samuel Wilson, Jr.

4. Sacramental records of the St. Louis Cathedral. Militia records are in Tulane Special Collections.

5. Olmsted, *Seaboard Slave States,* 597.

6. Vivant's signature is on notarial and court documents relating to her children's affairs. She lived in apparent comfort in her house on Burgundy Street until her death in 1869.

7. Olmsted, 594.

8. Martineau, quoted in Herbert Asbury, *The French Quarter* (New York: Knopf, 1936), 130.

9. George P. Meade, "A Negro Scientist of Slavery Days," originally published in *Scientific Monthly,* 62 (1946), reprinted in *The Negro History Bulletin* (April 1957). Citations refer to the reprinted version, augmented with notes by Sidney Kaplan. I have relied extensively on this article, which is the major, and in certain respects the sole, source on Rillieux's life and career. Rillieux's published papers have apparently not survived. I have recently learned that Edmond Rillieux was also educated in Paris. I am indebted to my father, Professor Theodor Benfey, for helping to track down school records of the Rillieux brothers.

10. Meade, 161.

11. Ibid., 160.

12. Olmsted, 671.

13. Ira Berlin, *Slaves Without Masters: The Free Negro in the Antebellum South* (New York: Pantheon, 1974), 274–5.

14. Meade, 160. For Duncan Kenner's use of the Rillieux apparatus, see Craig A. Bauer, *A Leader Among Peers,* 47–8, 289.

15. C. Vann Woodward, editor, *Mary Chesnut's Civil War* (New Haven: Yale University Press, 1981), 288. Benjamin in *De Bow's Review,* volume III (1846), 211. Rillieux's article, *De Bow's Review,* volume V (1848), 291–3 ("Now I will endeavor to come to a true estimate of the relative value of these [competing] apparatus of the same boiling power, giving the same quantity and quality of sugar. One an open steam evaporating pan and strike vacuum pan—one double vacuum pan apparatus—and a N. Rillieux's three pan apparatus.").

16. Louis Gruss, "Judah Philip Benjamin," *Louisiana Historical Quarterly,* 19 (1936), 987. John Alfred Heitmann, *The Louisiana Sugar Industry, 1830–1910* (Baton Rouge: Louisiana State University Press, 1987). Heitmann points out the irony that "many planters argued that an evaporator invented by the black scientist Rillieux was too complicated to be operated by black men" (39).

17. Eli N. Evans, *Judah P. Benjamin: The Jewish Confederate* (New York: Free Press, 1988), 34. Benjamin tried only once to lure Natalie back to America, when he was beginning his second Senate term in Washington in 1858. He spent a fortune outfitting an opulent house on Decatur Street, only to have Natalie, after an uneasy round of socializing, return to Paris again. That was the end of his attempts to restore his marriage to some semblance of normalcy (Evans, 104–5). He had failed, in a flamboyantly public way, at keeping his exotic bird in the gilded cages of Bellechasse and Decatur Street. Benjamin collected finery for his house, perhaps without realizing that he treated his Creole wife as a valued possession as well. Varina Davis, wife of Jefferson Davis, remarked of Benjamin: "His

life in his family must have been gruesome, but he always spoke of him-self as the happiest of men" (Evans, 105). Having sold off at public auc-tion the debris accumulated for the spectacular debacle of his marriage, Benjamin, as he had in the past, resorted to male intimacy instead.

18. Pierce Butler, *Judah P. Benjamin* (Philadelphia: G. W. Jacobs, 1907), 59. I found no mention of Rillieux among the Pierce Butler Pa-pers at Tulane.

19. Meade, 161.

20. Ibid.

21. Charles Barthelemy Roussève, *The Negro in Louisiana* (New Or-leans: Xavier University Press, 1937), 51–2, quoted in Meade, 161.

22. Meade, 161.

23. Meade identifies Kenner as "Keener" (161).

24. Ibid., 162.

25. On Rillieux's widow, see the biographical notes (page 8) by Ed. Koppeschaar, "sugar technician," appended to the commemorative brochure for the centennial celebration, in Amsterdam, of the first in-stallation of Rillieux's triple-effect apparatus *("Norbert Rillieux: 'Commé-moration du Centenaire de la mise en marche de la première installation d'évaporation dans le vide à triple effet à la Louisiane en 1834'")*. Koppeschaar was evidently in touch with Horsin-Déon's son, "who has also known Rillieux personally" (8). A copy of the brochure is in the Tulane Univer-sity Special Collections.

26. See the obituary notice on Rillieux in *The Louisiana Planter and Sugar Manufacturer* (November 24, 1894). Was this the same Laurent Mil-laudon? It could be father and son. See James B. Byrnes, "Edgar Degas, His Paintings" (64), on Benjamin Laurent Millaudon (1828–1885).

27. Reff, *Degas: The Artist's Mind*, 270.

28. Entry on James Freret in *Jewell's Crescent City Illustrated*, unpagi-nated.

29. Marilyn Brown, *DeGas-Musson Family Papers*, 23.

30. Evans, *Judah P. Benjamin*, 119.

31. Ibid., 263.

32. Kenner entry in *Jewell's*, and Bauer, *A Leader among Peers*, chapter X.

33. *Jewell's*, Kenner entry.

34. *Pages from the Goncourt Journal*, 206.

35. Loyrette, *Degas*, 382–3. Hugh Honour, *The Image of the Black in Western Art*, IV (Cambridge: Harvard University Press, 1989), 213. Richard Thomson, in *The Private Degas* (Great Britain and New York: Thames and Hudson, 1987), suggests that the portrait invokes the tradi-tional iconography of the Assumption of the Virgin. Degas "would have savoured the ironic substitution of the Virgin by a mulatto acrobat" (92).

36. See *A Degas Sketchbook: The Halévy Sketchbook, 1877–1883* (New York: Dover, 1988), unpaginated.

NURSES

1. Cable's letter is reprinted in Arlin Turner, editor, *The Negro Question: A Selection of Writings on Civil Rights in the South* (New York: Norton, 1958), 30–3.

2. King, *The Great South*, 30.

3. Boggs, "Degas et la maternité," in *Degas inédit, actes du colloque Degas*, 38.

4. James Byrnes, "Edgar Degas, His Paintings," 38.

5. Woodward, *The Strange Career of Jim Crow*, Third Revised Edition (New York: Oxford University Press, 1974), 42–3.

6. King, *The Great South*, 38; Robert Somers, *The Southern States Since the War, 1870–71* (1871; University, Alabama: University of Alabama Press, 1965), 194–5; Olmsted, *Seaboard Slave States*, 582.

7. John Blassingame, *Black New Orleans, 1860–1880* (Chicago: University of Chicago Press, 1973), xvi.

8. Ibid., 17, 20.

9. See Joseph Roach, *Cities of the Dead* (New York: Columbia University Press, 1996), 227. "The West Indian woman (identified by her headdress) became all but invisible to subsequent commentators . . ."

10. Reff, *Degas: The Artist's Mind*, 214.

11. See Linda Nochlin, "Morisot's *Wet Nurse*," in *Women, Art, and Power and Other Essays* (New York: Harper & Row, 1988), 45.

12. Ernest Chesneau, quoted in Loyrette, *Degas: The Man and His Art* (New York: Abrams, 1993), 45.

13. *Woman with a Bandage* is in the Detroit Institute of Arts. Henri Loyrette (in Boggs et al., *Degas*, 184) believes that it may be another portrait of Estelle, though Professor Hollis Clayson of Northwestern University, in conversation, suggested it might portray a victim of the Prussian bombardment during the Siege of Paris.

14. Loyrette in Boggs et al., *Degas*, 192.

COTTON BALLET

1. Edward King, *The Great South*, 50–51.

2. Cable, *Dr. Sevier* (Boston: J. R. Osgood, 1885), 6. One might compare Cable's noses "with more and sharper edge" with Degas's businessmen in *Portraits at the Stock Exchange* (Musée d'Orsay, c. 1879). Jewish stereotypes are apparently present in both.

3. James Byrnes suggested that Degas might have stayed on in order to attend Mardi Gras festivities (76).

4. For the Manchester connection, see Marilyn R. Brown, *Degas and the Business of Art*, especially chapter I.

5. See Theodore Reff, "The Morbid Content of Degas' Sculpture," *Apollo* 142, no. 402 (August 1995), 67. Carol Armstrong, *Odd Man Out*, mentions Baudelaire in relation to this painting (30).

6. Quoted in Reff, *Degas: The Artist's Mind*, 93.

7. Robert Somers, 194.

8. Arnheim, *Toward a Psychology of Art* (Berkeley: University of California Press, 1966), 166–7.

9. Armstrong, *Odd Man Out*, 33.

10. Quoted in Nancy Hale, *Mary Cassatt* (Garden City, NY: Doubleday, 1975), 71.

11. Valéry, *Degas, Danse, Dessin* (Paris: Gallimard, 1965), 91, my translation.

12. *Pages from the Goncourt Journal*, 206.

13. Theodore Reff, "Edgar Degas and the Dance," *Arts Magazine* 53, no. 3 (November 1978), 145.

14. I have not succeeded in tracing the source.

15. See Marilyn Brown, *Degas and the Business of Art*, 31–3. Brown suggests that René De Gas "could be perusing the fatal announcement" of the dissolution of the firm, in the *Picayune* of February 1, 1873.

16. Cf. Armstrong: "Michel Musson . . . looks more like a Dutch matron or serving girl working on her sewing than the mercantilist he was" (32).

17. Henri Loyrette, *Degas: The Man and His Art*, 72.

18. King, *The Great South*, 34.

19. Ibid., 90.

20. Robert Somers, 151.

21. Olmsted, *Seaboard Slave States* (New York: Dix & Edwards, 1856), 661.

22. Du Bois, *The Souls of Black Folk* (New York: Penguin, 1989), 138.

23. See Linda Nochlin, "Degas and the Dreyfus Affair: A Portrait of the Artist as an Anti-Semite," in *The Politics of Vision: Essays on Nineteenth-Century Art and Society* (New York: Harper & Row, 1989), 141–69. The Depression of 1873, which had a ruinous effect on the Degas family banking concerns, was popularly traced to such "Jewish bankers" as the Rothschilds—another possible source for Degas's anti-Semitism.

24. See Brown, *Degas and the Business of Art*: "Given the passing resemblance between the cropped seascape and representations of the Civil War confrontation between the *Kearsarge* and the *Alabama*, there may be a veiled comment on the stubbornly prolonged Confederate loyalties of Degas's family, or on the fortunes of the South and its cotton trade in the postbellum period" (26).

25. Cable, *Dr. Sevier*, 465–6.

MARDI GRAS

1. See Byrnes, 76. The letter is in the DeGas-Musson Family Papers, Tulane.

2. Ralph Keeler, *Every Saturday* (Boston, July 1, 1871).

3. John Brinckerhoff Jackson, *American Space* (New York: Norton, 1972), 165.

4. Much of the information on Mardi Gras is drawn from Robert Tallant, *Mardi Gras . . . As It Was* (1948; Gretna, LA: Pelican, 1994). See 125, 137.

5. Augusto P. Miceli, *The Pickwick Club of New Orleans* (New Orleans: Hauser, 1964). Professor Joseph Roach of Tulane directed me to this source, which includes membership lists and appendices of members who participated in Mardi Gras parades and in the "Battle of Liberty Place."

6. Edward King, *The Great South*, 43.

7. Tallant, 128, 140–2.

8. King, 39.

9. Tallant, 142.

10. Ibid., 144.

11. The Historic New Orleans Collection has a copy of the poem as originally published. It is reprinted in Perry Young, *The Mistick Krewe: Chronicles of Comus and His Kin* (New Orleans: Louisiana Heritage Press, 1969), 119–24.

12. D. A. S. Vaught, as recorded in Walter Prichard, editor, "The Origin and Activities of the 'White League' in New Orleans (Reminiscences of a Participant in the Movement)," *Louisiana Historical Quarterly* 23, 532.

13. Tallant, 145.

14. King, *Great South*, 43.

15. The standard history of the Unification Movement is the second lecture, "The Politics of Reconstruction," in T. Harry Williams, *Romance and Realism in Southern Politics* (Athens: University of Georgia Press, 1961), 17–43.

16. See Lawrence Powell, "A Concrete Symbol," in *Southern Exposure* 18, no. 1 (Spring 1990). "Lacking a glorious Confederate tradition to call their own, influential whites in New Orleans had to look elsewhere for a history that would justify their attempts to dominate blacks" (40).

17. Mary Gehman, *The Free People of Color of New Orleans: An Introduction* (New Orleans: Margaret Media, 1994), 86–7.

18. Foner, *Reconstruction: America's Unfinished Revolution, 1863–1877* (New York: Harper & Row, 1988), 547.

19. Soon after the war, Duncan Kenner had urged the Democratic Party to welcome the new black voters. See Tinker, *Creole City*, 119.

20. For biographical information on Edmond Rillieux and other leaders among the free blacks, see David C. Rankin, "The Politics of Caste: Free Colored Leadership in New Orleans During the Civil War," in Robert R. MacDonald et al., editors, *Louisiana's Black Heritage* (New Orleans: Louisiana State Museum, 1979), especially 144–5.

21. See Taylor, *Louisiana Reconstructed*, 277–9. Lawrence Powell, in conversation, insisted on the close links between the failure of Unification and the growth of the White League.

22. T. Harry Williams, *Romance and Realism*, 42.

23. Rodolphe Desdunes, in *Our People and Our History* (Baton Rouge: Louisiana State University Press, 1973), claims that V. E. Rillieux and Norbert Rillieux were brothers (59, n. 9), but this can hardly be the case, since Victor was born more than a decade after the death of Norbert's father. No birth certificate for Victor has been found. Approximate translations of the quoted lines are as follows. Of Beauregard: "One found in him truly a fine regard both for the humble veteran and for the widow subjected to the blows of hard destiny"; "magnanimous soldier"; "Tender husband, good soldier, and Creole gentleman." And of Aristide Mary: "You could have lived in France rich, happy among them all; but at the voice of your own [people] bowed with suffering, you returned among us, a patriot before all else"; "The poor in great numbers and your unsubjected race preserve your memory."

24. Foner, 550–1.

25. Since Ogden's most conspicuous feature was his fiery red hair, it is tempting to suspect that he might be the figure in the boater in Degas's *Cotton Merchants* (Fogg Art Museum, Harvard). By 1872, William Bell's brother Samuel had joined the Bell-Ogden business, and by the beginning of 1876 the firm was renamed Ogden & Bell, as William Bell left the firm to pursue other ventures. Information on the firm can be found in city directories and in Frederick Ogden's personal scrapbook, Frederick Nash Ogden Papers, Tulane Special Collections. The intimate ties between the Ogdens, the Bells, and the Mussons continued long after; the General's nephew, also named Fred N. Ogden, later owned the Musson residence in the Garden District.

26. Vaught, in Prichard, editor, "Origin and Activities," 532.

27. Ogden is described in an unidentified newspaper clipping in his personal scrapbook, Ogden Papers, Tulane.

28. See Howell Carter, *A Cavalryman's Reminiscences of the Civil War* (New Orleans: American Printing Company, 1900), 187–8. When Ogden's troops returned from the fray, there was some question as to whether he was retreating. "No, they are not retreating," said a fellow officer, "Ogden comes in front." Carter remarks that "the inference was that if retreating Col. Ogden would not be leading." Plater Robinson, of Tulane's Southern Institute for Education and Research, told me of this interesting and little known source on Ogden's early career. There is no full-length biography of Ogden.

29. Vaught, in Prichard, "Origin and Activities," 532.

30. Kendall, John Smith, *History of New Orleans* (Chicago, 1922), 360.

31. Emily Toth, *Kate Chopin*, 134.

32. For details of Ogden's raid, I have relied on contemporary reports in the *Picayune*. See also Foner, *Reconstruction*, 550.

33. Cable, *Creoles of Louisiana*, 267.

34. Kendall, *History of New Orleans*, 362–3.

35. Ibid., 363; Tinker, *Creole City*, 136.

36. For "Michael Musson," see the advertisement for Factors and Traders Insurance Company in *Jewell's Crescent City Illustrated*, reproduced in Marilyn Brown, *Degas and the Business of Art*, 23.

37. Kendall, 364, 367.

38. Tinker, 137.

39. Ibid.

40. Taylor, *Louisiana Reconstructed*, 293.

41. Foner, *Reconstruction*, 551; Alcée Fortier, *History of Louisiana*, Volume 4, second edition (New York, 1904), 153.

42. Taylor, 294.

43. Kendall, 370–1.

44. Grace King, *New Orleans: The Place and the People*, 328.

45. In W. O. Hart's "History of the Events Leading Up to the Battle [of Liberty Place]," *Louisiana Historical Quarterly* 7 (1924), the names of "——
—Musson" and "R. Dugas" are listed in the membership roll of the Washington White League, Sixth Ward" (630–1). The document was clearly difficult to decipher. There is no "R. Dugas" in city directories of the time, and the unidentified Musson could only be Michel. For Mathilde Bell's service, see Stuart Omer Landry, *The Battle of Liberty Place* (New Orleans: Pelican, 1955), 222.

46. *Picayune*, October 3, 1875.

47. Landry, *Battle of Liberty Place*, 202.

GRANDISSIMES

1. Foner, *Reconstruction*, 551. Foner calls him "Burns."

2. Kjell Ekstrom, *George Washington Cable: A Study of His Early Life and Work* (1950; New York: Haskell House, 1966), 66.

3. Cable, "After-Thoughts of a Story-Teller," *North American Review* (January 1894), 17.

4. Cable, "My Politics," in *The Negro Question*, 13–14.

5. Ibid., 11.

6. "After-Thoughts," 17.

7. Bruns to Cable, November 4, 1879. Bruns's letters are in the Cable Papers at Tulane University.

8. It isn't difficult to see how a psychoanalytic reading of the novel might look. The two Honorés are one, just as the light and dark women of romance are two sides—the angelic and the erotic—of the same woman. Hence the tie of each to Palmyre: loved by one, she loves the other. Honoré the fair must acknowledge his "darker half" (his half-brother, as business partner, but psychoanalytically his sexuality) before he can marry Aurora. Having "unified" himself, light and dark, the logic of the narrative requires the darker Honoré to disappear, which (like the black Unification leader Aristide Mary, and many other suicides among the Franco-African leaders) he does.

HAUNTED HOUSE (1874)

1. *New Orleans City Guide* (1938), 249, as mentioned above, chapter three.

2. Roger Fischer, *The Segregation Struggle in Louisiana, 1862–77* (Urbana: University of Illinois, 1974), 110.

3. Eliza Ripley, *Social Life in Old New Orleans* (1912; New York: Arno Press, 1975), 8–9.

4. Dora Miller to Cable, February 10, 1990. Cable Papers, Tulane.

5. New Orleans *Republican,* February 5, 1871, quoted in Fischer, 114.

6. Fischer, 114.

7. Cable's version may be found in his *Strange True Stories of Louisiana,* originally published in 1888. The currently available edition is from the Pelican Publishing Company, Gretna, Louisiana, 1994. All quotations are from this edition.

8. "My Politics," in Cable, *The Negro Question* (New York: Norton, 1958), 8.

9. Reprinted in Cable, *The Negro Question,* 27.

10. Fischer, 122.

11. Ibid., 125.

12. Ibid., 126.

13. Ibid., 127.

14. Ibid., 130.

15. The Dora Miller manuscript is in the Cable Papers at Tulane.

REVENANTS

1. The standard edition of Chopin's works is Per Seyersted, editor, *The Complete Works of Kate Chopin,* two volumes (Baton Rouge: Louisiana State University Press, 1969).

2. Quoted in Emily Toth, *Kate Chopin,* 31, on whose account of the accident I have relied.

3. I have followed Toth's account of George's death, 64–6.

4. Toth connects Crane and Chopin, 282. Chopin's virtuosity with the revenant theme is confirmed by "The Return of Alcibiade," of late 1892, in which the return of the "revenant" is staged, or performed. A daft old man mistakes his daughter's suitor for his own son, who promised to return to his Louisiana home by Christmas, but died in the war instead. To humor the old man, the suitor pretends to be the son for Christmas dinner, and complications are avoided when the father dies peacefully and content later the same night.

DIVIDED HOUSES

1. Chopin's diary from her New Orleans years, quoted in Daniel Rankin's early biography, has disappeared. For this passage, see Toth, *Kate Chopin,* 130.

2. Toth, 282.

3. Ibid., 42.

4. Ibid., 331.

5. It is not always clear from city directories when a move to a new residence occurred. But it is tantalizing to imagine that the Ogdens and the Chopins were acquaintances.

6. Toth, 450.

7. *DeGas-Musson Family Papers,* 21. Marilyn Brown, in correspondence, suggested the link to *plaçage.*

8. Murray Kempton, "French Quarter Feud," in *Interview* (September 1988), 82.

9. Boggs, "Degas as a Portraitist," in Felix Baumann and Marianne Karabelnik, eds., *Degas Portraits* (London: Merrell Holberton, 1994), 31.

10. Byrnes, "Edgar Degas, His Paintings," 79.

11. Ibid., 80.

12. For a summary of these documents, see Brown, *DeGas-Musson Family Papers,* 31. The documents may be found in Box III, Folders 29 and 30 of the papers.

ESPLANADE: A CODA

1. Mary Gehman informs me that Constance Vivant, *née* Cheval, acquired property on Bourbon Street from Paul Cheval (probably her father) in 1794. It was in Gehman's book *The Free People of Color of New Orleans* that I first came across the parentage of Norbert Rillieux, the clue I needed to link him to Degas.

2. Mary Louise Christovich et al., *New Orleans Architecture: Volume V: The Esplanade Ridge,* 111. The authors say the Musson house is "crowded between two late houses." Marilyn Brown first pointed out to me that one of those houses is not in fact "late" at all.

Index

Adhémar, Hélène, 60–1
Angell, Col. John C., 186, 250
Armstrong, Carol, 160
Arnheim, Rudolf, 160
Arvin, Newton, 200

Balfour, Estelle Musson, *see* De Gas, Estelle Musson
"Battle of Liberty Place," 15, 218, 187–91; and K. Chopin, 250–2; *see also* White League
Baudelaire, Charles, 98, 158
Beard, Dr. Cornelius, 189, 199; and attack on Warmoth, 219; as M. Musson's second in duel, 258
Beauregard, Gen. P. G. T., 181–2, 183–4, 260
Beauregard family, 12; *see also* Millaudon family
Bell, Quentin, 60
Bell, Mathilde Musson (Mrs. William A.), 90; death of, 257; Degas portrait of, 92–3, *illus.* 94, 96; and relief efforts for White League, 192
Bell, Samuel, 215
Bell, William A., 80, 81; depicted in *Cotton Office*, 166, 169; dispute with M. Musson, 258; Ogden, partner of, 15, 83, 184; on racing board, 85; as White League treasurer, 15, 185
Bellelli family, 12, 23
Benjamin, Judah P.: career of, 129–31; and Kenner, 135–6; marriage of, 129–30, 277 n17; and Musson family, 135; and N. Rillieux, 128, 129–31; and Slidell, 260
Biard, Auguste, 124
Blassingame, John, 146
Boggs, Jean, 142
Brickell, Dr. Warren, 189; as model for Cable's *Dr. Sevier*, 200
Brown, Marilyn R., 87–8, 123, 166, 280 n24
Bruns, Dr. John Dickson: advises Cable on *Grandissimes*, 200, 207–13; career of, 198; death of, 200; and Timrod, 198; and Unification movement, 197, 199, 208; and White League, 189, 198–9
Bujac, Mathieu-Joseph, 87
Butler, Gen. Benjamin, 50–2, 57; headquarters in Lalaurie mansion, 50, 214; lampooned in Mardi Gras, 175
Byrnes, James, 143, 256

Cable, George Washington, 5; Bruns's advice to, in writing of Grandissimes, 199–200, 207–13; career of, 16, 105–7; on Carondelet St. 153–4; K. Chopin influenced by, 119, 237, 238; on Congo Square, 237; on Haitian immigrants in New Orleans, 63; on Henry Clay monument, 187–9; homoerotic themes in work of, 115–16, 211–12; and E. King, 105–6, 108, 110–12; in Northampton,

A NOTE ON THE TYPE

This book is set in a typeface called Méridien, a classic roman designed by Adrian Frutiger for the French type foundry Deberny et Peignot in 1957. Adrian Frutiger was born in Interlaken, Switzerland, in 1928 and studied type design there and at the Kunstgewerbeschule in Zurich. In 1953 he moved to Paris, where he joined Deberny et Peignot as a member of the design staff. Méridien, as well as his other typeface of world renown, Univers, was created for the Lumitype photoset machine.

Composition by NK Graphics, Keene, New Hampshire

Printed and bound by Quebecor Printing,
Martinsburg, West Virginia

Designed by Harry Ford